PHOTOGRAPHING
UrbanLandscape

Architecture, modern or
traditional, provides us with
striking subject material. The
Trans-America building, in San
Francisco, is an excellent
example of adventurous
architectural design lending
itself to urban photography.
Picture by Chris Lees

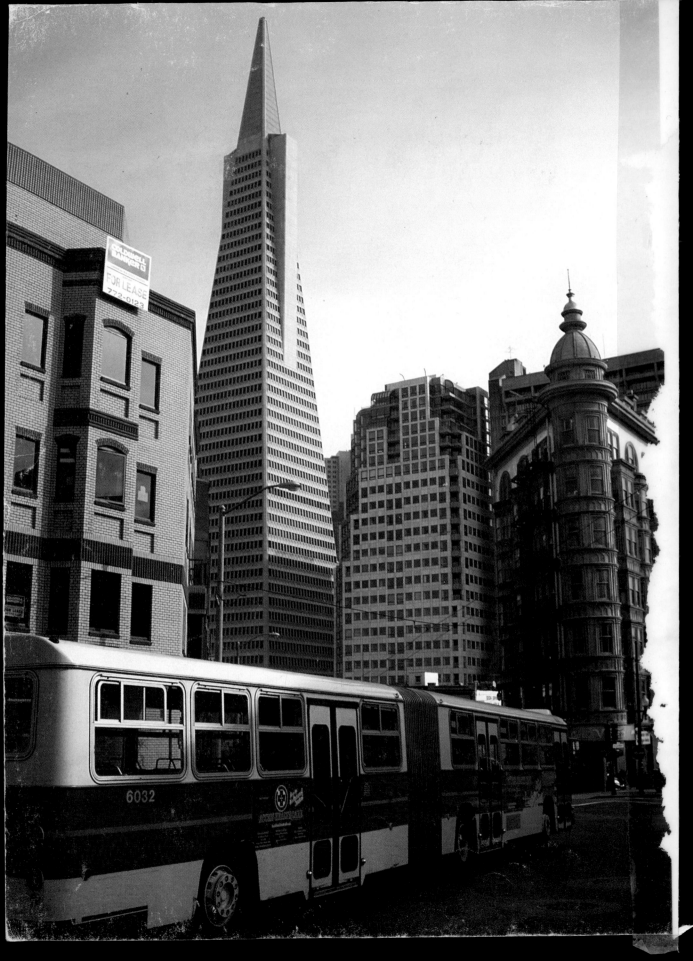

PHOTOGRAPHING
Urban Landscape

David Chamberlain

BLANDFORD PRESS
POOLE · NEW YORK · SYDNEY

First published in the UK 1987 by Blandford Press
Link House, West Street, Poole, Dorset BH15 1LL

Copyright © 1987

Series Editor: Jonathan Grimwood

Distributed in the United States by
Sterling Publishing Co, Inc,
2 Park Avenue, New York, NY 10016

Distributed in Australia by
Capricorn Link (Australia) Pty Ltd
PO Box 665, Lane Cove, NSW 2066

ISBN 0 7137 1849 8

Typeset by Keyspools Ltd, Golborne, Lancs.
Printed in Yugoslavia

Contents

Introduction

Landscape photography is second in popularity only to photographing people, yet many of us do not have the opportunity regularly to visit areas of outstanding natural beauty. I would think that most of us have looked at the work of the great photographers, such as Edward and Brett Weston, Ansel Adams, John Blakemore, Minor White and other outstanding landscape photographers, with admiration – and envy! How can we hope to compete with such excellence? Of course, we cannot. Such men have devoted their entire lives to their work and either live in, or spend a vast amount of time in, the environment which they photograph so well, and from which they often make their livelihood.

We, as amateurs, no matter how keen or dedicated, are not in a position to be able to devote so much time, energy and hard-earned finance to what is, after all, only our hobby. Even the most fortunate amongst us could afford only to devote perhaps between 2 and 4 weeks per year on such a pursuit, and this may be extremely difficult when many of us have other commitments. Our eagerly awaited annual vacation is more likely to be spent on 2 weeks in the sun with the wife and children. Two weeks of candyfloss and amusement parks is not exactly conducive to 'being at one' with nature!

Fortunately, there is an alternative type of landscape photography which is available to all, and very easily accessible – the urban landscape. Man has created his own, quite unique landscape within the towns and cities in which he lives and works. Although this might not at first sight appear to be particularly beautiful, with the right sort of attitude, and a positive approach to the subject, our urban environment can indeed produce very striking landscape images – yes, even beautiful! What is more, there is a vast, almost unlimited wealth of potential picture material available to the photographer who is aware of and prepared to take advantage of this enormous potential.

I think it is true to say that there is almost certainly a much greater potential for producing exciting and imaginative photographs within our urban areas than can generally be found in the countryside, where it is quite probable that you will have to travel considerable distances to find any great variation in the scenery. In our man-made urban environment, new pictures seem to present themselves around almost every corner, and there can be a large variety of subject material to be

found in an area, often within a quite small radius. What is more, very little effort is required from the photographer who wishes to tackle this most versatile of subjects, as in many cases all that is necessary is to step outside his or her own front door! It is extremely difficult indeed to think of any other subject which is quite so accessible to our cameras.

With such a versatile subject, and one which holds so much potential for our creative abilities, it is perhaps rather difficult to imagine that there might be any problems. Unfortunately there are – *ourselves*! Amateur photographers, for reasons known only to themselves, seem to be the most lethargic of all hobbyists. I cannot begin to count the times that I have listened to comments made by photographers which would indicate that they have no problem in finding excuses for 'not taking' photographs, whereas it does in fact seem very difficult for them actually to make the effort to get themselves out and to start taking pictures. Unfortunately, it is simply not possible to produce good photographs whilst your backside is firmly seated in an armchair! No matter how much potential there is in photographing the urban landscape, a certain amount of effort is required of you, the photographer. Like any other hobby or interest, you can only get out of it what you put in. You must be prepared to put some effort into anything in which you participate if you are to achieve worthwhile results. Get involved with the subject and you will without doubt be rewarded with superb pictures which, in their own way, are as satisfying as those masterpieces by the 'great' photographers.

Although many of you may have already attempted some urban landscape photography in one form or another, not many photographers seem to have yet realised the full creative possibilities which can be opened up through this fascinating subject. Without doubt, it does seem that the old saying 'Familiarity breeds contempt' is really very apt when it comes to describing our attitude towards our own surroundings. It is very easy to 'look' and yet not 'see'. This 'seeing' of pictures is very difficult to pass on to other photographers. However, there is a key word which you will see mentioned several times throughout this book which sums up very nicely this ability to 'see' pictures – *previsualisation*. Quite simply, this means having the ability to imagine the final photograph before it is taken. This is not as difficult as it may at first appear. Bear this word in mind and, with a little practice and a gradual building up of experience, your ability to previsualise the end result will grow.

It is my intention, through writing this book, to bring to your notice the great potential, and sense of fulfilment, which can be achieved in photographing the urban landscape – your landscape. I also hope that I may pass on to you lots of useful information and hints on technique, which will help you in this pursuit.

Pictures are a very important part of any book on photography, and particularly so with such a subject as urban landscape. Pictures have been an inspiration to both artists and photographers through many

years, and looking at the work of others frequently provides the stimulus for us to go out and produce work ourselves. This is how it should be. Urban landscape does not immediately appear to be a creative challenge until you see pictures which can confirm this. I hope the pictures in this book fulfil their purpose, and provide you with the stimulus to go out and take your own urban landscape photographs, bringing you the ultimate personal satisfaction that will come from tackling this most challenging and rewarding of subjects.

David Chamberlain ARPS

1 · The Urban Landscape

If you have never previously tackled the subject of urban landscape it may seem to be a rather uninteresting or perhaps even a daunting prospect. Nothing, however, could be further from reality.

It can be very easy to misinterpret urban landscape to mean architectural photography on a very general level. Although architecture is sometimes a feature in urban landscape photography, it is by no means the 'subject', and it may be found necessary to 're-think' your outlook towards the roads, buildings and other structures which together make up our towns and cities. People, and the things they use, are also a part of the urban landscape. It would certainly be a mistake to believe that urban landscape photography is merely about a town's architecture.

Acquiring The Taste

Any photographer approaching the subject for the first time will need to acquire a taste for the subject. Now this can prove a little difficult. The subject is so vast and varied that it may be difficult to know quite where to start. The only way of developing your taste for the subject is first to take a look at other photographers' pictures of urban landscape. This should give you some idea of just what can be achieved. Once you have some idea of the different styles or types of work that appeal to your own taste, go out and walk around your own town or city, looking for things which could potentially provide similar pictures to those that you have seen. Don't just drive around the streets in your car. You don't see anything in this way. Walk around. You will be amazed at the things which it would seem you have never before seen – missed, simply because you were too involved in the rat-race of everyday life. Even places with which you may have thought you were familiar can take on an entirely new aspect when viewed in a more leisurely manner. Give yourself 'time' to see things, and you *will* see them. It is often a good idea to leave your camera at home on these initial walk-abouts, for then you will not feel obliged to 'have' to take photographs. This often proves beneficial in that, when you do go back with your camera, you will in effect be taking a second look. This will allow you to assess a potentially interesting subject more constructively. In any event, these walk-abouts will familiarise you with the subject, helping you to get a 'feel' for it.

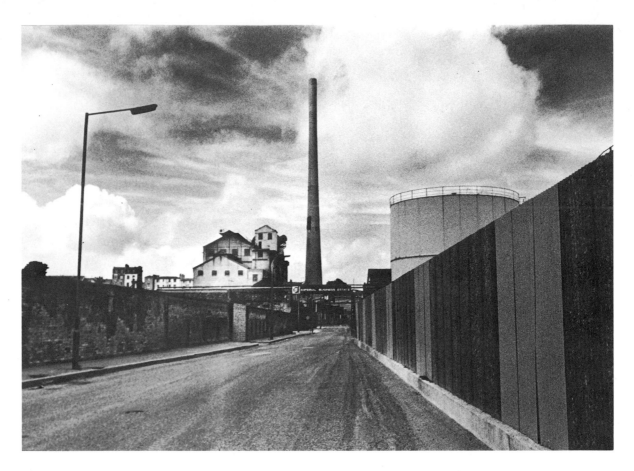

Accessibility

A great advantage to urban landscape photography is that, unlike many subjects which we might like to tackle, it is so easily accessible to nearly all of us. Most of us live in either a large town or city, and most of us who don't can usually find themselves in an urban environment within a short journey by car or public transport. Even those that live in the more rural areas will find it beneficial, and certainly photographically rewarding, to take a trip into town sometimes. This is certainly possible for at least 90 per cent of people, whereas I would think that a figure of only about 10 per cent can ever hope to be able to afford a trip to the more exotic locations which are illustrated on glossy calendars and in some magazines.

Unlimited Potential Of Subject Material

The scope and versatility of potential subject material in urban landscape photography is probably unapproachable in almost any other photographic subject. Every town or city can provide an endless variety of subject matter for our cameras. Mankind is perhaps not yet capable of creating the sort of beauty and perfection found in nature, but is most surely just as diverse, being a product of nature.

Industry of one sort or another is at the heart of many a town or city. Try to capture the mood or atmosphere which it conveys to you. *Olympus OM1, 35mm lens with red filter-Ilford HP5 ISO 400/27*. Picture by David Chamberlain

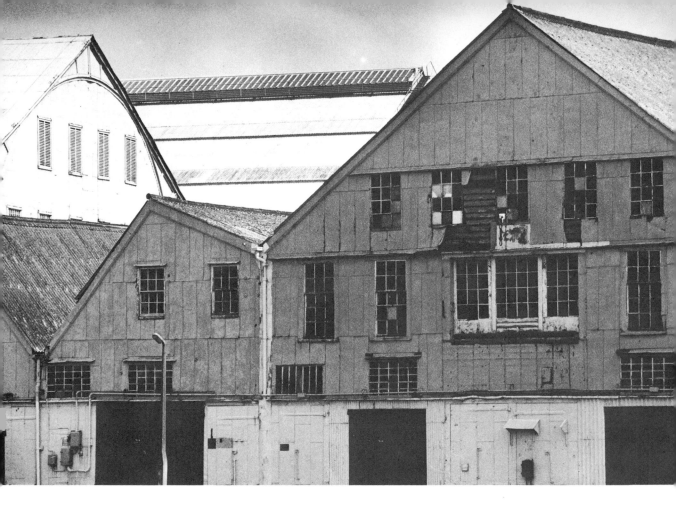

Look for different aspects of industry. This shot, taken in the now disused historic dockyard at Chatham in Kent, makes good use of the empty buildings with the rooftops forming interesting geometric shapes. *Pentax Spotmatic F, 135mm lens with yellow filter – Ilford HP5 ISO 400/27*. Picture by Angela Fernandez

Every city, even within just one country, will have its own quite distinct character. Even within just one town or city, there will often be enormous variations in character, or 'atmosphere' in different areas. Many cities, for instance, have at their heart either an industrial or business centre. Then, as we retreat further towards the outskirts of the city, the buildings become progressively more and more residential, until finally the city begins to fade away into the rural environment.

We create, within our towns and cities, buildings and other structures which are designed purely to make life more practical within this purpose-made environment: subways, bridges, parks, fly-overs, traffic control systems, car parks etc. All of these things are really quite alien to the natural world, but are essentially a part of man's world. Man, without any doubt whatsoever, is the most unnatural living creature to inhabit the earth, but it is this very fact which perhaps makes us, and our artificial habitat, so very, very interesting – at least to other human beings!

As we take a walk through a large city, we have the opportunity to witness a great deal of our progress, both in technological achievements and in a social context. We can also find evidence of our industrial and commercial growth – or decline. The city scene is forever changing, with

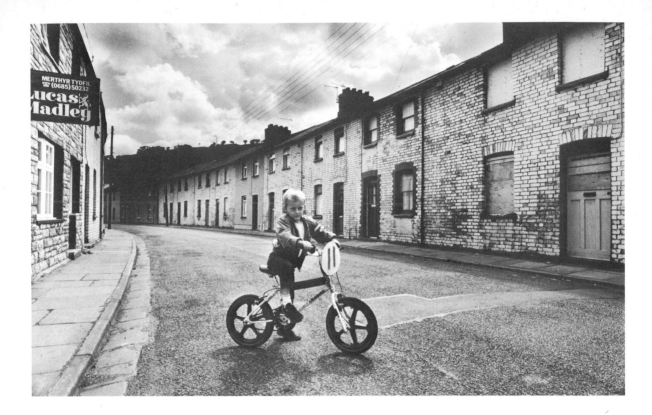

old buildings being demolished to make way for new ones, and new roads etc being constructed. If keen photographers cannot find enough scope and versatility in such an environment, they really should stop to consider whether or not they are really cut out for this hobby of photography!

Towns, villages and even great cities often 'grow up' around a particular industry. This shot, of a street of terraced houses in Aberfan, South Wales, seems to reflect the recent decline in the coal-mining industry through which it exists. *Olympus OM1, 21mm lens with yellow filter – Ilford FP4 ISO 125/22*. Picture by David Chamberlain

Creative Potential

The creative potential, too, is vast. The more imaginative photographers will find great satisfaction in photographing the urban scene. In most cities, at least some of the people involved in its construction had some degree of creative talent and, in towns or cities in which we are fortunate enough to have left some buildings of historical interest, we also have the benefit of being able to draw on the creative talents of people from another era. Combine our modern creative photographic ability with the creative talent of architects and designers, whether of the past or present, and you have a formula for extraordinary photographs.

However, don't think that you can afford to relax and simply rely on the creative abilities of these architects. This alone is not enough, and will only result in the production of pictures which are at best no more than faithful architectural record shots. Although there is of course nothing wrong with such pictures, I do believe that this type of photograph, unless required for a specific purpose, is a waste of such an exciting and potentially creative source of subject matter.

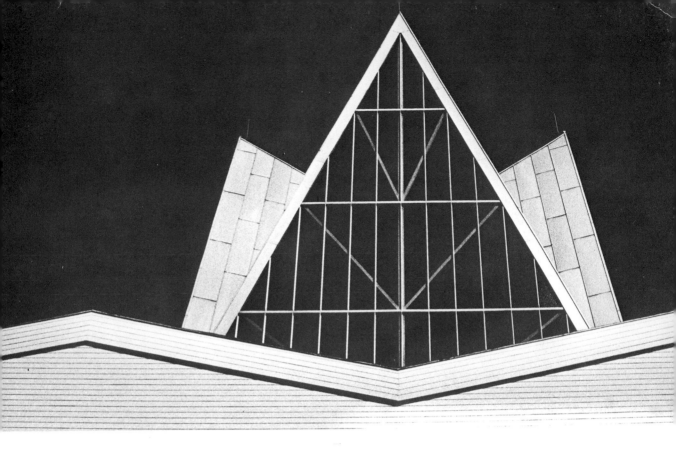

Modern architecture can provide us with some of the most exciting images, the bold architectural design providing striking graphics within our photographs. This shot is of the chapel roof at Christ Church College, Canterbury, in Kent. A rich blue sky has been darkened to black by using a red filter and polariser combined. *Olympus OM1, 35–70mm zoom with red (25A) and polarising filters – Ilford HP5 ISO 400/27.* Picture by David Chamberlain

Learning To 'See' Pictures

The ability to 'see' pictures is rather difficult to pass on to others. However, this ability may be better understood if you have taken the trouble to study the work of other photographers, who perhaps do have this ability. The one thing that is most noticeable about the work of more accomplished photographers is that they do seem to be able to 'create' a picture out of almost anything. The most mundane of objects can be transformed into worthwhile and, indeed, exciting photographs. Why is this so? How do they do it? It is this ability to 'see' pictures which enables photographers to produce such pictures. But what exactly is this ability? And how can it be acquired?

One thing is certain. You cannot hope to obtain this ability overnight. It can only come about by a gradual learning and development process, and this, unfortunately, does take time. The ability to see pictures is really the end result of achieving a high level of technical competence on the behalf of the photographer. If you have a sound and reasonably thorough knowledge of basic photographic technique, you will also have a good understanding of just what is necessary to make a good photograph. You will also know how to use your camera's controls – exposure, allied to aperture and shutter-speed selection, depth of field etc, to create the type of image you want. If you are a monochrome worker, you will have, in addition, the technical knowledge and ability to carry out creative printing-control techniques to modify the final

result. The ability to 'see' pictures is really the art of previsualisation – that is, being able to previsualise the desired end result before actually taking the picture. If you have the knowledge of technique to control the image at all stages, you will also have a sound basis for previsualisation, or being able to 'see' pictures.

A thorough knowledge of the equipment you use is also essential, and this knowledge should extend to fully knowing and understanding the purpose and function of all additional lenses and accessories which you might own. A common mistake that many amateur photographers make is to buy too many lenses and accessories. A great many of these items are really quite unnecessary and, in most cases, not even desirable. Extra lenses should only be purchased as and when they become necessary. It is really quite surprising just what can be achieved with only a standard lens. It is often better to work with just the one lens until you fully learn what this lens is capable of, whereas, if you buy several lenses at once, you may end up never quite understanding what any of them do. By getting to know your equipment and lenses in this way you will have a far greater chance of being able to 'see' pictures, as you will be able to relate a scene to what you know will be the effect obtained with a particular lens. You will quite naturally reach the limitations of a particular lens of your own accord. When you find that you consistently encounter situations where you need either a wide-angle or telephoto lens, that is the time to consider purchasing one.

Whatever lens is fitted to your camera, you must learn to use the camera's viewfinder to full advantage. Much of the ability to see pictures stems from getting everything right at the initial taking stage. Use your camera's viewfinder properly and effectively – not merely to make sure that you are 'getting everything in'. Inexperienced photographers are frequently so absorbed by the main subject of their photograph that they tend to neglect the rest of the composition. The best attitude to adopt is to try to imagine that the image in your camera's viewfinder is a finished picture. Try to visualise the image in your viewfinder as if it was a framed picture hanging on the wall in your home. Ask yourself, is there anything, anything at all, which, given the opportunity, you would prefer to alter. Look all around the viewfinder, not just at the main subject. Are there any distracting details which would best be removed or at least disguised? If you are using a single-lens-reflex camera, where the image is viewed through the actual lens which takes the photograph, stop the lens down to the selected aperture at which the photograph is to be taken using the depth-of-field preview control, if your camera is equipped with such a device. Do any distracting details suddenly snap into sharp focus which were previously disguised by the shallow depth of field when viewed at full aperture? This is quite a common mistake to make, now that all modern lenses are fitted with fully automatic diaphragms. You may be able to conceal unwanted details by delibe- rately selecting a large lens aperture, when it might be possible to throw

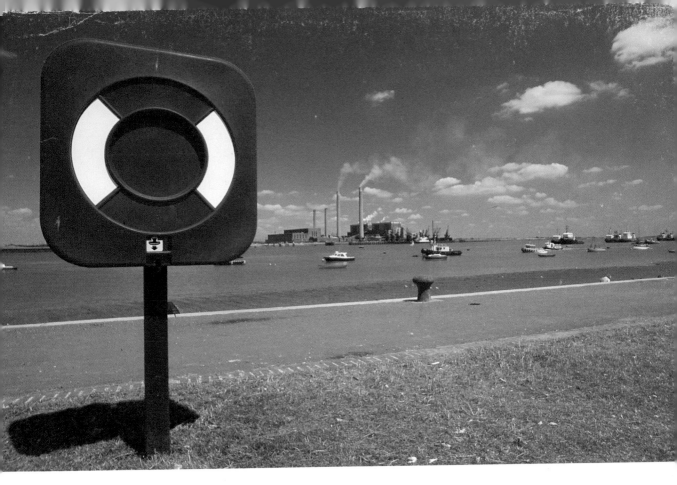

Industrial scenes can be found in most cities world wide, providing interesting pictures whether taken from near or far. In this shot, industry itself becomes almost a secondary feature viewed from across the river Thames. The red life-belt holder has been utilised to provide a primary point of interest, making good use of strong colour. *Olympus OM1n, 21mm lens with polarising filter – Kodak Ektachrome 100.* Picture by David Chamberlain

them out of focus through differential focusing – shallow depth of field.

Even if you are not able to disguise or conceal unwanted details at the taking stage, by careful use of your viewfinder, you will at least be fully aware of their presence and be able to arrange them in the composition so that they will be at their least distracting. If you are a monochrome worker, you will have the advantage of being able to manipulate the print to further disguise any such unwanted details and, of course, if you have used your viewfinder correctly, you will be in a position to be able to pre-plan this work.

As your ability to control the entire photographic process develops, and your knowledge of the creative use of the camera's controls expands, you will progressively improve your ability to be able to look at a scene and previsualise the end result which you wish to achieve. The more competent you become at this, the better will become your ability to develop a photographer's 'seeing' eye.

Making The Most Of Light

Light is the single most important requirement in photography. Without it there can be no photography, and yet I feel that many photographers do not fully grasp the importance of light and how it affects results.

The time of year, weather conditions and the time of day, all affect the

15

quality and intensity of light, and this will control to a very great extent the type of photographs which we produce.

Although in some countries the weather can be extremely unpredictable, the secret of success is to try as often as possible to put yourself in control. Of course, we are not in a position yet of actually being able to control the weather conditions, but we do have the benefit of modern meteorological technology to provide reasonably accurate weather forecasts, which we, as photographers, can use to our advantage.

By planning our picture-taking activities with the prior knowledge of expected weather conditions we are immediately able to exercise some form of control over lighting conditions. Of course, both the season of the year and the time of day will also affect the light. During the winter months, the sun is much lower in the sky, producing more oblique lighting angles than are found during mid-summer. Early morning or late evening sunlight produces a similar effect during the summer months. Light quality, too, changes through the seasons and through the hours of the day. It is up to us, as photographers, to take advantage of these different lighting conditions, using them to produce the sort of pictures that we want.

It is very much easier to use such lighting conditions constructively when photographing urban landscape than it is with conventional landscape photography. The ease of access to the subject makes this possible. However, you cannot always be certain of being in just the right place at the right time, so always be prepared to make notes of a potentially interesting subject so that you may return to it another time when the lighting conditions may be more favourable.

Inclement Weather Conditions

As soon as the weather turns poor, most photographers seem to hide their cameras away. Although I will confess that it is not always the easiest of things to build up any degree of enthusiasm for going out to take photographs under adverse weather conditions, certainly a lot of good pictures can be missed if you are not prepared to brave the elements occasionally.

Wind, rain, snow and fog, can all provide very worthwhile picture-taking opportunities and there is no reason why it should be necessary to risk valuable equipment, or to be miserable and uncomfortable, if you prepare yourself properly.

Cameras can be protected quite easily simply by inserting them into a plastic bag. Cut a hole out of the bag through which the front of the lens can protrude and fit a clear glass – UV or Skylight filter – over the front of the lens to protect the front lens element. You can, if you prefer, buy purpose-made weather protection accessories, many of which are based on the simple plastic bag principle. If you intend to carry out a great deal of photography under inclement weather conditions you might prefer to buy a camera specially designed for the task, such as the well-known

Historically interesting architecture, particularly that of famous buildings, is always of prime interest to us photographers. A building as important as Canterbury Cathedral is difficult to photograph without the presence of tourists, unless you tackle the subject during the winter months and very early in the morning. However, visitors are an important element to such a building and surely the very reason for its existence! *Olympus OM1n, 21mm lens with red filter – Kodak Technical Pan ISO 25/15. Picture by David Chamberlain*

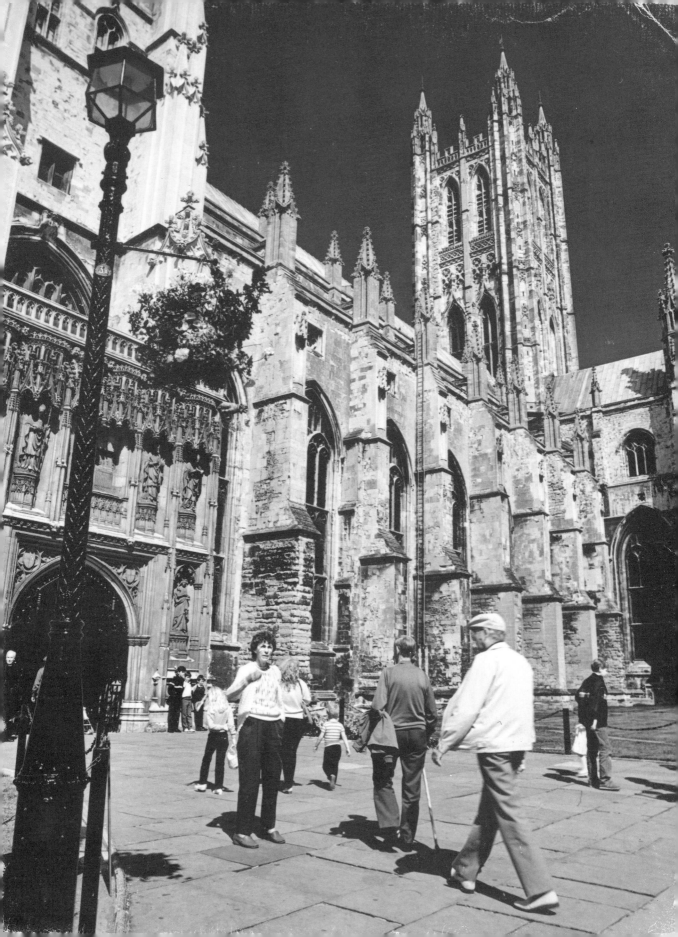

Nikonos-V A camera such as the Nikonos-V offers full protection under any weather conditions – indeed, it is designed for underwater use – and features fully interchangeable lenses. Photo courtesy Nikon UK Limited

Nikonos waterproof camera, which can actually be used under water. There are also special 'professional' water-proof housings available for some cameras. Although these do tend to be expensive, they could prove to be a worthwhile investment if you propose to do a lot of work in bad weather.

If photography under such conditions is to be a pleasure rather than an ordeal, you should take steps to protect yourself effectively from the weather. Buy proper *water-proof* clothing and boots. Modern 'shower-proof' clothing very quickly becomes saturated and you will then become cold, damp and very miserable indeed. If you are to make the most of this versatile subject of urban landscape under all conditions, do buy the right gear!

Dedication

Don't think for one minute that, because the urban scene is so accessible to us, it is by any means an 'easy' option. Just like any other subject for our cameras, a certain amount of dedication and determination is required. Certainly, the subject is all around us, but you really do need to 'give it your best' if you are to achieve the best results.

Don't be prepared to give up too easily on a picture. It is quite common, having spent a couple of hours or perhaps an entire day taking photographs, to accept results which are a little less than perfect, simply because it may be too much trouble to go back to do it again. Good pictures come about not only by being technically and creatively good at photography, but often by pure determination. If you have taken a picture which has all the potential of being a good shot, but somehow doesn't quite make it, go back and take it again, if this is at all possible. A

Historically interesting architecture, famous or otherwise, can provide interesting subject matter for urban-landscape photography. This shot of 'Big Ben' in London has been made more interesting by the imaginative use of the foreground to provide a 'frame' around the main subject. Picture by Ian Jenkins

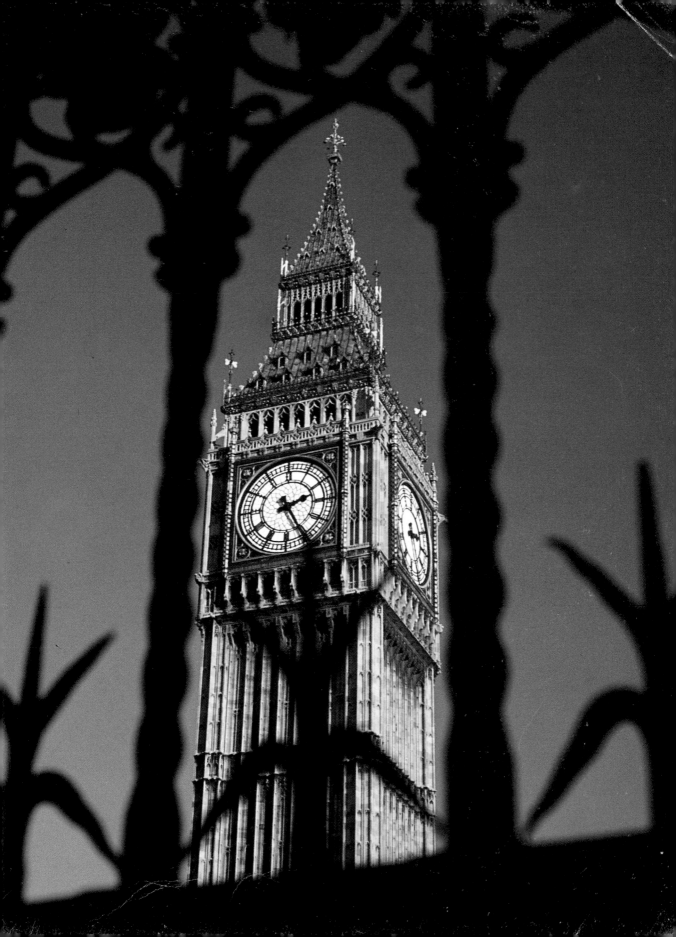

dedicated photographer may repeat a shot several times in order to obtain the result he wants. Making mistakes, or not getting everything right the first time, is not the sign of a 'poor' photographer. Not being prepared to have another go, however, is!

This dedication and determination needs to extend throughout the entire procedure, from the initial taking of the photograph to the final print. Never be prepared to 'skimp' at any stage.

Fun, Art Or Social Documentary

Your approach to the subject of urban landscape can take several directions. The direction *you* take, however, will be decided by your own interests or considerations. Most likely, your approach will be a blend of several things, but above all I do believe that a hobby should always be enjoyable. When it ceases to be so, it then ceases to be a hobby in the true sense of the word.

For most amateur photographers, I would think that fun, or pure enjoyment, is enough reason to become involved with the subject of urban landscape. Some, however, with a special kind of ability, may be capable of turing it into an art. Others might choose to use their photographic ability to produce a social document of a town or city, particularly if that town is of public interest, or perhaps if there is a changing environment within that town. This type of photography can prove to be extremely valuable, although it must be stressed that, whatever direction your own approach takes, the greatest value must surely be your own personal satisfaction. The urban landscape will provide plenty of this!

2 · Equipment

Cameras and other photographic equipment are merely tools or instruments which we as photographers use to produce our photographs. They are *not* jewellery to be hung about our person, or indeed, a means to show off our status to fellow photographers. Cameras – all of them – are designed for the sole purpose of taking photographs, and it is this for which we should be using them. I am sure nobody is really ever impressed by the make or model of camera slung around someone's neck, and yet there are still those who buy a particular camera almost solely for that purpose, hardly ever producing any worthwhile pictures.

However, choice of equipment is important. It can have quite a considerable effect on your approach to photography and, sometimes, if you have a particular specialised photographic interest, this may even dictate the type of equipment you choose.

I would think that a vast sum of money is wasted by amateur photographers, particularly when first starting out in the hobby, simply through choosing the wrong equipment for the type of photography they want to do. This is not always their own fault, of course, as often the direction of their photographic interest is not decided upon before taking up the hobby. More usually, people first take up photography simply to take pictures of their holidays, or the family, and then their interest develops from this. I started my own photographic career in much the same way, as an amateur, and made all the same mistakes with equipment choice. It is, unfortunately, only as I have progressed in photography that I am now in the happy position of knowing precisely what my own personal equipment requirements are.

Many of you will no doubt already have made an initial choice of equipment, and will probably be perfectly happy with that choice. However, for those of you who may be about to purchase your first 'serious' camera or outfit, and for those who may be considering extending their range of equipment, the following run-down of equipment, and the different formats, may prove very helpful.

The 35mm Camera

The 35mm camera is by far and away the most popular, and certainly the most widely used, type of camera amongst nearly all amateur photographers, and a great many professionals too.

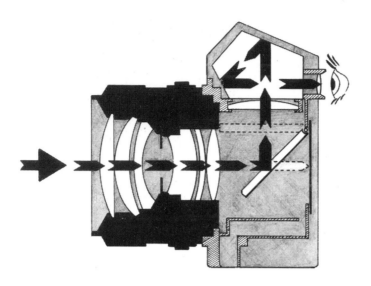

Light path of typical SLR (single-lens-reflex) camera Light enters the lens of the camera and is reflected upwards by a mirror set at 45° to the optical axis onto the focusing screen. The image is viewed right-way up and laterally the correct way round *via* a 45° glass pentaprism and optical eye-piece. At the moment of exposure the mirror flips up beneath the focusing screen immediately prior to the shutter opening, so permitting the image-forming light rays from the lens to fall on the film's light-sensitive emulsion. In most modern cameras the mirror returns to the viewing position immediately after exposure (instant-return mirror), so permitting almost uninterrupted viewing.

There are, however, different types of 35mm camera, including compact models, rangefinder cameras and, by far the most popular with the more dedicated amateurs and professionals alike, the 35mm SLR (single-lens-reflex) camera. The SLR camera permits, through a penta-prism and reflex mirror housed within the camera body, viewing of the image through the actual camera lens. This allows extremely accurate framing of the subject, with the image in the viewfinder being almost precisely identical with that recorded on the film.

Most 35mm SLR cameras also have incorporated into their design TTL (through-the-lens) exposure metering. This provides a highly accurate and very convenient metering system and, with many current models featuring fully automatic exposure control, often with a choice of operating mode (such as shutter or aperture priority, spot or averaged light-reading methods and fully automatic programmed modes), these cameras are very quick and easy to use.

Although nowhere near as popular as the 35mm SLR some photo-graphers still prefer to work with a rangefinder camera, such as the ever-popular Leica. Such cameras feature a viewfinder which is positioned on the camera a short distance away from the actual taking lens. This produces a slight difference between the image seen in the viewfinder and that recorded on the film. However, this causes little problem at normal focusing distances because the camera has an automatic parallax correction built into it. When focusing at very close distances, however, parallax really does become a problem. The type of rangefinder used in these cameras is not suitable for use with extreme-wide-angle lenses or telephotos much over 135mm, and it is mainly for these reasons that this type of camera has lost favour to the single-lens-reflex design.

Rangefinder cameras are really an advanced form of the more simple viewfinder cameras. These may or may not incorporate a means of

Leica M6 rangefinder camera.
Photo courtesy E. Leitz
(Instruments) Ltd

Olympus OM1n 35mm single-lens-reflex camera. Picture by
David Chamberlain

focusing the lens. This more simple design is often used in so-called 'compact' cameras, so named because of their small, or compact, design. Some such compact cameras incorporate a zone-, or symbol-, focusing method, while others may use a proper distance scale or even a rangefinder. All such rangefinder or viewfinder cameras are very quick and convenient to use, and can be particularly good in low-light situations when the clear and bright viewfinder offers some advantage over most SLR cameras.

ADVANTAGES OF 35MM

Portability Nearly all 35mm cameras are relatively small in size and are therefore extremely portable. Compact cameras, which do not

Rolleiflex 3003 An alternative and highly versatile style of 35mm single-lens-reflex camera featuring both eye-level and waist-level viewfinders, built-in film drive and fully interchangeable film backs, enabling 35mm film to be changed mid-roll just like some medium-format SLR cameras. Photo courtesy *Amateur Photographer* magazine

usually have interchangeable lenses, are particularly useful as a second camera, which can conveniently be carried almost everywhere. Even the more versatile rangefinder cameras, with interchangeable lens facilities, and SLR cameras are lightweight enough for a fairly comprehensive outfit to be carried with reasonable ease, and such a system might be ideal if you intend to do a lot of walking with your equipment, as will probably be the case with urban landscape. No other format can provide such a good blend of versatility and convenience.

Versatility The 35mm rangefinder camera is a very versatile machine indeed, and has the advantage of being extremely quiet in operation. This will be particularly useful if you like to include people within your urban landscapes, as they will probably not be aware that they are being photographed. The type of rangefinder incorporated into such cameras is, with a little practice, very quick and precise in operation, and this can be particularly useful when trying to focus wide-angle lenses.

Although cameras such as the Leica have available a range of interchangeable lenses in both wide-angle and telephoto focal lengths, they can in no way compete with the 35mm SLR camera for versatility. Lenses can often range from fisheye lenses, which may have an angle of view of up to 220°, producing a circular image on the film, to super-telephoto lenses, which may have an angle of acceptance of perhaps only 2°. Between these two extremes can be found full-frame fisheyes, which cover an angle of 170° or 180°, ultra-wide-angle lenses, moderate wide-

Wide-angle lenses can help provide an impression of perspective. This has been emphasised even further in this picture by the unusual trimming, with part of the image extending beyond the borders of the print. Picture by John Disdale

angles, perspective-control lenses, standard-focal-length lenses of various maximum apertures, short- and medium-telephoto lenses and, of course, zoom lenses, where the focal length may be varied to provide different angles of acceptance.

In addition to these vast lens ranges, many accessories are available for the 35mm SLR, including close-up accessories and dedicated flash units. Some of the more advanced of these cameras also feature fully interchangeable viewfinder systems, so that the standard pentaprism may be exchanged for a waist-level finder, rotary finder or magnifying hood etc. Film winders or motordrives are also available, although these will hardly be necessary for photographing urban landscape.

IDEAL 35MM OUTFIT

It is very easy, particularly with the extremely versatile 35mm SLR systems, to get a little carried away when setting up an outfit. There is simply such a large variety of equipment and lenses available that it can be quite difficult to decide just what your requirements are. This is of course not such a problem with 35mm rangefinder cameras, as

25

comparatively very few lenses are available for such systems. Urban landscape photography requires no special-purpose equipment and an outfit suitable for such work will be no more than a basically standard, yet versatile, outfit.

Certainly if you intend to shoot both colour and monochrome, it will be preferable to carry two camera bodies. This will save any problems with having to re-wind a part-used film to change from colour to monochrome. Alternatively, if you are on particularly good terms with your bank manager, you could purchase the Rolleiflex 3003, which is currently the only 35mm SLR camera with interchangeable film backs, enabling film stock to be changed mid-roll. You would have to get used to a fairly unusual design of 35mm camera, however, and this may not be to everybody's liking.

Choosing lenses for your outfit can be particularly difficult. Ultimately the final selection will be based on personal preferances, which should be founded on the particular requirements of the type of photography which you do most of. However, the most useful lenses for urban landscape work are fortunately those which would be found in any good comprehensive basic outfit, the only exception to this being perhaps a wide-angle perspective-control lens. These are invaluable for architectural work, which is frequently a characteristic of urban landscape photography, and will enable the vertical lines of buildings and other structures to be rendered 'upright'. However, such lenses are a specialised item of equipment and hence rather expensive. Don't worry if such a lens is out of the question for you – they are for me too! Good urban landscape pictures are quite possible without such a lens.

By far the most important lens in your outfit will be your standard 50mm lens. The versatility of this standard optic never ceases to amaze me. There are a good many top landscape photographers who work only with a standard lens and much of their work is outstanding, so don't make excuses for the humble 'standard'. It really doesn't need them! Other lenses are, however, still very useful. Wide-angle lenses may seem an ideal for urban landscape photography, and they most certainly are very useful. But so, too, are telephoto lenses. You will find, as you gain experience, that all lenses have their uses and, when you need a particular lens, that is the one which is 'most' useful – at that time. The most popular wide-angle lenses are probably the 24mm or 28mm focal lengths. These are perhaps a little too similar for both to be included in your outfit, so you should decide which is best for you. Either are perfectly suitable for use in the urban environment, but it is perhaps worth bearing in mind that, if you choose the lens with the wider angle of view, you can always crop the image during printing, or mask, if using colour-transparency film, to produce a result very similar to that which would be provided by the slightly longer focal length wide-angle lens – albeit with a slight loss of quality. Remember, you cannot in any way increase the angle of coverage of a 28mm lens to that of a 24mm lens!

Don't put your camera away during winter months; there are still plenty of good pictures to be found. Frost on a car's windscreen transforms a very ordinary object into an interesting abstract composition. Picture by Andy Morant

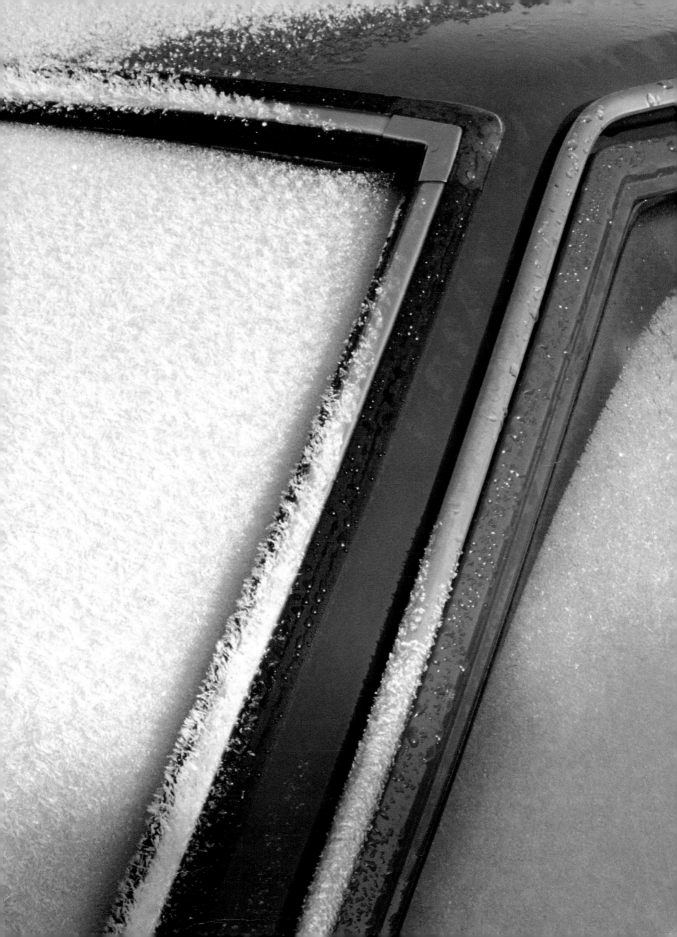

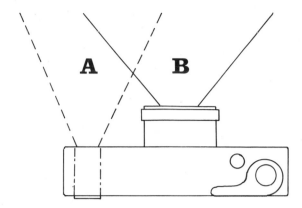

Parallax Most non-reflex cameras, such as viewfinder or rangefinder cameras and twin-lens-reflex cameras, suffer the problem of parallax. This is more of a problem at close camera-to-subject distances when the image seen in the viewfinder (*A*) may be different to that recorded on the film (*B*). This is caused by the different respective positions of the camera's lens and viewfinder. More expensive rangefinder cameras may incorporate automatic parallax compensation for all normal focusing distances, although this is never totally accurate when working very close up.

A very useful lens to include in your outfit is a 35mm moderate-wide-angle lens. This focal length used to be very popular some years ago, but in more recent years has lost favour to the more extreme-wide-angle lenses. This is a pity, for such a lens produces a very pleasant perspective – not too obviously wide angle, yet capable of achieving most of the popular wide-angle characteristics – i.e. enhanced foreground interest.

Beyond our standard lens, we move into telephoto lenses. These may not at first sight seem particularly ideal for urban landscape photography. In fact, nothing could be further from the truth. Telephoto lenses are very useful indeed. The apparent foreshortening of perspective, or 'stacking up' effect, can produce very exciting pictures indeed. This effect is more pronounced with the longer-focal-length lenses of 200mm or more. However, shorter telephotos, in the region of 85mm to 135mm, can also prove very useful for pulling in or isolating smaller details. Extremely long lenses can produce very dramatic effects of foreshortening indeed, but they do require a great deal of care in use, and successful results depend a great deal on the viewpoint selected. Mirror lenses, which are a highly compact design of telephoto lens, incorporating mirrors in their design to effectively shorten the overall length of the lens, are commonly available nowadays and at quite moderate price. Compared to a conventional telephoto lens of comparable focal length, they are extremely lightweight and compact. However, they are in most cases limited to one fixed aperture, making it impossible to control depth-of-field. This type of design produces strange 'doughnut' shapes with out-of-focus highlights which can be very effective. However, the effect is now widely known and tends therefore to become something of a cliché.

Zoom lenses are now very popular, mainly because of their extremely convenient design, incorporating a complete range of focal lengths all within one lens. However, although the performance of such lenses has been greatly improved in recent years, unless you are prepared to part with quite a large sum of money for such a lens, performance will not equal that of fixed-focal-length lenses. Convenience or ultimate quality – the choice is yours!

It is really very difficult to suggest an ideal 35mm outfit, as everybody will have their own views on this. It is only possible for me to state my own preferences in relation to tackling the subject of urban landscape. In this respect, I would consider an ideal outfit to be two 35mm SLR camera bodies – only one if shooting on a single film stock – 24mm wide-angle lens, 35mm moderate-wide-angle lens, standard 50mm lens, a short-telephoto lens of between 85mm and 135mm and, if the bank account will stretch to it, a long-telephoto lens of 300mm or more. A further essential piece of equipment to be included is a good sturdy tripod – the heavier the better. Don't underestimate this important item of equipment. No other single piece of equipment has such a marked effect on the quality of your results!

DISADVANTAGES OF 35MM

With such a versatile format, it may seem difficult to imagine that there might be any disadvantages, but there are just a few. It is for you to decide whether the enormous versatility and pure convenience of this format outweighs the small but significant disadvantages.

The most obvious disadvantage is the fairly small negative size. Although it is certainly possible to produce high-quality results on 35mm, you may find that you are restricted to using slow-speed, fine-grain films to do so. Even then, it will be necessary to exercise great care through every stage in producing your pictures. Very slight faults or blemishes can become very evident with the large magnifications necessary to produce images which can be comfortably viewed from this small format. Grain and definition may also become a little 'strained' at large magnifications.

Another disadvantage, not immediately recognised, is that the very convenience and ease of use of the 35mm camera produces a tendency to be what could perhaps best be described as 'too casual' in our approach. In addition to this, the fact that we may have 36 exposures available tends to make us a little 'trigger happy', shooting off too many exposures without giving enough thought to each picture. This can be quite difficult to control. Powerwinders and motordrives only serve to make this problem worse. However, the problem can be solved quite simply by your own attitude. Self-discipline is required. Think about each and every picture!

If you are able to overcome these minor problems, the 35mm format has a great deal to offer. The convenience of use, and the enormous versatility, offer vast opportunities to the imaginative and creative photographer.

Medium-Format Cameras

Medium-format cameras, using mainly 120 or 220 size roll film, are available in different camera designs. All are usually larger and heavier than their 35mm counterparts, and most are at least a little slower in use.

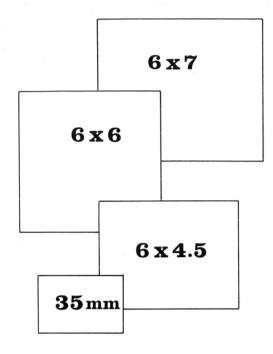

Format sizes The relative picture area of the most commonly used negative formats – 6 × 7cm, 6 × 6cm, 6 × 4.5cm and 35mm negative sizes.

There are basically three different types of medium-format camera available today. These are the roll-film SLR (or single-lens-reflex) the TLR (or twin-lens-reflex) and viewfinder or rangefinder cameras. The most commonly available negative sizes are 6 × 4.5cm, 6 × 6cm and 6 × 7cm. Most current models accept both 120 and 220 size roll films, providing 15 exposures for 6 × 4.5cm cameras (30 on 220 film), 12 (24/220) for 6 × 6cm cameras and 10 (20/220) for cameras using the 6 × 7cm format.

Cameras of the 6 × 4.5cm format have proved very popular with photographers moving up to medium format from 35mm for the first time. The fact that many such cameras handle in a similar manner to a 35mm SLR and, with 220 film, carry almost as many exposures, has made these an ideal stepping stone. 6 × 6cm and, in particular, 6 × 7cm cameras are more likely to be used by professional photographers or very dedicated, *and wealthy*, amateurs. These systems can be expensive both to buy and to run, with such a limited number of exposures per film.

The most versatile of medium-format cameras is, without doubt, the single-lens reflex. Many current models incorporate almost as many features as their 35mm counterparts, and are highly versatile machines indeed. Most feature interchangeable lenses, viewfinder systems and focusing screens. Many also have interchangeable film backs or magazines, enabling film stock to be changed even in mid-roll, which saves carrying two complete camera bodies. Some models have, either built in or available as an optional extra, through-the-lens (TTL) exposure-metering systems, in some cases with fully automatic exposure control. A few medium-format SLR cameras even have built-in, or add-

Wide-angle lenses can be used to alter or exaggerate apparent scale or perspective by selecting a close-up viewpoint. *Olympus OM1n, 35mm lens – Ilford HP5 ISO 400/27*. Picture by David Chamberlain

on, power film-winders. So you will see that basic camera versatility need not give anything away to the 35mm format.

120 roll-film SLR cameras are available in all three main negative formats, but before considering such a system, you must seriously consider whether the type of photography that you do really justifies the considerable expense that can be incurred in setting up such an outfit. Remember, it is not just a matter of buying a camera!

The TLR, or twin-lens-reflex, camera may perhaps be somewhat a remnant from the past, but there still remains a strong following for this type of camera. Offering some of the advantages of reflex viewing, with a large uncluttered focusing screen which can be viewed at waist level, and the large negative size, it has the added advantage of being very rugged in construction and extremely quiet in use. It isn't all that difficult to understand why this old design remains popular. Unfortunately, with the reflex viewing being *via* a separate lens positioned directly above the actual taking lens, parallax problems do still exist. However, such cameras have a certain 'charm' all of their own and, I am quite sure, will remain popular with a small, but discerning, number of photographers.

There is currently only one twin-lens reflex available with interchangeable lens facilities. This is the Mamiya C330s/C220f which features interchangeable lens pairs. Focal lengths available range from 55mm wide angle to 250mm telephoto – a perfectly adequate range for most purposes. The format is the ever popular 6 × 6cm size, and the camera also features interchangeable viewfinders and focusing screens.

Finally, there are the viewfinder cameras in roll-film sizes. These are available in 6 × 4.5cm, 6 × 7cm and 6 × 9cm negative formats. Although this type of camera is much less versatile than many other roll-film types, many modern examples of these are extremely compact indeed and are ideal 'carry everywhere' cameras for the devoted medium-format user.

The quality and specification of some of these viewfinder cameras is very high indeed. Although lenses are not interchangeable, many have coupled rangefinders for accurate focusing and built-in exposure meters. Such cameras are an ideal second camera for the 120-roll-film reflex owner – if you can afford one! Unfortunately, many such cameras are a little on the expensive side.

ADVANTAGES OF MEDIUM FORMAT

Extra Quality The large negative size provided by medium-format cameras does offer many advantages over the very much smaller 35mm format when it comes to quality. Make no mistake about it, when it comes to negative sizes, the old saying 'The bigger the better' really is very true. There quite simply is no substitute for size and any medium-format negative, produced on a reasonably good-quality camera, will be vastly superior to its 35mm counterpart on identical film stock. Not only will the results appear more fine grained and of higher definition, but

Full-frame fisheye lenses can produce quite 'straight'-looking results if used with a little care. Straight lines running through the centre lines of the optical axis will show little distortion. *Olympus OM1n, 16mm full-frame fisheye lens – Kodak Technical Pan ISO 25/15.* Picture by David Chamberlain

also the tone gradation will be better. This is not to imply that 120-roll-film cameras are of superior quality to 35mm cameras. Simply that the negative is that much larger and consequently requires considerable enlargement to obtain any given print size.

In addition to the extra quality which is possible from the larger negatives, medium-format cameras offer some further advantages, not all of which are immediately obvious.

Interchangeable Film Backs Firstly, many such cameras offer the facility for fully interchangeable film backs. This can be extremely useful when working with both colour and monochrome film stocks. Many of the cameras which don't have fully interchangeable backs at least offer quick-change film inserts, which can be preloaded and inserted into the camera very quickly indeed whenever it is necessary to re-load. However, these inserts cannot be changed in mid-roll.

Slowness Of Operation Almost a blessing in disguise is the fact that many roll-film cameras are much slower in operation than their 35mm counterparts. This has the advantage of slowing down the rate at which you work, forcing you to take your time. This provides a greater

opportunity to 'think' more about each picture you take, and often results in a much higher percentage of successful photographs. The fact that there are less exposures available on each film also helps to make you think more about each shot, particularly with the larger 6 × 7cm format, which only has 10 exposures available on 120 film! If you have just moved up from 35mm, you may find this slower work-rate a little difficult to get used to, but once you have accepted the slower operation of some of these cameras, you will find it a very pleasant way to work, making your photography a whole lot more enjoyable.

Portability Medium-format cameras are considerably heavier and larger than most 35mm cameras and are therefore not quite so easily portable. However, this problem is somewhat balanced out by the fact that medium-format photographers generally tend to carry fewer items of equipment.

There is always the tendency, when working with 35mm, to carry quite a large range of lenses and accessories. This is neither possible, nor necessary, with medium-format equipment. For example, very long-telephoto lenses are not really necessary unless specialising in this type of work, as it is usually possible, to some extent, to crop the image of a picture taken by a short- or medium-focal-length telephoto lens. The large negative size provides enough detail to make this possible without losing out too much on quality. In much the same way, an image cropped from a negative, taken for example with a 40mm wide-angle lens, can provide a result almost identical to that taken with a 50mm wide-angle lens, making it unnecessary to carry two wide-angle lenses. As the medium-format lenses, and other accessories, are very much larger and heavier than the equivalent 35mm equipment, you will certainly find it beneficial to make economies in the equipment you carry!

Versatility By far the most versatile of the medium-format cameras is the single-lens reflex-type. Featuring virtually all the features found on 35mm SLR cameras, these are extremely capable machines indeed.

However, it is for you to decide just how much or what sort of versatility you personally require. Do you really need interchangeable film backs or magazines? If you work only in one type of film stock this will be very unlikely. Different cameras offer different types of versatility. Some, like the Pentax 645, offer a choice of operating modes and fully automatic operation, including film advance, just like many 35mm cameras, but do not offer interchangeable film backs or viewfinders. The Pentax 6 × 7 camera has no interchangeable backs or inserts, but does have additional viewfinders, including one with through-the-lens exposure metering but no automatic operation and, being constructed just like an enormous 35mm SLR, offers superb hand-held operation. Others, like the Bronicas and some Mamiyas, offer interchangeable everything and, in some cases, the potential for fully automatic

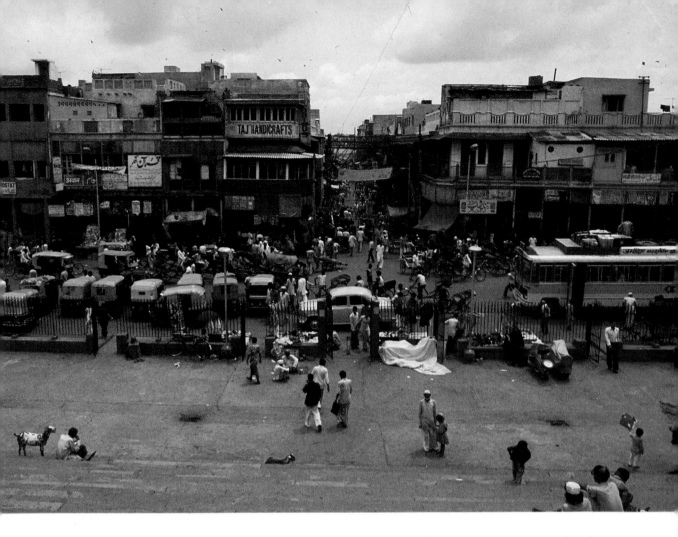

Busy street scenes, like this view of a taxi rank in Old Delhi, have an atmosphere all of their own, depending for their success on the hustle and bustle of life. A viewpoint some 6m above ground level in a mosque was necessary to capture this scene effectively (see Chapter 3). *Olympus, 28mm lens – Agfachrome 100.* Picture by Abdus Sookia

operation. The choice is considerable, but only you can decide. You must, however, take into consideration any additional lenses or accessories which you might require. Does your chosen camera have these items available within the system?

IDEAL MEDIUM-FORMAT OUTFIT

An ideal medium-format outfit might appear quite basic if compared to the average 35mm outfit in which it is possible to include a large range of lenses and accessories without creating too much of a weight problem.

A very comprehensive outfit of medium-format equipment might consist only of one camera body, particularly if your chosen model has interchangeable film backs, one wide-angle lens – preferably the widest conventional (not fisheye) lens in that camera's system, and just one telephoto lens of between 150mm and 180mm.

A good quality 2 × converter can provide a useful and compact means of 'stretching' the telephoto end of your lens range, although it must be said that such converters rarely provide the quality which is produced by a prime lens. In fact, you may often be better off simply cropping the

image during printing to produce the required increase in magnification, when the final quality may be superior to that obtained with a 2 × converter!

Always a useful accessory, I think, is a waist-level viewfinder if your camera is equipped as standard with an eye-level type, or indeed, an eye-level viewfinder if your camera comes only with a waist-level viewfinder as standard.

Extension tubes or close-up lenses are particularly useful with medium-format cameras, as often the lenses do not focus at short camera-to-subject distances unaided.

DISADVANTAGES OF MEDIUM FORMAT

The main disadvantage of medium format is the high initial purchase price. Inexpensive medium-format cameras are indeed a rarity, and the few such models available are usually fairly restricted in their versatility. In addition to the high equipment prices, running costs for film etc are also considerably higher than those for 35mm.

You should also consider supplementary equipment prices. If you are keen on monochrome photography you will need an enlarger which is capable of handling the format size. Medium-format enlargers may be a little more expensive than ones designed for 35mm only. Much the same thing applies to the colour-transparency worker. In the 35mm field, there are dozens of suitable slide projectors available, many at very reasonable prices. This is not the case with medium-format projectors. There is really a very limited selection available from which to choose, and they do tend to be rather more expensive in general. If you are to work with the big 6 × 7cm format, you might have trouble finding a projector at all!

You do need to be much more careful in your selection of equipment with medium format, as not all cameras are suitable for all types of photography. Some are better for studio use and are not quite so good outside, while others may be quite the reverse. Obviously, not all your photography will be urban landscape and if, for instance, you like to do some sport or motor-racing photography etc, you should consider that there is not currently available any medium-format camera with a motordrive facility! Some do have powered film advance, but whether this would be a substitute for a true motordrive is extremely doubtful.

Large-Format Cameras

Large-format cameras in the 5 × 4in, 7 × 5in and 10 × 8in formats are probably *the* ideal tool for the subject of urban landscape, offering the potential of near-perfect image control through a range of lens and film-plane movements incorporated in the design.

These are the most simple in design of all cameras, being virtually just a lens at one end, a film holder at the other and a concertina-type bellows in between! There are basically two main types of large-format camera –

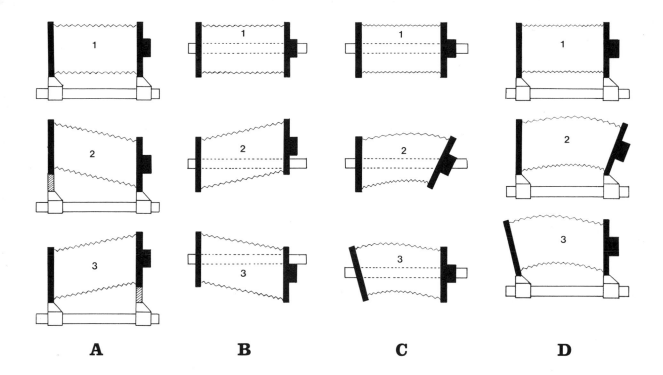

A **B** **C** **D**

Movements of large-format cameras (A) Rise and fall: 1. All movements at zero 2. Rising back (or drop front) 3. Rising front (or drop back) (B) Sideways shifts: 1. All movements at zero 2. Front standard 'left' shift (or rear standard 'right') 3. Front standard 'right' shift (or rear standard 'left') Rear standard usually has identical shift facility. (C) Swings: 1. All movements at zero 2. Front standard 'right' swing 3. Rear standard 'left' swing (D) Tilts: 1. All movements at zero 2. Front standard 'forward' tilt 3. Rear standard 'backward' tilt. A combination of several of these movements may sometimes be necessary for correction of perspective, distortion and plane of sharp focus.

monorails and drop-bed designs. The first type, which is the most versatile of the two, consists only of a long sturdy steel or alloy monorail on which are mounted two 'standards'. These are upright metal 'frames', which serve to hold the lens, usually mounted into a flat panel which sits in the 'frame' of the front standard, and a film back, which fits into the rear standard and accepts a sheath-type film holder. The film back usually has the facility to rotate through 90° or, in some cases, a full circle of 360°, locking in any desired position.

The front and rear standards incorporate a range of movements, including swing, shift, tilt, rise and fall, permitting the lens and film back to be moved in relation to each other. As the lenses for large format have a circle of coverage much greater than that required by the format, these movements make it possible to utilise different parts of the image circle. Such movements permit very precise control over image distortion and perspective.

The drop-bed design of large-format cameras features a flat base equipped with guide rails along which a lens-bearing front standard moves. The rear standard on such cameras is fixed, although some movements may often be incorporated in the actual film holder. Although this type of camera is extremely versatile, it does not have such a vast range of movements as the monorail design.

All large-format cameras have interchangeable lenses which are very quickly substituted simply by inserting a complete lens panel with a lens already attached. Monorail designs often have bellows, which can be

easily changed for longer ones for close-up work, or long-focus lenses and very short 'balloon' or 'bag' bellows, which enable a comprehensive range of movements to be carried out when working with very short-focus (wide-angle) lenses. With the additional facility that most such cameras have of being able to accept roll-film backs, these are extremely versatile cameras indeed.

This extreme versatility and, in particular, the potential for almost total image control, makes this design of camera very nearly perfect for urban landscape photography. Unfortunately, there are sure to be some drawbacks to almost anything, no matter how perfect it might at first appear, and one such drawback to large-format cameras is the very high cost of equipment. Most of these cameras are virtually handbuilt and the purchase price will usually reflect this fact.

ADVANTAGES OF LARGE FORMAT

Ultimate Quality Just as the roll-film camera provides a great increase in quality over the smaller 35mm format, so the large-format camera provides an equally noticeable quality increase over the medium format. Large prints of 20×16in or more, made from large-format negatives, will prove to be much more finely grained, sharper and of smoother tonal range than any which one can hope to produce from even the biggest of medium-format negatives.

Perspective and Image Control The movements which are incorporated into these cameras enable great control to be exercised over the image recorded on the film. The rise-and-fall facility permits control over the common problem of converging vertical lines, which is a fault found in many pictures of buildings or other tall structures taken with rigid body cameras. Horizontal lines may be controlled in a similar manner using the sideways shift movements. Neither of these movements have any great effect on the actual shape of an object recorded on the film, as rise-and-fall or sideways shift do not alter the angular relationship between the lens and the film. However, the movements of tilt and swing do affect image shape and these movements can be very useful either for correcting distortion or, indeed, inducing it, perhaps for creative effect.

There are basically only two things to understand when dealing with either tilt or swing movements. Firstly, when the film plane is tilted, or swung, in relation to the lens, the shape of the object being photographed will change. Secondly, when the lens is tilted or swung, the focus on the object will change. These movements are therefore very useful for modifying image shape and correcting the focus of the modified image.

From this, you may be able to understand just how versatile such cameras are, and an experienced photographer will be able to use these movements, either separately, or in combination, to provide the ultimate in perspective and image control.

A relatively slow shutter speed has captured an impression of movement in these flags which were blown by a stiff breeze. Taken at the Stock Exchange in the City of London. *Olympus OM1n, 75–150mm zoom, 1/30 second – Kodak Ektachrome 100*. Picture by David Chamberlain

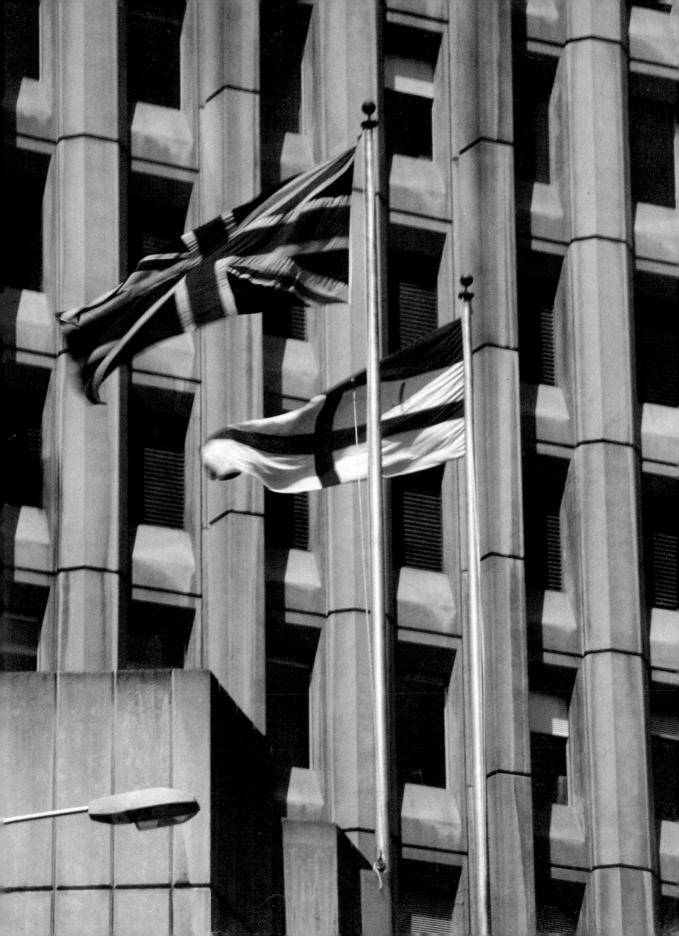

Image circle of large-format lenses The actual image circle formed by most large-format camera lenses is much larger than is actually required in order to 'cover' the format. This permits the full use of camera movements when the film may be placed in different positions within the lens's circle of coverage. Alternatively, the circle of coverage may be 'moved' around the actual format area. In the diagram (*a*) shows the position of the film format with all movements at zero and (*b*) illustrates the position the format may be in when camera movements are carried out.

Slowness Of Operation Because these cameras use a single sheet of 'cut' film, one at a time, the speed of operation is obviously very slow indeed. This provides ample opportunity for the photographer to think about the picture. The fact that a rather dim image is projected on the focusing screen, and that this is inverted, further serves to slow down the rate at which the photographer can work.

Size Of Negative Obviously, the superb quality that can be obtained from negatives which need very little enlargement to provide a respectably sized print is a very great advantage indeed. Larger examples of these cameras may produce negatives of 10×8in, or even 11×14in, when there may be no need for enlargement whatsoever, and straight contact prints can be made, with no loss of quality at all!

Portability and Versatility Large-format cameras, Particularly the monorail types, have the unique advantage that every single component is interchangeable, making it possible to adapt a camera for almost any photographic task. Lens focal length, and even the negative format, may be quickly and easily changed. A 5×4in camera, for example, may be quickly converted to a 10×8in simply by changing the rear standard, film holder and bellows. Such versatility cannot be found in any other type of camera.

Portability may become a bit of a problem with such cameras, especially for the larger versions. Such cameras are, in effect, extremely high-precision optical benches and can therefore be easily damaged by rough or careless handling. Most camera manufacturers produce large aluminium cases, which are usually specially designed to hold a particular camera, and these provide ideal protection for such valuable instruments. Most of these cases will have ample storage space for extra lenses and other accessories, enabling a very comprehensive outfit to be carried fairly conveniently. Some monorail cameras can be folded flat, and these can be carried in much smaller cases, more like a small suitcase.

The Scheimpflug principle When photographing objects in a flat plane, either horizontal or vertical, it may sometimes be difficult to gain adequate depth of field with a normal rigid-body camera. This is particularly true when close-up detail is important. If focus is set for the closest part of the scene, the distant part will be unsharp. If you focus on the distant parts, the foreground will be unsharp. Although it may be possible to set focus on a mid-distant part of the subject this may still frequently not provide enough depth of field. The answer to this problem lies in the large-format camera and its range of movements – the Scheimpflug principle can solve this problem. When the plane of the film (a), the plane of the lens (b) and the subject plane (c) meet at a common point, maximum depth of field will be obtained.

Drop-bed-type cameras mostly fold flat anyway, and these are very easily transported, making them particularly suitable for field work.

If you intend to do a fair amount of walking with one of the larger monorail cameras, it can be an advantage to mount the camera on your tripod and carry this over your shoulder, leaving the large and heavy aluminium case in your car. A large plastic bag may be used to cover up the camera itself, so providing some protection from the weather and dust etc.

IDEAL LARGE-FORMAT OUTFIT

With such a large negative size, one doesn't need to carry such a vast range of lenses. Some photographers even prefer to restrict themselves to just one lens – the standard focal length for the format size. However, I think that a wide-angle lens can be very useful for urban landscape photography, and for this reason I would recommend carrying only two lenses, a 90mm wide angle and 150mm standard, if working on the 5 × 4in format for instance. In this case, you will probably not even have to carry a set of wide-angle 'balloon' bellows in your outfit, as most standard bellows will provide an adequate range of movements with a 90mm lens. An essential piece of equipment, I feel, is a bellows lens shade to protect against lens flare, particularly when shooting into the light. This type of lens shade fits directly onto the front standard of the camera, not the lens itself, and can be adjusted in length to suit lenses of different focal lengths.

Your camera should be fitted with a focusing hood of one type or another, as the image on the focusing screen is very dim and it will be absolutely essential to prevent any extraneous light falling on the screen. A focusing dark cloth may also be necessary. Placed over the back of the camera, you can drape this around your head to eliminate completely any extraneous light, providing the brightest possible viewing image.

41

Relative sizes of 5 × 4in format when compared to the more commonly used formats: (*A*) 35mm (*B*) 6 × 4.5cm (*C*) 6 × 6cm (*D*) 6 × 7cm and (*E*) 5 × 4in large format.

You will also, of course, need to carry some film sheaths. These usually carry two sheets of cut film, one per side, and you will find that between six and ten of these, providing between 12 and 20 exposures, will be perfectly adequate for a day's picture taking.

DISADVANTAGES OF LARGE FORMAT

The high initial cost of a large-format outfit is the most obvious disadvantage, but the other more important one is that it is almost impossible to photograph any moving subject, unless that is you can set everything up beforehand, with everything being directly under your own control.

As the leaf-type shutter, which is incorporated in the lens, has to be opened for viewing of the image, and then shut after inserting a film sheath and before withdrawing the protective dark slide, simultaneous viewing and taking of the exposure is impossible and, with a moving subject, quite a lot can happen between the viewing of the subject on the focusing screen and in making the actual exposure – so forget about sport or motor-racing photography!

However, urban landscape isn't very likely to get up and run away, so the above should not present too many problems with this subject. However, if you are to include people or moving traffic in your pictures, great care must be exercised.

Tripods, Filters And Other Useful Accessories

The tripod you use (and use one you should) is a very important consideration indeed. Make no mistake about it, a good sturdy tripod will make all the difference between sharp and unsharp photographs.

A telephoto lens has been used to 'compress' the apparent perspective of this picture, the street lights appearing to be much closer together than they are in reality. *Olympus OM1, 75–150mm zoom (set at 150mm) with red filter – Ilford HP5 ISO 400/27*. Picture by David Chamberlain

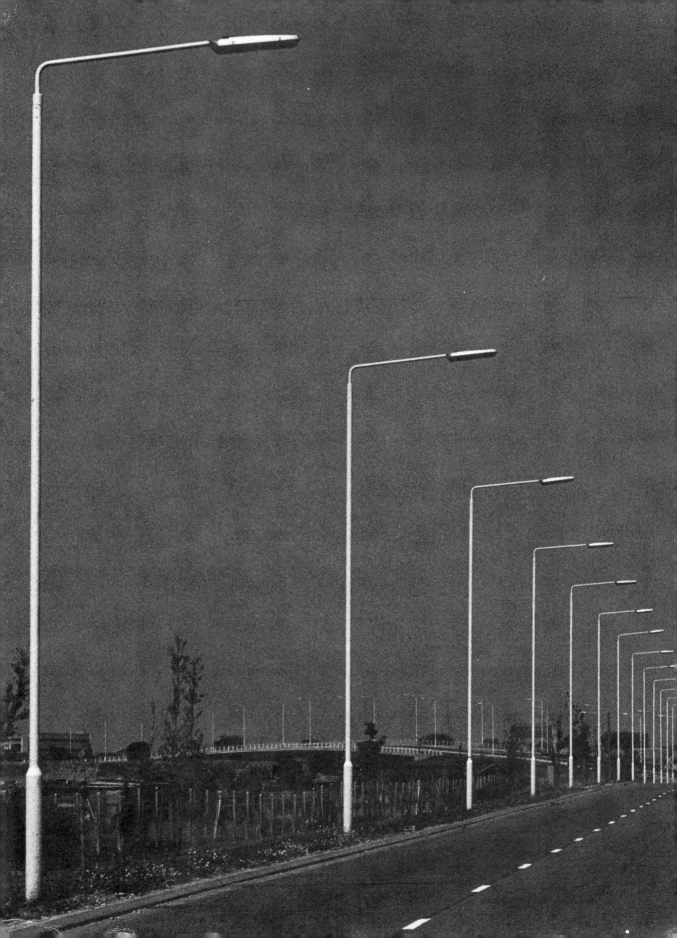

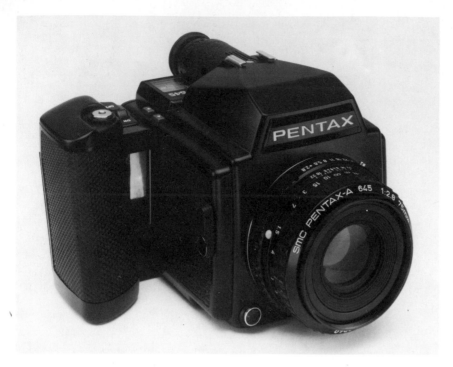

Pentax 645 The Pentax 645 is the first of a new breed of medium-format SLRs offering the versatility and high degree of automation normally only found in 35mm cameras. Photo courtesty Pentax UK Limited

Purchase the best that you can afford and carefully check its stability with the heaviest of your own equipment which you will be using on it. You should not try to make any economies with this purchase, neither in cost nor in weight, for you will pay dearly for this later with sub-standard pictures. The cable release you use should also be chosen carefully. The short variety is not much use. Choose a longer model which will provide a smoothness of operation not to be found with the shorter ones.

Filters are very useful items of equipment for photographing the urban landscape. For monochrome work, they can be used to control contrast or to modify the way certain colours record as tones in black and white prints.

Probably the most useful of these filters will be the red, orange, deep yellow and green. Such a range of contrast filters, with the addition of a polarising filter to help eliminate unwanted reflections in glass etc, will cover virtually any eventuality in monochrome urban landscape photography.

Filters do not offer quite so much potential for the colour worker. Besides the polarising filter, which can be used to darken a blue sky and generally enrich colours overall by the exclusion of nearly all reflections, the only other filters available to the colour worker are either special-effect filters or colour-correction filters.

Special-effect filters are available in an enormous variety of effects, and a separate book could be written simply describing all of these. However, the most useful are perhaps the range of graduated filters,

A comprehensive outfit of medium-format equipment need not be so extensive as the average 35mm outfit. Just one camera body, perhaps with a spare film magazine, waist-level and eye-level finder, standard, wide-angle and telephoto lens is adequate for almost any task. Picture by David Chamberlain

which can be used to add tone, or indeed colour, to a blank sky. Star-burst filters, although perhaps a little over-used, can still provide added interest to a night scene by turning any small point light sources or bright reflections into sparkling star-bursts. Colour-correction filters on the other hand can be extremely useful to the colour-transparency worker for controlling the colour balance of his or her photographs. This can be particularly useful when working under artificial lighting, as will often be the case with street scenes taken at night.

Another very useful accessory to carry with you, both at night and during the day, is a small portable flashgun. This can be used not to provide the main illumination, but as a fill-in light, or to provide a 'squirt' of light for those awkward little corners. A fairly powerful torch may also be used for a similar purpose at night. An unlit area may be quite literally 'painted' with light during a long time exposure. It may also come in useful to help you when fumbling for small items of equipment in the dark!

3 · Approaching the Subject

Making A Start

There surely cannot be many types of photography where it is quite so easy to make a start. The most essential requirement is self-motivation.

However, like any subject, it can be a little difficult deciding just what sort of pictures you want to take. If you have taken the trouble to look at other photographers' work, as suggested earlier, you should have found at least one or two particular photographs which appeal to you, and it is perhaps a good idea to keep these in mind when you venture out on your first attempts at tackling urban landscape. Looking for similar subjects in this way will at least provide you with a starting point and help you to become accustomed to 'looking' for potential pictures. It doesn't matter that you may not find anything exactly like these photographs, but it will help you concentrate, and make you more intent on actually seeking out possible subject matter. A simple row of terraced houses, for instance, might not appear very attractive until you have seen for yourself just what can be done with such a subject by another photographer.

Once you find a subject that interests you, and you start to take photographs, everything becomes very much easier. After the first few exposures it seems to become more and more easy to find further pictures. Gradually, you will find that you are beginning to develop your own 'taste' for the subject, and that there will be certain types of photographs which you particularly like. As you progress further, you will almost certainly forget all about the work of other photographers and use your own personal preferences as a basis from which to work.

What To Look For

This is perhaps an impossible question to answer, as the potential choice of subject matter which falls under the general heading of urban landscape is extremely vast. However, if you have never tackled this subject before it can be beneficial to select just one single aspect and initially concentrate only on this. In this way, you will learn how to approach the subject much more constructively than perhaps you would if you simply walked around taking photographs of everything with which you were confronted. By concentrating on one single type of subject in this way, you will quickly learn how to make the most of it,

A normally busy street may appear quite different when photographed in off-peak hours, almost devoid of people or traffic. A sense of space and emptiness has been assisted by the use of an extreme wide-angle lens. *Olympus OM1n, 21mm lens with yellow filter – Kodak Technical Pan ISO 25/15.* Picture by David Chamberlain

and once you have acquired this ability to 'squeeze' the utmost from a limited choice of subject, you can then apply it to every other type of subject that you encounter.

When starting out in this way, don't set yourself a subject which is either hard to find or difficult to tackle. Choose something which can quite easily be found generally within your own local area. A good example of such a subject might be something as simple as 'shadows.' In

47

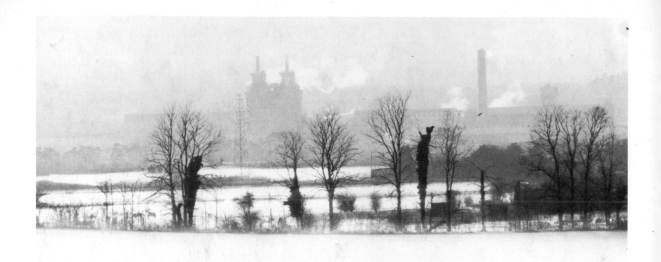

this case, you should be looking out for every possibility of shadows being incorporated in your photographs.

Look out for the obvious things, such as the shadow of one building falling onto another but also try to find slightly less obvious examples, such as the shadows of leaves, falling perhaps across a heavily textured wooden door, or shadows of trees, lamp-posts, telegraph poles etc, even people. Quite abstract compositions can be produced from pictures incorporating shadows. It is up to you to learn how to exploit the possibilities to the full.

Of course, what you choose as an initial subject is really quite unimportant. You could just as easily start out with 'doorways', 'street-lights' or 'high-rise buildings'. What is important, however, is the way you approach your chosen subject. Explore every conceivable possibility, trying out different angles, viewpoints and even lenses.

Although this method of getting started is very useful, don't restrict yourself to the one subject to the total exclusion of everything else. Keep a look out for any other potentially interesting material, using your 'chosen' subject to provide an initial 'purpose' to your photographic walk-about. Through your enhanced awareness brought about by looking for a specific type of picture, you will be surprised at how many other types of interesting subject material you will discover.

Even more experienced photographers can benefit by having a specific subject in mind before venturing out on a picture-taking trip. Almost anything seems easier to undertake when you have a purpose in mind.

Winter and the inclement weather that it brings can provide variety to the urban scene. This shot, looking across snow-covered fields towards the mist-covered paper mill on the outskirts of a large town, has an atmosphere which simply could not be captured at any other time of year. *Nikon F3HP, 85mm lens – Ilford HP5 ISO 400/27.* Picture by David Chamberlain

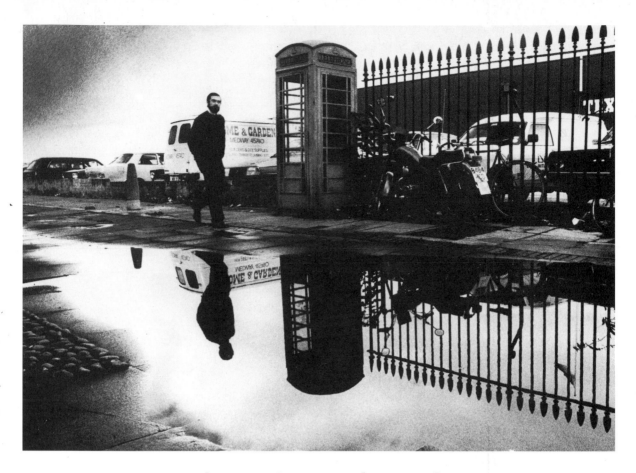

Interesting pictures can be found immediately after the rain. Puddles can transform a scene through reflections. *Olympus OM2n, 28mm lens with red filter – Ilford HP5 ISO 400/27.* Picture by Robert Burden

The Best Times For Photography

Urban landscape, which is peculiar to itself, demands certain special considerations as to the time of day, or indeed, the day of the week, when photographing certain areas. The urban environment is in almost constant use by human beings and, depending on the type of pictures we wish to take, this might be the factor which dictates when our pictures must be taken.

For example, if you want to photograph a busy shopping area whilst retaining an impression of busy activity, it would of course be best to tackle the subject at the busiest possible time. This might be, for example, on a Friday afternoon or on a Saturday, when everybody is buying their weekly provisions. On the other hand, a quite different effect would be produced by taking photographs of the same area on a Sunday, perhaps early in the morning, when there will be very few people about. The same area of urban landscape can produce pictures of totally different 'mood' depending quite simply on 'when' you take your photographs.

Residential areas, on the other hand, may be quite different. At weekends, interesting streets may be cluttered up with parked motor-cars when everyone is at home relaxing. During the weekdays however,

these same people use their motorcars to travel to and from their places of work and the residential areas will be relatively free of parked vehicles. Recreational areas also have their 'prime' times and days for use. Always give this some thought before attempting to take your pictures. Constructive use of this very simple knowledge will enable you to have greater control over your picture-taking activities and the type of results you achieve.

The Seasons Of The Year

Photography, and in particular the subject of urban landscape, is not merely a summer-time or good-weather pursuit. Make the most of the changing seasons of the year to provide variations in mood and character to your pictures.

We can probably all appreciate the changing scenery through the year's seasons in the countryside, but we may not all realise just how much the urban scene is affected by these changes too. The appearance of a tree-lined road or avenue in winter will be quite different from its appearance in the spring or summer, and this can produce a profound effect on your photographs. In many countries snow can often be expected during the winter months, and this can provide very different and often extremely stark pictures. Rain, fog, mist, and even high winds, can all be used to provide atmosphere to your urban landscapes.

To capture the effects of wind, which is perhaps not such an obvious weather characteristic to capture on film, any one of three different techniques may be used.

If the wind is very high, it will probably be best to try to capture the effect by using a fast shutter speed to arrest the movement of flying leaves, litter, or whatever. Small trees may be stopped in motion at their maximum point of bending using the same technique. However, some form of blurring often creates the strongest impression of movement in a still photograph, and there are two methods by which this effect can be achieved.

The first and the most commonly used method of producing this 'blurring' effect is to use a fairly long, or slow, shutter speed. The subject movement which takes place during the time that the shutter is open will record as a blurred image across the film. This technique can provide a very good impression of movement in your final photograph.

Another technique is to make use of multiple exposures on a single frame of film. Your camera must of course be capable of making multiple exposures to achieve this effect.

The technique is really quite easy to produce and will provide a result similar to that obtained by the slow shutter-speed technique, whilst being just a little different. Instead of the subject movement causing a continuous streak of image blur, the multi-exposure technique will produce several sharp, or fairly sharp, images of the subject as it moves across the film.

Exploit inclement weather conditions – don't try to avoid them. Wet weather can provide atmospheric shots by day or night. Protect your camera from the rain, or use a camera specially designed for wet weather. (See Chapters 1 and 3.) Picture by Norman Osborne

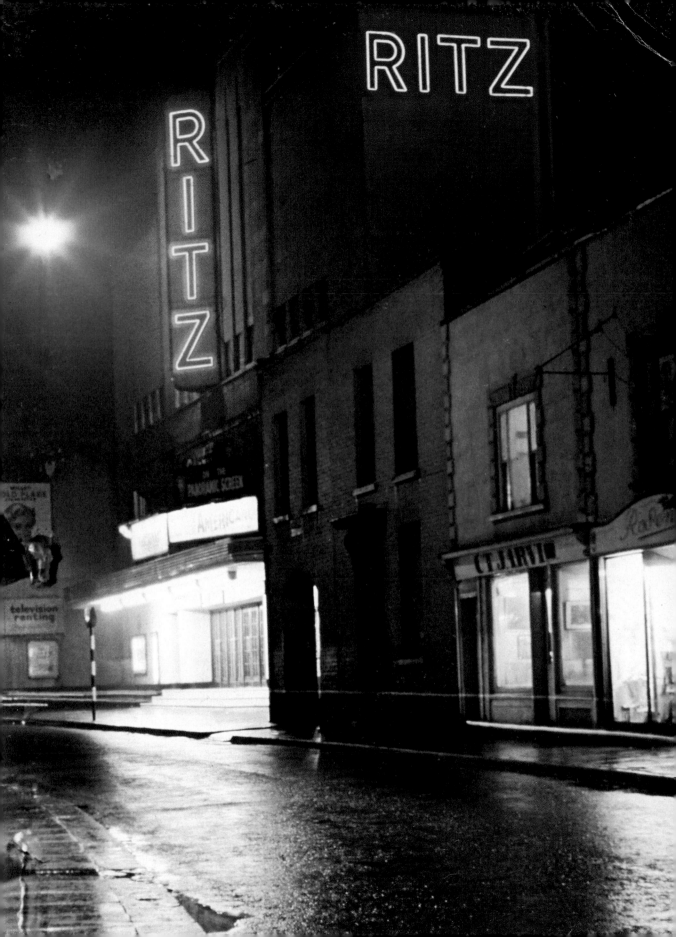

Firstly, take a normal exposure-meter reading to determine the correct exposure for the subject. Now decide how many multiple exposures you wish to make, bearing in mind that the task is more easily accomplished if carried out in steps which 'double-up' on each preceding step, i.e. 2, 4, 8, 16 and so on.

Suppose you decide that 8 exposures are necessary. You must now select a faster shutter speed which, when multiplied by a factor of eight, will provide an exposure equivalent to that indicated by your initial exposure-meter reading. For example, if your initial reading produced a required exposure of 1/60 of a second at f11, the shutter speed necessary to maintain 'correct' exposure over the 8 separate multiple exposures would be 1/500 of a second — 8 separate exposures at 1/500 of a second being equal to a total exposure time of 1/60 of a second.

Intermediate numbers of exposures can be obtained simply by adjusting the lens aperture setting, i.e. decreasing exposure by $\frac{1}{2}$ f-stop ($\frac{1}{2}$ stop smaller).

Such a technique can provide extremely interesting effects with any stationary object which is moving about in a breeze. However, it cannot be used for moving objects as some considerable time may have elapsed between the first and last exposures and a moving object will probably have travelled right out of the camera's field of view.

Such techniques may be useful during any season of the year, as they can be used to record the movement of water, clouds, people or, indeed, anything else which moves or has some movement imposed upon it by the elements, or even Man, although it may be necessary to use ND (neutral-density) filters to cut down the amount of light reaching the film on a bright spring or summer day.

Fog and mist can provide very attractive and moody pictorial effects in both colour and black and white, when foreground objects may often be rendered quite dark, or bold, with the background or more distant scene quickly receding into the mist.

If you are using black-and-white film in foggy or misty conditions, an orange or red filter will help to penetrate the mist, increasing contrast and providing a rather more 'snappy' effect. A blue filter on the other hand will have the opposite effect, and will actually increase the impression of mist, sometimes creating quite strange and mysterious effects. For the colour worker there are a great many 'special-effect' filters available, and some of these, particularly the 'dream', 'pastel', 'diffusion' and 'graduated' filters, can all be used to enhance the effect of fog or mist. You can even create your own fog, if there is none, with a purpose-made 'fog' filter! The coloured graduated filters can be particularly useful in providing a touch of colour to otherwise grey and dismal conditions.

When taking photographs in fog, mist, or when snow is on the ground, you must take particular care with exposure-meter readings. Such conditions can easily 'fool' your exposure meter into providing

Oblique lighting angles, early in the morning or late in the evening when the sun is low in the sky, can provide highly dramatic lighting effects. This type of light can be found throughout most of the day during winter in England, making this an ideal season for photography. *Olympus OM1, 21mm lens with red filter – Ilford HP5 ISO 400/27.* Picture by David Chamberlain

readings which would produce under-exposed results. This is due to the intense scattering of light that such conditions cause, and the best way to overcome the problem is to use an exposure meter which has the facility to take incident-light readings, as this type of reading will provide far more accurate results under such conditions. If you have to use your TTL (through-the-lens) exposure metering system, do try to make allowances for the artificially high light readings. In fog or mist, open up your lens aperture by between $\frac{1}{2}$ and $1\frac{1}{2}$ f-stops and, if taking photographs when thick snow is on the ground, open up by at least $1\frac{1}{2}$ or 2 f-stops. If your pictures are of particular importance, bracket your exposures to ensure that you have at least one correctly exposed picture.

During winter, the lighting is often very flat and lifeless. If you are a black-and-white worker you can use high-contrast techniques to provide more worthwhile results, producing more impact. Such techniques can be particularly useful with fog, mist or snow pictures.

Perhaps the easiest way to produce such results is to use a fast black-and-white film and 'push process' this to increase both contrast and grain. Such negatives, when printed onto a hard grade of printing paper, can produce extremely striking results. Pictures taken in snow are often suitable for very high-contrast techniques and for these it may sometimes be worthwhile to make high-contrast lith-film negatives, eliminating all half tones so that you end up with stark images of only black and white.

Whatever you do, you must be prepared to make the most of the changing seasons of the year. Photography should not cease simply because the sun stops shining, and if you are to obtain the most from this challenging subject you must be prepared to take photographs the whole year round.

The Quality Of Light

The quality of natural daylight is rarely constant. Through each hour of the day the light is gradually changing in several ways and, if we use this knowledge constructively, we can place ourselves in a better position to be able to make the most of photographing the urban scene.

Smaller details of modern architecture can also produce interesting pictures. These chromium railings hold a beautiful quaity in black and white. *Pentax Spotmatic F, 50mm lens with red filter – Ilford HP5 ISO 400/27*. Picture by Angela Fernandez

Modern architecture provides us with striking images – none more so perhaps than the new Lloyds Building in the City of London. *Olympus OM1n, 21mm lens with red filter – Kodak Technical Pan ISO 25/15*. Picture by David Chamberlain

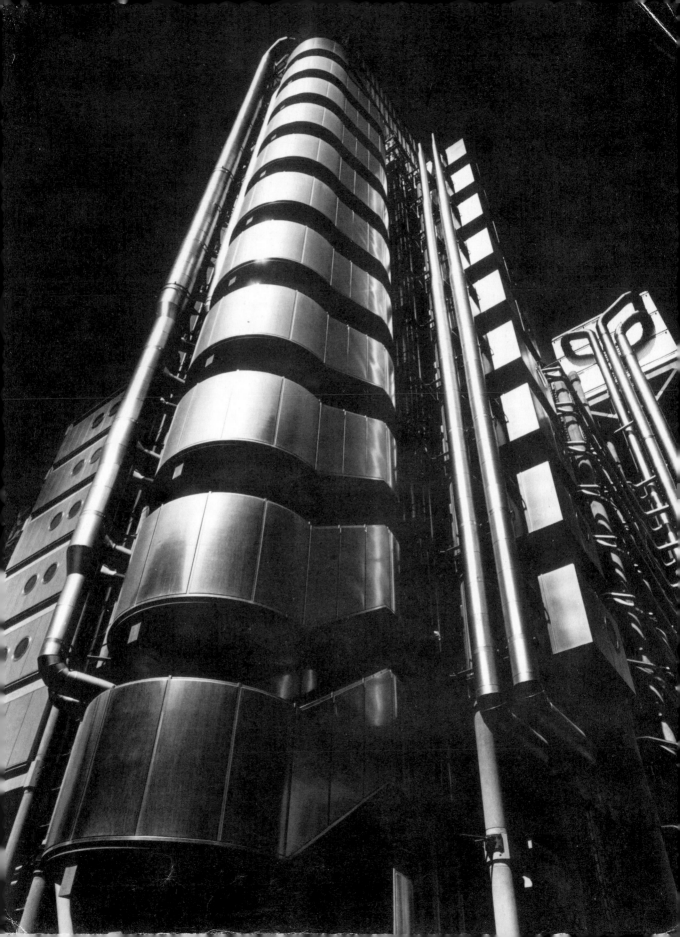

Early in the morning, before the sun has risen, the light is extremely flat, producing very little modelling to shapes and textures. However, this early morning light is, more often than not, extremely 'clean'. If there is no mist or haze about, this can be an ideal time to take distant landscapes. As the sun appears above the horizon, very strong modelling is quite suddenly produced by the highly directional light from the low sun. A similar effect will be obtained during the evening, as the sun begins to set, once again low in the sky. However, the light is often still much clearer in the morning. Either of these times is ideal for texture shots when a subject can be found to be ideally positioned. Very dramatic pictures can also be produced at these times of the day, making full use of the extremely long shadows cast by the low angle of the sun.

Probably the least successful quality of light is at mid-day, when the sun is usually almost directly overhead. This type of lighting can produce a rather boring, featureless type of picture with many subjects, although it must be said that good photographs can still be produced under such lighting, if the subject is suitable.

During winter months, the sun is much lower in the sky throughout the entire day, and this can be a particularly good time for photography – even at mid-day. However, winter sunshine is often much more hazy than summer light and shadows are consequently often a little less well defined.

The amount of cloud cover in a sky will have a considerable effect on lighting quality. Quite a thin layer of cloud will soften the light

Many modern buildings make good use of glass. We too can put this to good use – look for interesting reflections. *Olympus OM1n, 75–150mm zoom with yellow filter – Ilford FP4 ISO 125/22*. Picture by David Chamberlain

In many towns or cities, industry may give cause for concern – particularly with regard to its potential destruction of the environment. Some industries have become extremely guarded about their business – almost secretive. Certainly protective! *Olympus OM1, 75–150mm zoom – Ilford HP5 ISO 400/27*. Picture by David Chamberlain

considerably and a heavily overcast day will produce extremely soft diffused lighting. However, this will usually result in flat and unexciting photographs, and a much thinner layer of cloud, producing highly diffused but still directional light, will be much better.

The colour of light also changes throughout the day, and this can be quite important to colour-slide workers, as it will affect the entire mood or atmosphere of a colour photograph.

Early in the morning, just before the sun rises, the light is quite blue, and this will impart a very cold 'feeling' to a picture. As the sun rises above the horizon, a lot of warmer yellow tone will be added to the scene, although the shadow areas not reached by the sun's golden rays will still be very blue indeed. Quite striking effects can be produced at this time of day with the mixture of warm and cold tones.

After sunrise, and as the sun climbs higher in the sky, the cold shadow tones gradually warm up, and the light becomes at its most neutral at mid-day. Later, in the afternoon, as the sun sinks slowly lower in the sky, the colour of the light very gradually warms up still further, until just before sunset, when the sun is at its lowest position in the sky shortly before disappearing below the horizon, the tones change to a beautiful golden glow. This is often considered to be one of the most attractive times for colour photography, although it must be said that a sunset picture has to be pretty outstanding if it is not to become 'just another sunset photograph'.

Some really discerning photographers may choose to use CC (colour-

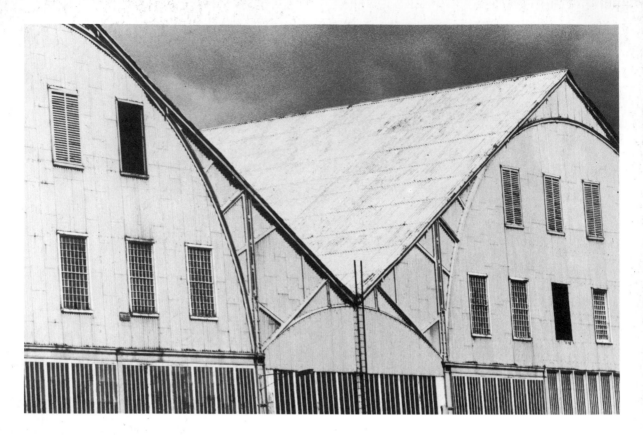

correction) filters to 'correct' the changing colour of daylight back to neutral. Although the professional commercial photographer may have to bow to the wishes of clients who deem this necessary, I think it is a shame for the amateur photographer to attempt to alter, or 'correct', these colour changes, which after all, do exist! Far better, I think, to use these changes to your own advantage.

Photographing The Urban Scene

Once you are photographing the urban scene in earnest, you may choose to use your car to transport you to and from different areas, especially if you are taking a comprehensive and perhaps heavy camera outfit with you. However, once you have found a suitably interesting area which you wish to cover, you must be prepared to walk. This is the only way to find pictures, as so much can be missed from the car and, besides, it is quite impossible to concentrate properly on both driving and looking for potential photographs!

Park your car and walk around a selected area. Don't make this area too large. It is far better to investigate a fairly small area thoroughly than it is to rush around a much larger one. Once you have thoroughly covered this one area, it is a simple matter to get back into your car and move on to another place. Gradually, you can cover an entire town or city in these small stages, leaving very little 'unseen'. However, even just

Disused industrial sites can also provide worthwhile pictures. Covered slipways (disused) in Chatham Naval Dockyard, Kent. *Pentax Spotmatic-F, 135mm lens with red filter – Ilford HP5 ISO 400/27.* Picture by Angela Fernandez

The reflective glass surfaces of some modern buildings often provide interesting reflections of other buildings. A grossly distorted street scene has been captured by moving in close to the steeply curved windows of a modern building in the City of London. (see Chapters 1 and 3) *Olympus OM1n, 35–70mm zoom with polarising filter – Fujichrome 100.* Picture by David Chamberlain

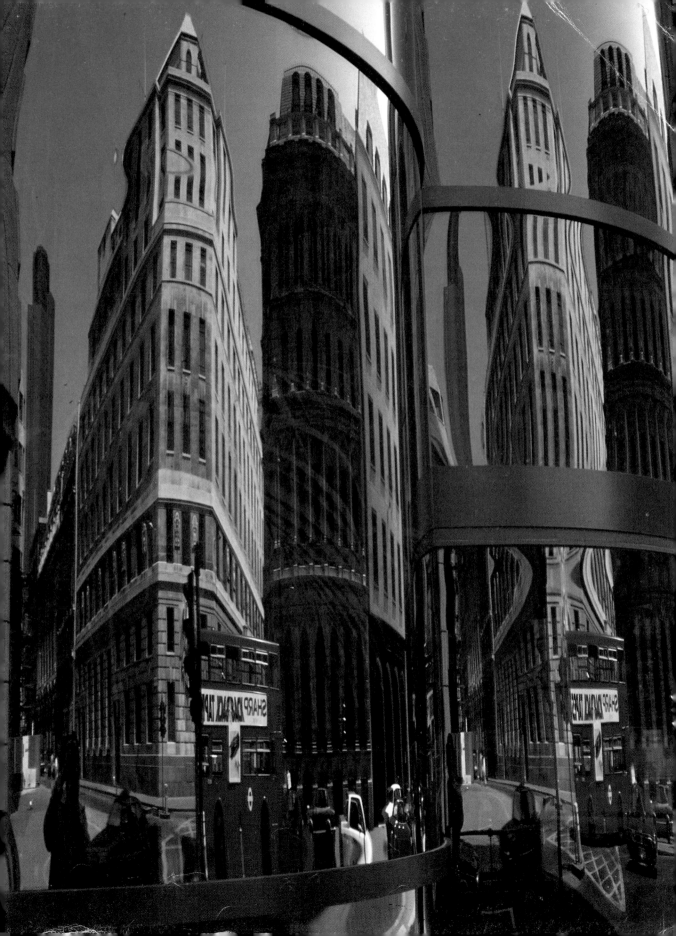

Conflicts can often be found within the urban landscape. The attractive face and rich tones to the photograph on this advertisement hoarding seem to conflict strongly with the somewhat shabby gable-end to the building to which it is fixed. *Olympus OM1, 75–150mm zoom with red filter – Ilford HP5 ISO 400/27.* Picture by David Chamberlain

one small town can provide an almost unlimited amount of potential, and it will be quite possible to revisit each of these small areas many times, through different seasons, at different times of day and under variable weather conditions, and still be able to find 'new' pictures on each visit.

ISOLATING DETAIL

During your walk-abouts, don't just look at the general scene. Keep your eyes open for the smaller details which can easily be overlooked. Try to look more closely, or intensely, at everything around you. Buildings may be quite large objects, but they contain a great deal of smaller detail within their structures. Look at individual windows, doorways, steps, chimneys, guttering, rainwater pipes, even the brickwork itself. You may be surprised just how many separate pictures can be found lurking within the structure of a single building.

Try to isolate smaller details which cannot perhaps easily be reached, by using telephoto lenses to 'pull' the subject in closer. Very small features may require some means of enabling your lens, standard or telephoto, to focus closer. A set of extension tubes may be ideal for this. When fitted between the lens and camera body this extra extension permits much closer focusing than could be achieved otherwise. Unfortunately, a set of extension tubes will take up as much room in the gadget bag as another lens, and a more convenient alternative might be to use supplementary close-up lenses. These are no larger than ordinary filters and a highly versatile set of three of these close-up lenses will take up very little room indeed. When fitted to the front of any lens, the

Even relatively new buildings fall victim to decay and dereliction. In the 1960s multi-storey blocks of flats were considered the ideal answer to housing problems. Views change, however, and they are now rapidly being demolished. *Olympus OM1n, 21mm lens with yellow filter – Kodak Technical Pan ISO 25/15.* Picture by David Chamberlain

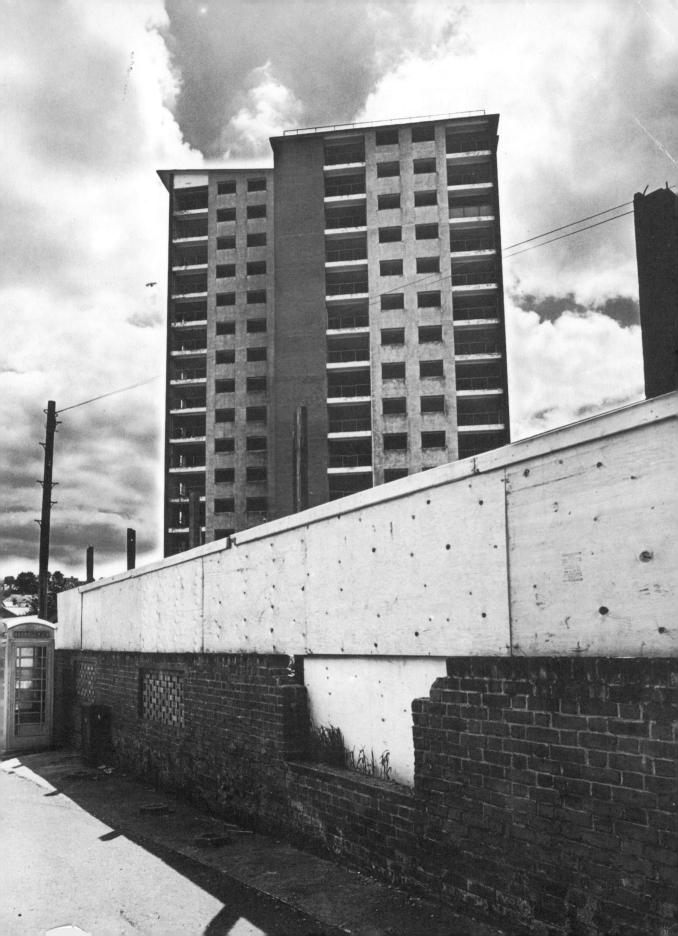

closest focusing distance will be greatly reduced and, as long as you use a fairly small lens aperture, quite high-quality results will be obtained. Used at large apertures, the edge quality of the image will be extremely poor, although it is possible to use this effect creatively. Rather like a 'centre-spot' filter, the image in the centre of the field of view will be quite sharp, whilst being surrounded by a very softly defined image area. This effect can be used constructively to place emphasis on an important area of the subject positioned in the centre of the frame.

Zoom lenses can be extremely versatile when it comes to isolating details. The variable focal length and subsequent angle of view enables highly precise framing of the subject and, through the zoom range, many different fields of view may be selected even from just one single viewpoint.

MODERN ARCHITECTURE

Many of today's modern architects have done us a great favour in our photography with their imaginative and sometimes quite adventurous architectural designs. Modern construction methods and materials have enabled these highly creative people to design buildings and other structures that would have been quite impossible a quarter of a century ago.

This has provided us with plenty of exciting subject matter for our cameras, as many of these modern buildings incorporate in their designs very strong geometry, providing for us the potential for pictures incorporating pattern, geometry and strong graphic impact. However, if we photograph these merely as they appear, we are doing no more than recording the work of the architect. It is up to us, therefore, to try to 'create' a photograph which is something above and beyond the obvious architectural delights. We must use our equipment, knowledge, lighting and, of course, our creative ability, to help us produce a picture which will have our own identity stamped upon it. Don't make the mistake of allowing the initial impact of an unusual architectural design to take over your mind and become the sole 'reason' for taking a photograph. Look at the subject carefully, moving all around it. Try to find something that the architect did not see, perhaps through the use of a wide-angle lens and close viewpoint, or telephoto lens and more distant viewpoint. This may alter the characteristics of your photograph considerably. Lighting may be another important consideration and two photographs, one taken early morning and the other late in the afternoon, could produce surprisingly different results.

URBAN INDUSTRY

Many cities or large towns have some form of industry and, indeed, in many cases this may be the reason for the town or city's very existence. Such industry can provide us with valuable subject matter, producing pictures quite different from those to be found in the more residential

The conflict of colour and thoughtful composition are the keys to the success of this picture. New-style 'business parks' are rapidly replacing the more traditional forms of industry and these can often provide a wealth of bright and colourful material for our cameras. Picture by Keith Adams

areas. Some forms of industry even have their own residential areas for the company's employees, or in some cases a town may 'grow up' around a certain industry. All this can prove to be very interesting material to us as photographers.

CONFLICTS

In any town or city, conflicts are usually to be found somewhere: either a conflict of architectural styles, such as frequently occurs with old and modern architecture, or perhaps a conflict where industry encroaches on residential or rural areas. This too can provide worthwhile and interesting photographs.

Colour can also provide very interesting conflicts, and it is well worth keeping your eyes open for brightly painted doors, windows, signs or even road markings. Many of these boldly painted objects will provide very strong conflicts with their immediate surroundings, and will often provide pictures full of colour impact.

URBAN DECAY AND DERELICTION

Many towns and cities have their own areas of decay and dereliction, especially in the inner-city areas of the older and larger cities, where there seems to be very little money available to repair and maintain the

slowly crumbling buildings. Although this situation is of course terrible for those that have to live or work under these conditions, for us urban landscape photographers, it is simply great!

The dirty and often crumbling buildings of such areas are absolutely superb material for photography and, in some city areas, it would seem that wherever we point our cameras, we are likely to be confronted with exciting subject matter.

A word of warning however. Sadly, we now seem to live in extremely violent times. With high levels of poverty to be found in the deprived inner-city areas of large cities throughout the world, a photographer carrying expensive photographic equipment could be an obvious target for any mugger and, in the interests of one's own safety, it is advisable to carry out photography in such areas in the company of at least one other person, especially if you intend to carry out any night photography in such areas.

Capturing Mood – Creating Drama

It is possible, through the use of your equipment and knowledge of technique, to impart an impression of 'mood' in a photograph or, by the same token, a sense of drama. The form this may take and how you achieve the effect is, to a very large extent, dictated by the actual subject you wish to photograph.

For example, a very modern building which perhaps features quite strong geometry, may be given a very clean-cut 'drawing-board' look. This could perhaps be achieved by using a telephoto lens with quite a long camera-to-subject distance, to 'compress' the apparent perspective, making the picture somewhat two-dimensional. This, combined with printing on a hard grade of printing paper, or other high-contrast technique, such as lith-film negatives, could produce a result which almost puts the architecture of the building right back on the drawing board.

In the opposite direction, areas of urban decay can be given an extremely deep and depressing 'mood' simply by deliberately underexposing the picture. If you are a monochrome worker, you can substantially add to this effect with very dark and heavy printing, perhaps on a harder than normal grade of printing paper.

When taking photographs in very misty or foggy conditions during daylight hours, a certain amount of over-exposure will often benefit the end result. This is a useful and worthwhile technique for both colour and monochrome workers, but is perhaps of particular benefit to the colour-slide worker who does not have the advantage of the extra control at the printing stage which is available to the black-and-white photographer. About a full 2 f-stops of over-exposure will produce an extremely light 'wistful' rendering, which can greatly enhance the effects of fog or mist.

Fast films and 'push-processing' techniques can be used to produce images with large- or coarse-grain structures, and this type of result can

A highly dramatic 'portrait' taken straight out of the urban scene. A showroom dummy lit by display lights. The 'moody' atmosphere to this shot has been created by the coarse grain and careful printing. You don't need expensive equipment for good photographs – this shot was taken on an elderly 35mm compact! *Olympus Trip – Ilford HP5 at El 800*. Picture by John Disdale

greatly enhance the mood or atmosphere of any suitable subject. Fast colour-slide films, perhaps push-processed to further increase their grain size, can be particularly effective when used in conjunction with over-exposure for fog or mist pictures, producing highly atmospheric results with this type of subject.

Always try to assess accurately the type of effect you would like to achieve before attempting to take your photograph. In this way you can make use of both your equipment and special techniques to enable you to produce the desired result, and it is worth bearing in mind that it is far more difficult to give your picture any sort of mood or atmosphere after you have taken it. Although it may be possible to modify the image to some extent during the printing stage, this alone is rarely totally satisfactory and, of course, the colour-slide worker has no such option open to him. Mood or atmosphere is best controlled at the taking stage when your feelings or impressions of the subject are at their strongest.

The human element can be an important part of urban landscape photography – even when used merely as a point of interest within a picture. Place de la Concorde, Paris. Picture by Norman Osborne

People are an important part of the urban scene and some, like this tramp in London, are almost an integral part of our urban environment. *Bronica ETRS, 75mm lens – Ilford FP4 ISO 125/22*. Picture by Sonny Schembri

The Human Element

Just as in more conventional types of landscape photography, the inclusion of the human element within your urban landscape pictures can be a very important factor.

The human figure when included in any sort of landscape photography can help to form an impression of scale. We can all directly relate to the size and proportions of the human form and, when a person is situated either in an open landscape, or in an urban environment, we can more easily appreciate the size or scale of the surroundings.

However, the human element can be usefully incorporated within our urban landscape photographs for reasons other than merely providing a scale reference point. In the simplest of terms, the human figure may provide a 'focal point' to a picture which otherwise might allow the viewer's eye to wander. In reality, we usually settle our gaze on something positive. Indeed, often another person. Although we may be

67

primarily 'looking' at this one person, or 'focal point', we also see the rest of the surroundings. The inclusion of a human figure within a two-dimensional photograph can provide a very similar effect, and so enable a viewer's eye to settle more comfortably.

The human figure in an urban landscape photograph can be given different degrees of 'strength', placing a variable amount of emphasis on this focal point. This can have quite considerable effect on the way a picture is viewed overall in relation to the other main elements within the picture. For example, in colour photography, if a human figure clothed in bright red is included in the photograph, the viewer's eye will be drawn towards this very strongly. This will happen even if the figure is quite minute. A figure dressed in yellow would have a similar effect, although not quite to the same extent as that in red. The degree of emphasis placed upon the human element can therefore be controlled not only by the relative scale of the figure to its surroundings, but also by colour. In black-and-white photography a similar effect could be achieved through the use of contrasting tones, i.e. a figure dressed in light colours against darker surroundings or, indeed, in black against very light-toned surroundings. The key to success is to try to find the ideal balance in size and colour (or tone) in relation to the surroundings.

Sometimes, the human element is the most important feature within an urban landscape photograph. If, for instance, you wanted to photograph a busy street scene, it would probably not appear very 'busy' unless people were included in the shot and, in such a case, it might be beneficial to use a fairly slow shutter speed, creating blur, to illustrate the movement of the people as they hurry about their business.

The human element may also be used either to complement the urban scene or, indeed, to contrast with it. Take for instance two very simple examples of this. Imagine first a fashionable shopping area. A girl dressed in fashionable clothes could be incorporated within the picture, either as quite a small element, when she could be perhaps standing near a shop window looking at the display, or as a more major element, perhaps standing with her back towards the camera in the immediate foreground. In this way, she would actually complement the main subject matter, but now imagine, if you will, the same girl placed in a scene of derelict buildings, perhaps in one of the run-down inner-city areas. Her presence would now take on a totally different significance, providing a stark and perhaps strange kind of contrast with the surrounding scene.

Think carefully about how you use a human element in your urban landscape photographs. Make the most of it, and you will produce photographs which have that 'something' extra. If you are a little too shy to ask people in the street to pose for your camera, try enlisting the help of one or two friends. Although the natural or 'candid' inclusion of people is often most desirable, deliberately 'set-up' pictures can also be used very successfully on many occasions.

The Picture Essay

A simple picture essay can provide a very useful and attractive method of documenting a particular aspect of the urban environment. Your chosen subject for such an essay would of course depend on which particular aspects are of interest within your own chosen area, but might include such things as a decline in industry, redevelopment or slum clearance etc. The picture essay can be an effective way of telling a story in pictures more effectively than could ever be achieved in a single photograph.

The number of individual photographs that you use will depend on just how much of the story you wish to tell, but a successful picture essay could include from as few as three or four prints up to about twenty or more.

Always try to start the picture essay with at least one very strong photograph. Don't make all your prints of the same size as this will not provide any variety throughout the essay. Use prints of correctly balanced densities to 'put over' the correct mood to suit the subject. Dark and sombre prints will for instance convey a sense of drama or depression, while predominantly light-toned prints may provide a feeling of space, freedom or lightheartedness.

Mount all your prints in sets of three or four on large pieces of card, aiming for a pleasing balance of formats and sizes whilst retaining a correct order of progression through the story. You can even add typed or hand-written words to complement the pictures and perhaps provide some hard facts to back up your photographs.

A picture essay can provide a very worthwhile and highly satisfying 'purpose' for your photography and, done properly, will provide an interesting, lasting and extremely valuable documentary on your chosen subject.

4 · Monochrome or Colour

Deciding Which

Many amateur photographers might be under the impression that black-and-white photography has now all but given way to the medium of colour. However, this simply is not true. Although there are certainly more people using colour film, by far the higher proportion of these are the casual 'snapshooters' who use mostly colour-negative film for their family and holiday snaps.

Among the keener and more dedicated amateurs, black-and-white photography is still extremely popular and, certainly in recent times, there has been a revival of interest in monochrome photography generally. Many 'famous' names in the world of professional photography still prefer to use black and white for nearly all of their personal work.

Amongst the keener colour workers, transparency film for positive colour slides seems the most popular material, and this may be evident from the increased use of colour in many magazines within the photographic press nowadays. But which medium is the best? And which is the most suitable for photographing the urban landscape?

HORSES FOR COURSES

It is really quite impossible to make any firm statement regarding which of these two quite different media is best. Neither one is any 'better' than the other. They are, however, 'different' and subsequently both are useful for their own specific purposes.

It would be a foolish photographer who would dismiss either one of these media, although it must be fair to say that most people will indeed have a preference, often depending on the particular 'type' of photography that they themselves enjoy. This preference should not however be prejudiced in any way, and least of all through ignorance. The fact is that some pictures are essentially 'colour' pictures, while others may be more effective in black and white, and this may become very evident in your urban landscape work. It would be totally pointless to shoot a picture which depends on its strength of colour, such as brightly coloured doors or window shutters etc, in black and white. In such pictures, colour impact may be the sole reason for taking the photograph and without that colour the picture would fail. Although

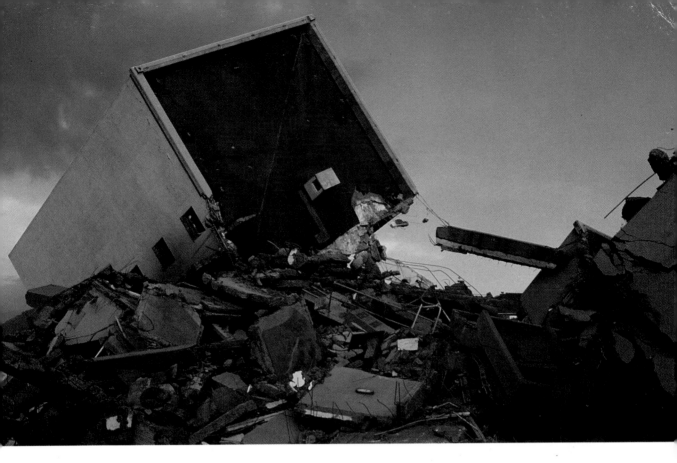

Urban decay and dereliction provide interesting material. This shot is the result of changing attitudes towards our urban environment – the high-rise flats built as an answer to housing problems 15 or 20 years ago are now no longer 'desirable' and are rapidly being demolished to make way for new 'low-rise' housing – similar to that which they replaced when originally built! Picture by Ian Jenkins

there are very many pictures which could be taken equally successfully in both colour and monochrome, there are still some that remain more suitable for either one or the other of these two media. The important thing to remember is that, if 'colour' is in any way 'essential' to the subject or scene, then your choice must of course be colour film. If colour is not an essential element to the subject, stop to consider whether you might be able to produce a more interesting result on black-and-white film.

LET THE SUBJECT DECIDE

It may seem obvious that the subject should determine whether colour or black-and-white film is used, but it is quite surprising just how many photographers load their cameras up with either one of these and expect to be able to take all kinds of photographs on this one particular film stock.

The best answer to this problem is to use two camera bodies, one loaded with colour film and the other with black and white. If you use a medium-format camera which has interchangeable film backs, the problem is even more easily solved. However, if you only have just one camera body, don't load a film into it until you find a suitable subject. Then let the subject itself decide if you should use colour or black and white. If working with the 35mm format, use only the shorter lengths of

71

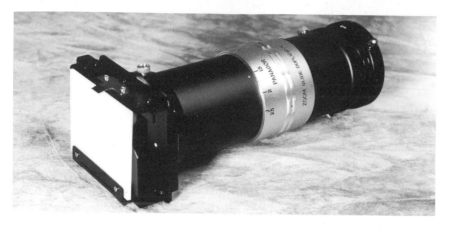

Panagor zoom-slide duplicator
A simple slide duplicator can become a useful 'creative' tool to the colour worker, making possible a whole range of manipulations to an original image when copying. Photo courtesty Camera Gear Ltd (Kent)

film – 12 or 20 exposures – so that you may have a chance to use up the entire film on or around each subject. Alternatively, you can note which frame you are on and change the film in mid-roll by winding it back into its cassette, being careful to avoid winding the film leader back into the cassette, making it impossible to reload it later. Medium-format cameras which do not have interchangeable film backs cannot be used in this way, and you will have to be prepared either to use the entire film on your chosen subject, or to wind the film off, with some frames remaining unexposed, if this should prove necessary. However, most medium-format sizes do not have an enormous number of exposures available on each roll of film and it is often possible to use the whole roll while investigating every aspect of your chosen subject.

Always be prepared to make the most of each and every potential subject which you come upon, even if this does mean changing your film in mid-roll. I know this might seem very awkward and inconvenient, but if you really want to obtain the best possible results you must be prepared to go to such lengths. Your efforts will be well rewarded.

MONOCHROME FOR DRAMATIC EFFECT

Black-and-white photography is often considered an 'easy' option by many colour workers, and some might consider it to be perhaps a beginner's medium. Nothing could be further from the truth, however, and monochrome photography, at its best, is a far more difficult medium to handle successfully. In fact, today, many photographers who started out by using colour only attempt monochrome photography after having built up their skill in colour work, which does require less skill to produce 'acceptable' results.

Black-and-white photography demands that little bit extra dedication for, if you are to make the most of this versatile and creative medium, you really do have to do your own processing and printing, and it is this 'extra' stage in the process which provides an ideal opportunity for almost total image control.

However, black and white is, by its very nature, immediately

Although the subject did contain colour – the wall being a pale green – this picture works far better in black and white, simplifying the image for greater graphic effect. *Nikon FM, 50mm lens with 2 × converter – Ilford FP4 ISO 125/22*. Picture by Angela Fernandez

abstracted from reality. With the absence of any colour, the image is restricted to black, white and shades of grey, and this in itself makes it necessary for a photographer to adapt his way of thinking in respect to the way in which he 'sees' any potential subject matter. A subject will not be recorded on film as it is seen by the eye, and a monochrome worker must learn to anticipate how each potential subject will translate to tones of black and white. Some people find this quite difficult, although it usually comes through experience.

The mistake that many photographers make is to use the medium of black and white in exactly the same way as they would that of colour. This is never very successful and will usually result in bland and somewhat uninspiring prints. In monochrome photography you cannot

rely on colour to provide contrasts or tone variations, and only an understanding of the medium will enable you to produce the best possible results.

Black-and-white photography is an ideal medium for creating a sense of drama or mood within a picture, the abstraction through total lack of colour providing an ideal basis for this. In addition, the ability of black-and-white film to cope better with extremes of contrast enables such films to be much more versatile in handling extremes of brightness, and this too can be used creatively.

Although dramatic effects can be produced on colour film, these are usually restricted to 'colour impact', and black-and-white materials are much better suited to handling the type of impact that can be found through light and shade, or tone simplification.

COLOUR AND REALITY

We do of course actually see everything in colour, and colour film therefore is the ideal medium for achieving reality in photography, or at least in theory anyway. However, if realistic results are to be achieved with truly authentic rendering of the colours around us, great care is required. As explained earlier, the colour of daylight itself gradually changes throughout the day and, in addition to this, our towns and cities make considerable use of all sorts of artificial lighting. If we are to obtain anything approaching realistic colour rendition it will be necessary to make use of special colour-correction filters. These are used over the camera lens to compensate for, or correct, any unwanted colour casts. Unfortunately, when working under several different mixed light sources, it may often prove impossible to obtain a neutral colour balance, when it will simply not be possible to 'correct' the various colours of light from the many different light sources.

Under such circumstances it may often be better to forget trying to achieve a 'correct' colour balance, and actually make use of the mixed lighting conditions to provide more unusual and interesting results.

During normal daylight hours it is much easier to obtain authentic colour rendition, and this enables extremely realistic results to be obtained. Without any doubt, authentic colour can be very important to certain types of photography, and could perhaps be considered almost indispensable for some types of documentary photography, or any architectural work where colour may be an important factor.

The realism of colour can also be used to provide extremely atmospheric pictures, such as when taking photographs in misty or foggy conditions, when beautiful pastel colours are often to be found. Such delicate shades can only be properly accommodated on colour film. Bold colour or colour contrasts would in most cases be totally lost on monochrome film and, indeed, in photographing the urban landscape you will find many instances where the reality of colour is absolutely essential to the success of your photograph.

74

A highly dramatic churchyard scene has been created by the use of an extreme-wide-angle lens from a low viewpoint and the use of a deep red filter (normally used only for black-and-white photography). (See chapter 3.) *Contax RTS, 18mm lens with red (25A) filter.* Picture by David Chamberlain

Darkroom Controls In Black And White

The black-and-white worker has one additional advantage available to him over the colour-slide worker: darkroom printing controls. This enables the experienced black-and-white photographer to be able to control creatively the final result through manipulating the print by burning in or shading certain areas of the picture to either darken or lighten them.

Such printing controls can have a considerable effect on the final picture, and it is quite possible to alter totally the 'mood' or 'atmosphere' of a scene in this way. Such controls are therefore an extremely important asset in the hands of a creative and imaginative photographer. However, creative print controls rarely make it possible to salvage an unsuccessful photograph, and the best results will always be achieved by the photographer who can previsualise the end result at the time of actually taking the photograph. An experienced black-and-white worker will already know what print controls will be necessary, even at the taking stage, and will be able to take steps to make any such work easier by careful exposure when initially taking his photograph.

The basic principles of these printing controls are very simple indeed, and very little practice will be required before worthwhile and satisfactory results can be obtained. Quite simply, there are really only two types of print control: shading, to make an area of the picture *lighter*, or burning in, to make an area *darker*.

SHADING

Shading is carried out quite simply by positioning an object in the light path of the projected negative image from the enlarger, between the enlarging lens and the printing paper. More experienced workers will often use their hands to cast a shadow onto the printing-paper surface, moving the hands to manipulate the shape of the shadow. However, it may often be much easier to cut shapes out of thin but opaque card. These shapes can then be attached to the end of a thin piece of wire and positioned in the light path of the projected image. Keep the piece of card moving very slightly during this shading operation to avoid any hard and obvious 'edges' around the area being shaded.

Very large areas of a print can be shaded by positioning a card mask, cut to the correct shape, a little way above the surface of the printing paper. Start by positioning your large piece of card under the enlarger, raised about 2 or 3in above the baseboard or masking frame. In ball-point pen, draw the outline of the area you wish to shade and, with a pair of scissors or a sharp scalpel, cut out this shape from your piece of card. If the area to be shaded extends right down to the base of the image, it is a simple matter to hold the mask in your hands, keeping it slightly on the move, whilst observing the image projected onto the back of this card to make sure it is correctly positioned. You can also watch the shadow cast onto the printing paper to ascertain correct positioning.

If the area to be shaded, however, is situated in the centre of the image, it may be necessary to lay your mask on a sheet of glass suspended 2 or 3in above the paper surface. This will avoid the problem of the shadow from your own hands falling across the paper surface causing unintentional shading. Once again, keep the glass, complete with cardboard mask, slightly on the move to avoid any hard edges.

Very small areas indeed can be easily shaded by using a small piece of card attached to the end of a very thin piece of wire. Alternatively, a small blob of plasticine or modelling clay may be used on the end of your piece of wire. This has the added advantage that it is very easily manipulated to any required shape simply by pressing and squeezing it.

BURNING IN

Burning in produces exactly the opposite effect to that of shading by darkening a selected area of the print. Quite simply, this means giving extra printing exposure to a small area of the picture.

Once again, an experienced worker would mainly use his hands for this purpose, but even the experienced worker will have to resort to other means for burning in very small areas.

Burning in is easily achieved by using a large piece of opaque card with a hole cut out of the centre. Position this in the light path from the enlarger to allow only a small area of the image to be projected through this hole. The size of the area being burnt in is easily controlled by raising or lowering the sheet of card. The nearer the hole to the enlarging

Black-and-white infra-red film can be used to produce strikingly 'different' pictures. Use with a red filter – R(25A), Kodak Wratten No. 25, or Hoya R-72 – over the camera lens to produce surreal pictures where grass and foliage record white and blue sky turns black. Best effects are obtained in bright sunlight. *Olympus OM1, 21mm lens with red R(25A) filter – Kodak High Speed Infrafed Film at El 50.* Picture by David Chamberlain

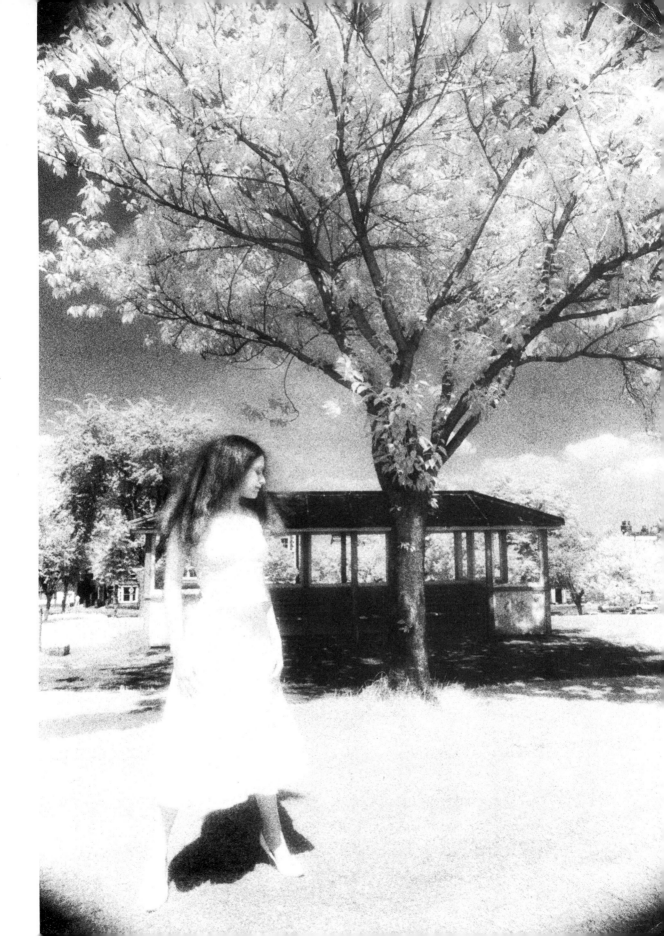

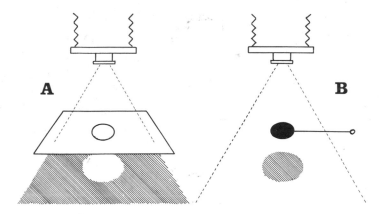

Printing controls 'Burning in' and 'shading' are methods of controlling local print density available to the photographer who prints his own work. Burning in (*A*) is most easily carried out by positioning a piece of opaque card with a suitable-sized hole cut out of it between the enlarging lens and the sheet of printing paper. Extra exposure is given to the required area(s) of the print to darken it, while the rest of the paper is protected by the card. Shading small areas (*B*) to lighten them may be carried out by affixing a small piece of opaque card, or pliable modelling dough, to the end of a thin piece of wire. This is positioned between the enlarging lens and the printing paper to 'shade' the required area of the print so that it receives less exposure than the rest of the image. The card in both cases may be cut to suit a particular shape but must always be kept slightly on the move during printing to avoid any hard edges. More experienced workers may often use their hands to form the required shapes to burn in or shade.

lens, the bigger the area being burnt in; the closer the hole is moved towards the printing paper surface, the smaller the area. In this way, it is possible to burn in quite small areas, but if an extremely small area is required to be worked on, simply make a very small hole in the card and hold it very close to the printing paper.

Quite precise shapes may be dealt with by cutting a hole of the correct size and shape. As with the mask for shading, draw the outline of the part of the image which you wish to darken on your piece of card, and very carefully cut this out. It will then be a simple matter to hold this in position, slightly above the surface of the printing paper, while extra exposure is given to this small selected area.

Before any printing controls are attempted, it is very important to first make a 'straight' print for assessment purposes. This will provide a basis from which to assess precisely which areas require burning in or shading, and will also provide a basic starting point for exposure time from which any times for print controls may be estimated.

EXTRA CONTROL WITH VARIABLE-CONTRAST PAPERS

Variable-contrast printing papers, such as Ilford Multigrade or Kodak Polycontrast, provide a quite unique opportunity for extra print controls. Such printing papers have a variable-contrast range which is controlled by special filters used in the enlarger's filter drawer or below the lens and, when using these types of papers, it is quite a simple matter to print a single image using two or more different contrast grades, all on the one sheet of paper.

This is achieved by burning in and shading in the normal way, except that the contrast of small selected parts of the image can be changed during the burning in simply by changing the contrast filter in the enlarger.

This can be particularly useful when dealing with photographs which contain an excessive contrast range, and such printing papers may be the only satisfactory way of printing some of these more difficult pictures.

It is nearly always best with this versatile method of print control to

The Sabattier effect – a print which is part positive and part negative – is produced by re-exposing a partly developed print to light. Picture by David Chamberlain

A more versatile method is to use lith or line film in 5 × 4in sheet size. Contact print your original negative onto this high-contrast material to produce a positive – this can be re-exposed to light during development to produce the effect on the positive image. When the positive is washed and dried, contact print once again onto another sheet of film to revert back to a negative – this too can be re-exposed. Now print the resulting negative; alternatively you could re-expose the print to produce a triple effect! This print is from a lith negative and is in effect a 'double' Sabattier effect picture.

commence by printing the parts of the image which require the use of a 'hard', or more contrasty, filter grade. Once this has been done, it is usually a simple matter to 'burn in' the difficult highlight areas through a suitably shaped hole cut out of a large piece of card, using a 'softer' grade of contrast filter. Remember, however, that the areas to be 'printed in' will have already received a certain amount of exposure during the printing of the parts which required the hard grade of filter. Any test strips which you make to determine this extra burning in should also incorporate this initial exposure with the harder filter.

Filter Effects

IN COLOUR PHOTOGRAPHY

Although the colour worker who chooses to use colour-negative material and print his own work will have similar 'extra' control available to him in much the same way as the monochrome worker through creative darkroom techniques, the photographer who prefers to work with colour-reversal film for transparencies will have no such 'extra' controls available.

Fortunately, this situation may be redressed by the vast range of 'special-effect' filters which are now available. Such filters now make it possible to produce effects that would have been thought 'impossible' only a few short years ago. Companies such as Cokin and Hoya produce a truly vast range of these special-effect filters, far too many to outline all

of them here. Suffice to say that almost any effect you can imagine is possible with a filter from one company's range or another. Some of the most popular and more commonly used of these filters are those such as the 'star-bursts', 'soft-focus', 'pastels', 'centre-spots', and 'graduated colours'. Companies who produce these filters can usually provide a catalogue or brochure covering their entire range, and if you want to experiment with these filters I would suggest you obtain one of these.

Unfortunately, now that these filters are so readily available, many of the special effects have suffered from overuse, and nowadays great care is required in their application if an effect is not to become something of a cliché. Always stop before taking a photograph using one of these filters, to consider whether its use is really necessary or, indeed, even desirable. A special effect will not automatically guarantee a good or 'successful' photograph. Examine and investigate your chosen subject carefully. Try to determine whether it might be possible to achieve an 'effect' which is every bit as dramatic as that which can be provided by the use of a filter, simply by utilising a more dramatic camera angle to provide a more dynamic composition. Only use a special-effect filter if you really believe it will 'add' something *worthwhile* to your photograph.

IN BLACK-AND-WHITE PHOTOGRAPHY

Although many of the 'special-effect' filters used in colour photography may also be used for black-and-white work, by far the most useful filters for monochrome are the coloured 'contrast' filters. These are available in yellow, orange, red, green and blue. In addition to these, a polarising filter is also extremely useful. This may be used either for controlling unwanted reflections in glass, water and many other reflective surfaces, or may also be used in combination with any of the contrast filters to further increase contrast in addition to eliminating unwanted reflections. This is most effective when used in combination with a deep red filter, when contrast will be increased to such a degree that a 'night for day' effect may in many cases be achieved.

The yellow filter may prove to be very useful in photographing the urban landscape. Besides being very useful for slightly darkening a blue sky, enabling any white clouds to stand out more boldly, it will also slightly lighten yellow, orange or red brickwork, often providing better rendering of detail. Orange and red filters can also be used in exactly the same way. With these, the same effects will be even more pronounced, the red filter in particular increasing contrast quite considerably, providing very dramatic results. For full information on all of these filters and the effects which they achieve, see the Filter Chart For Black-And-White Film (p.82).

As with all filters, never use them merely for the sake of it without really knowing what you want to achieve. Used constructively, filters are a useful tool which can be used creatively, to control 'mood', 'atmosphere' and, ultimately, the 'quality' of your final photograph.

Line or lith film can also be used to produce interesting 'line-drawing' effects – simply by printing from a high-contrast positive and negative sandwiched together. Picture by David Chamberlain

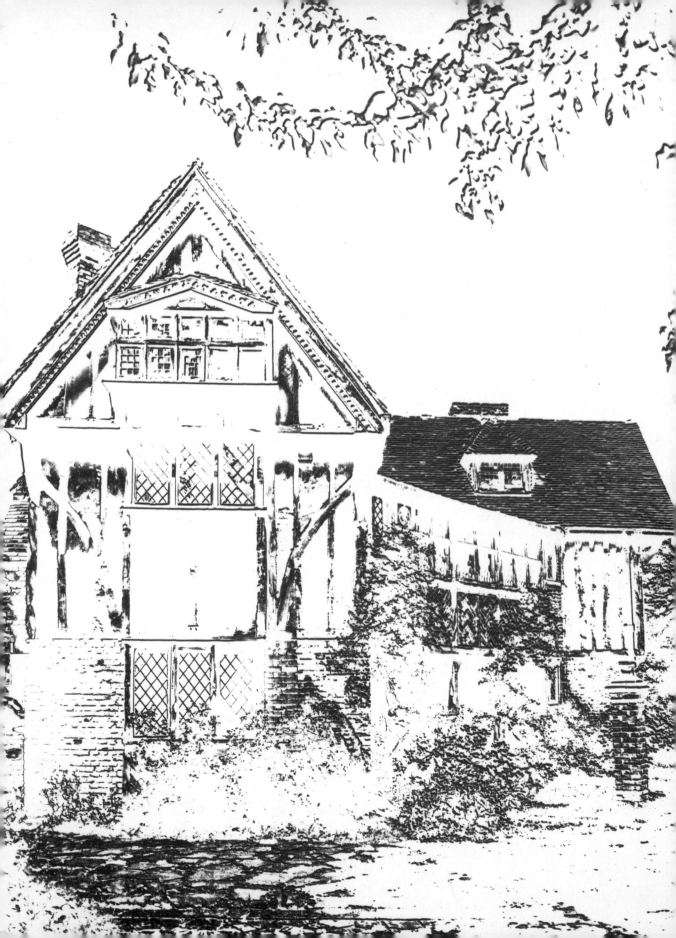

FILTER CHART FOR BLACK-AND-WHITE FILM

Filter	Effect	Application	f-stop increase
Yellow (× 2)	Absorbs UV, lightens yellow and orange more slightly. Darkens blue. Helps penetrate haze and increases contrast slightly.	Darkens a blue sky to a level approximating that 'as seen' by the human eye making white clouds stand out more clearly. Can be used to provide a 'snappier' result with some flatly lit subjects. Good for photographing light-coloured brick buildings.	1
Orange (× 5)	Absorbs UV, lightens yellow, orange and red slightly. Will darken blue quite considerably. Good haze penetration and contrast increase.	Will darken a blue sky quite considerably making white clouds stand out boldly. Can be used to boost contrast, producing deepening shadows. Very good for showing texture in brick buildings etc. Cuts through haze and light mist providing clearer pictures of distant subjects.	2
Red (× 8)	Absorbs UV, lightens yellow, orange and red. Darkens blue and green almost to black. Increases contrast dramatically and provides very good haze, mist and even fog penetration.	Produces an extremely dramatic darkening of blue sky (almost black) and increases contrast to make white clouds stand out very strongly. Will increase contrast of almost any subject, producing deep shadow values and bright highlights. Very good for stark effects or when wishing to exploit the graphic elements of a subject. Effect can be emphasised by using in combination with a polarising filter.	3
Blue (× 5)	Increases effect of UV, lightens blue, violet and turquoise. Darkens red and yellow; green slightly.	Can be used to lighten a deep blue sky if stark white sky tones are required. Increases effects of haze, mist or fog and can be used to provide mysterious effects in such conditions.	2
Green (× 6)	Lightens green and yellow/green slightly. Darkens red, orange and some blues. Strong increase in contrast.	Lightens foliage on trees and grass helping to provide greater detail. Will also darken rich blue skies. Beware of using with subjects which include red or yellow brick buildings – these will be darkened with subsequent loss of detail. Good for pictures in parks etc.	$2\frac{1}{2}$
Polarizing* (× 3– × 4)	Will darken a blue sky without any severe increase in contrast. Will minimise reflections in glass or water and help reduce glare from some glossy surfaces.	Darkens blue sky when used at angles approaching 90° to the sun without increasing the overall contrast. Provides clearer pictures of distant subjects on bright days. Useful for reducing obtrusive reflections in windows etc. Can be used as a neutral-density filter to cut the light level reaching the film in extremely bright conditions or when slow shutter speeds are required.	Various

*The same effects and applications apply to the use of this filter in colour photography.

A human form, no matter how small in scale, is a very powerful element within a picture and can successfully be used as a point of interest within a more general scene. This view of the busy main road through Las Vegas seems dominated by that relatively small figure crossing the road. *Contax 137, 80–200mm zoom (set at 200mm).* Picture by Malc Birkitt

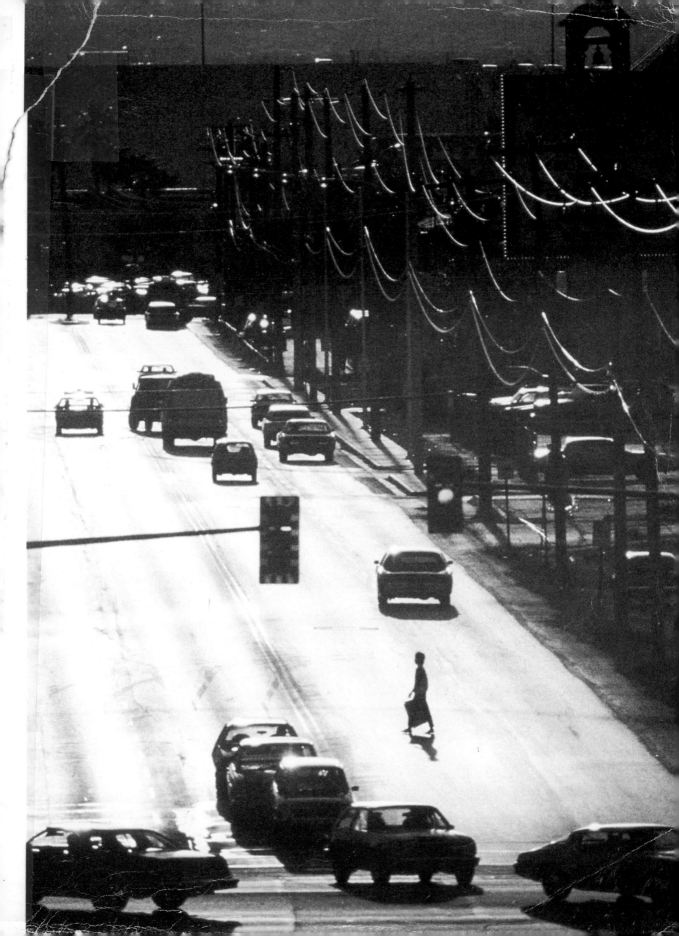

Special Effects

Although this is not a book on special effects, these do have certain applications which may prove useful in photographing the urban scene. There are basically two different methods of creating special effects. Either 'in camera', or by 'post-camera' techniques. Most are applicable to both colour and black-and-white photography and, used imaginatively, these can often help to provide interesting and unusual results.

Remember, however, that the use of a special effect will not necessarily guarantee a 'good' picture, and such techniques are rarely necessary with a subject as versatile as urban landscape. If you are to use any of these special effects, try to use only those which really suit the subject, preferably adding that little 'something' extra to your final photograph.

IN COLOUR PHOTOGRAPHY

Although there is no doubt a vast range of special effects which can be applied to colour photography, I propose to cover only a few simple effects which may be particularly useful in urban landscape photography.

Multiple Exposures Multiple exposure is a very simple to use method of combining two or more images onto a single frame of film. Most modern cameras are now fitted with a 'multi-exposure' device, enabling this technique to be carried out very easily. This control simply enables the camera's shutter to be cocked without advancing the film, so enabling several exposures to be made on a single frame of film.

This technique can be very useful for 'overlaying' two or more separate images onto each other. The best results are achieved when the pictures have dark backgrounds, and night photography of well-lit buildings or neon signs etc can provide worthwhile subject matter for this sort of treatment. Although this is an 'in-camera' technique, a similar effect can be produced 'post-camera' by sandwiching two transparencies together in a glass slide mount. With this method it is better to use mainly light-toned transparencies; even overexposed slides can provide good results. When combining more than two slides in this way, it is often a good idea to copy the 'sandwich' using a slide copier, so that you end up with just a single thickness of film.

Copy Manipulations Copying can also provide a useful method of manipulating the image in itself. By using a simple slide-copying attachment on any 35mm SLR (single-lens-reflex) camera, it is a simple matter to copy your slides, providing an ideal opportunity to either lighten or darken the copied image by either deliberately over- or under-exposing. You can introduce deliberate colour casts, using filters, to complement the mood of a picture or, indeed, to correct a cast which is already present on the original. In a similar way, a sharp image can easily be softened, or even a texture added, by introducing a thin diffusion or

Montage is a very simple method of combining two or more images together. Separate elements are cut-out from several prints and quite simply mounted together to form a new single image. This picture combines parts from three separate pictures. Picture by David Chamberlain

texture screen between the lens of the copying attachment and the slide itself.

If you use your own camera lens fitted to either extension tubes or bellows for copying, this will offer even greater potential for manipulating the image. By positioning a thin sheet of glass between the camera lens and the slide to be copied, all sorts of effects can be created, and if you make a very simple stand to hold several sheets of thin glass in different layers, quite extraordinary results will be possible.

Try smearing some sort of thin grease, such as margarine, cooking fat or oil, onto the top sheet of glass. With your slide positioned beneath this on a lower sheet of glass, this will in effect provide a greasy screen through which the slide is copied. You can manipulate the grease or oil into different textures or patterns by using your finger or a small brush. The effect is infinitely variable and may be further softened or hardened depending on how close the screen is positioned in relationship to the slide beneath it.

Infra-Red Film (Colour) Infra-red film is unusual in that it is sensitive to the invisible infra-red end of the light spectrum in addition to the normal visible wavelengths. This can provide some highly unusual, if a little unpredictable, results.

A certain amount of care is needed in the use of this strange material. Infra-red light rays do not always behave in a similar way to the visible spectrum, and it is possible for these to pass right through many apparently solid objects which would not be possible with normal light. Even the cassette that contains the film may not be proof against infra-red light. So remove the cassette from its special container and load it into your camera only in total darkness.

Infra-red light does not focus on the same plane as the visible spectrum, and you will have to adjust the focusing distance from your camera to subject, to the special infra-red focusing index which can be found on most modern camera lenses. Your problems when using this material do not end here either. When you take into account the fact that the indicated film speed of this material is only 'nominal', and that in order therefore to guarantee at least *some* satisfactory exposures it will be necessary to bracket exposures by at least 1 f-stop over- and underexposure, you will begin to appreciate that this material can be quite a lot of fun to work with! Even processing brings its own problems. This material uses the now almost defunct 'E4' process, and you will have to send your film off to a company which still offers this service. Alternatively, you can process this film yourself in a suitable 'home process' E4 chemistry kit. Such a kit is available in Great Britain from 'Speedibrews', 54 Lovelace Drive, Pyrford, Woking, Surrey, GU22 8QY. Similar specialist suppliers may be found in many countries, and camera clubs are often a good source of this sort of information.

Results can be rewarding, however, the film providing in many cases very bright and 'unreal' colours. For best results use deeply coloured filters on your camera lens. There are no hard and fast rules as to which ones, just try them all! Many of the deeply coloured 'contrast' filters used for black-and-white photography provide the best results. Try the deep reds, greens, blues and yellows.

IN BLACK-AND-WHITE PHOTOGRAPHY

Many of the techniques used for colour, such as multiple exposure, sandwiching negatives and copy manipulations, can be applied to monochrome equally as well. Even infra-red film is available in black and white. All the same comments apply to black-and-white infra-red film as those for colour, except that for true infra-red effects only a very deep red filter should be used. Kodak produce a filter specially for use with this film, or you could use the Hoya R72 filter. These filters, however, are so dark that it will be necessary to view and focus *before* fitting the filter if using an SLR camera.

Black-and-white infra-red film may be developed in most ordinary film developers, such as Kodak D76 or Ilford ID-11. The negatives appear extremely dense and are also very grainy indeed.

Results with black-and-white infra-red film are equally as striking as those obtained with IR colour film, perhaps even more so. However,

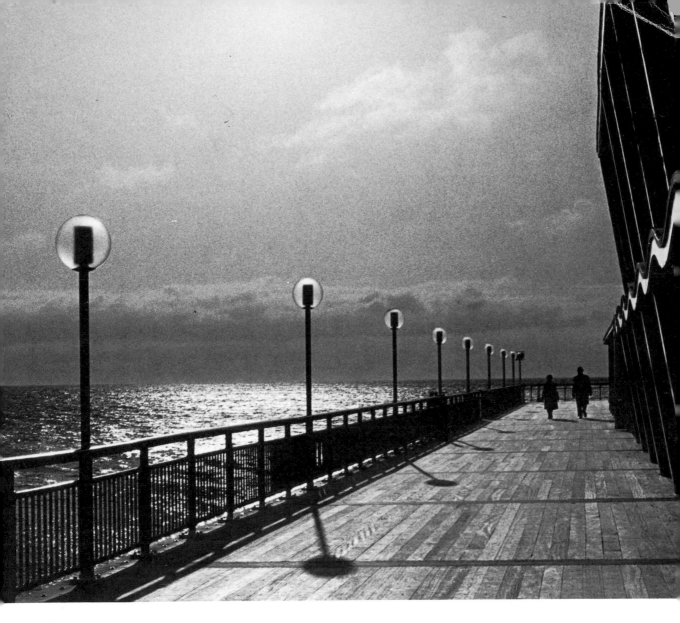

Monochrome is far more versatile than colour through the extra control which is available during printing. It is a simple matter, with experience, to alter totally the character of a scene by burning in and shading. Picture by John Pollock

results are difficult to predict as they tend to rely to an extent on the amount of infra-red radiation given off or reflected by different objects.

Sabattier Effect This effect, created quite simply by re-exposing a print to light during development, can provide very interesting results with the right choice of subject matter. Although the technique is quite unpredictable, it is in fact very easy to achieve.

Start by making a print in the normal way, but preferably on a hard grade of printing paper. During development, re-expose the partly developed image to light for a very brief moment, and then complete the development. This re-exposure is most easily carried out by placing the developing dish on the baseboard of your enlarger and, without a negative in the negative carrier, quickly flashing the enlarger lamp on

and off. The final effect can be varied depending on the duration of the re-exposure and the stage of development reached when the re-exposure is carried out.

The result of this technique is a part-negative, part-positive image, and the darker elements of the picture will have thin light-toned lines around the edges. These are known as 'Mackie Lines' and are a well-known characteristic of the Sabattier Effect.

High-Contrast Images Lith or line film can be used to provide very high contrast images of stark black and white, with no intermediate half tones whatsoever. This sort of treatment can provide extremely bold and graphic results with the right choice of subject matter.

These types of film are available in 5×4in sheet film, and whatever format camera you work with, this is the best size to use. The technique is very easy to master and no special knowledge or extra equipment is required beyond your normal darkroom equipment.

Choose a negative from your files which you feel will be suitable for this technique and make a 'contact print' onto a sheet of lith or line film. This material can be used just like normal printing paper. Being orthochromatic it is not sensitive to red or orange, and can therefore be safely used in normal black-and-white safelighting conditions. Place your negative in close contact, emulsion to emulsion, with the sheet of lith or line film and cover with a sheet of plate glass. These films have a notch on one edge of them so that it is possible to determine which is the emulsion side of the material. When this notch is positioned at the top right-hand corner of the film, the emulsion side will be facing you. Now make a test strip in the normal way to determine correct exposure, followed by a normal contact print on a fresh sheet of film. This will provide you with a high-contrast 'positive' image. Once this has been fixed, washed and dried in the normal way, repeat the procedure on another sheet of lith or line film using the positive to make a final high-contrast negative. You can now make high-contrast prints of stark black and white directly from this lith negative. Alternatively, you could produce 'line-drawing' effects by sandwiching together, slightly out of register, the high-contrast negative and positive. Tape the two together so that you can see the image as a thin outline and print as normal, using a glass negative-carrier to ensure that the two thicknesses of film are held in close contact with each other.

Combining Images Very effective results can be produced by combining two or more images together. This can be achieved by multiple printing, when two or more negatives are printed onto a single sheet of printing paper, using simple card masks to protect one part of the printing paper while another part is printed in.

Make a simple 'master sketch' to determine how the separate images are to be positioned, and then cut out the shapes from pieces of thin

Lith film The light-sensitive emulsion side of lith film may easily be identified in the dark by the film's 'notching'. When the sheet of film is held before you with the notch in the top right hand corner, the surface facing you (*A*) will be the emulsion side.

Pos **Neg**

Lith film High-contrast lith film positive and negative.

opaque card. Using the master sketch to set up each negative, print in the first image while shading the area of printing paper reserved for the second image with the card mask. Now replace your master sketch over the sheet of printing paper and use this to set up the second negative. Print this part in while shading the area previously printed with the second card mask. Keep the masks positioned slightly above the surface of the printing paper, and keep each mask slightly on the move while printing to avoid any hard edges.

A much easier way to combine images is to use the technique of montage. This simply means the physical cutting up of two or more finished prints and their re-assembly to make one single image.

It is usually best to start by printing the 'background' picture. Once this is washed and dried, use it as a guide to scale when setting up the other negative to print the separate picture elements. Once all these separate elements are printed, mount the background print onto a piece of card. Now carefully cut out each of the separate elements using a sharp scalpel. Sandpaper the back of these around all of the edges to help them to lie as flat as possible when mounted and, using a spray-on adhesive, which permits some degree of re-positioning to be carried out, carefully mount the separate picture elements into position on the background print. Once this work is complete, carry out any retouching which may be necessary and copy the montage to produce a master negative from which any subsequent prints may be produced. This will also help to disguise any small faults or retouching.

5 · Night Photography

Anyone who chooses to restrict their photography only to the convenient hours of daylight will find that they are missing out on the extra potential for exciting photographs which is available through night photography. Because our general way of life revolves around the normal pattern of human activity – work or business during the day and sleeping during the night – we tend to find it more difficult to put that little extra effort into altering our routine and actually to get ourselves up and out to take photographs at night. This is perhaps most difficult during the cold winter months, especially in the knowledge that nearly everyone else is comfortably tucked up in bed! However, it is rarely necessary to miss out on a complete night's sleep, as much night photography can be carried out during the evening. It is only when we require quiet and empty streets that it will be necessary to work through the more anti-social hours of the night.

No extra or special equipment is required for night photography and, indeed, all the equipment which you use during the normal daylight hours will be equally suitable for photography after dark. A slightly different technique may be required, along with perhaps a little extra care, but this is very easily mastered. So don't always put your cameras away as soon as the bright light of day begins to fail. Make that small 'extra' degree of effort. The results will be reward enough.

The Beauty Of Dusk

Much of the best 'night' photography is produced by shooting not at night, but at dusk. Just after the sun has set, and before complete darkness descends, there is this beautiful period of dusk, when there still remains some small trace of light in the early night sky. This is, without doubt, the best time to produce 'night' shots. Once darkness completely descends, subjects seem to be isolated in a sea of blackness, but while there is still a small amount of light in the sky it is often possible to create a much more realistic impression of night-time atmosphere, the sky still providing some degree of tone or colour.

When photographing the urban landscape, working during the period of dusk makes it possible to provide a much better lighting balance between buildings and sky, and the subject will not appear so isolated. If working with colour film, the sky can sometimes provide a

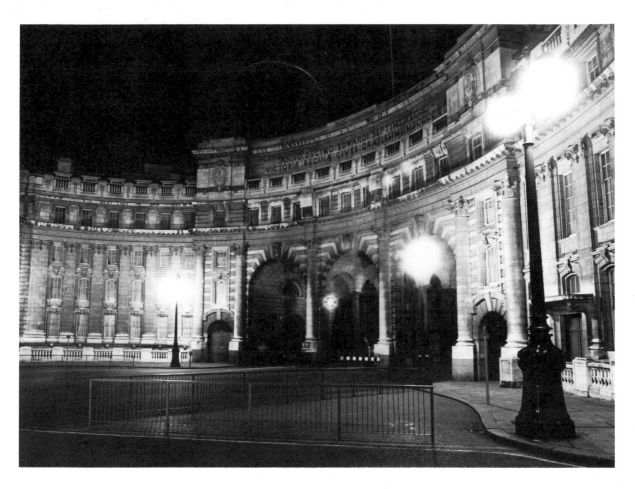

Admiralty Arch, London. Even a major city like London can seem strangely empty when photographed in the early hours of the morning. Taken at 3.30 a.m. Sunday morning. *Olympus OM1n, 21mm lens, 4 seconds at f11 – Ilford FP4 ISO 125/22.* Picture by David Chamberlain

very attractive range of colours to complement the urban scene and the sky may often change from rich reds, oranges or pinks, through to light violets and deep rich blues. Even with monochrome, there are still some benefits to working at dusk. Contrast will not be quite so high as when total darkness falls, and some tone will remain in the sky, enabling the shapes of buildings and other structures to stand out more boldly against the sky-line.

The Urban Scene After Dark

After dark, and particularly during the hours of late night or early morning, the urban landscape takes on a strange and 'empty' atmosphere. Gone is the hustle and bustle of daily life. Streets and buildings seem very different indeed, once all the human beings are asleep. Even some of the largest and busiest of cities can appear strangely empty during the very early hours of the morning which most of us would still refer to as 'night'.

By working during these somewhat anti-social hours, it is possible to 'see' the city in a way which would simply not be possible at any other time and, if we can force ourselves to stay awake to take advantage of this

situation, the results of our efforts can be most striking and highly rewarding.

When working in the depth of night, it is best to concentrate your attentions on the city's structure. Try to avoid including the sky if at all possible, as this will only record as a great black void, rarely 'adding' anything to your pictures. A large city after dark may take on a 'mood' of its own, with a totally different character to that found during the daylight hours. This mood or atmosphere may take many forms and, depending to some extent on how you 'see' it yourself, might be translated as romantic, peaceful, eerie or forbidding. Try to make a point of creating your own impression of the city in your photographs. Do, however, try to work quietly. It is not very fair to disturb the sleep of other people who may very well have to get up to go to work in a few hours' time. Also, do carry some form of identification. This might save you a great deal of difficult explaining if you should be questioned by inquisitive policemen!

Exposure – Problems And Solutions

LONG EXPOSURES

Long exposure times simply have to be accepted when taking photographs at night, and even with 'fast' films, exposure times may often run into several seconds. Strangely, photographers often seem reluctant to use exposure times longer than those conveniently marked as 'speeds' on the camera's shutter-speed dial. This may be perfectly all right with some cameras which have a shutter-speed range extending to 4 or perhaps even 8 seconds, but many cameras have a longest shutter speed of only 1 second. In this case, you must use the 'T' (time) or 'B' (brief) settings on your camera. These settings permit the camera's shutter to be held open for periods much longer than that provided by the camera's slowest shutter speed and, indeed, can be used to obtain exposure times which run into minutes, or even hours, if necessary!

When using the 'T' setting, the camera's shutter will remain open once tripped, until either the film is advanced or the shutter-speed dial is moved off the 'T' setting, so terminating the exposure. Using the 'B' setting, the camera's shutter will open on depressing the shutter-release button and will remain open as long as the shutter-release button remains depressed. As soon as the button is released, the shutter will immediately close. Not all cameras have a 'T' setting, and in this case it will be necessary to use a 'locking' cable release with the camera set to 'B'. Once the shutter has been tripped, using the cable release, 'lock' the cable in the depressed position using the special locking facility provided. Once the exposure time is completed, simply unlock the cable release to close the camera's shutter and terminate the exposure.

Never be tempted to 'cut corners' with night-time exposures. If a picture requires good depth of field, be prepared to give a long exposure

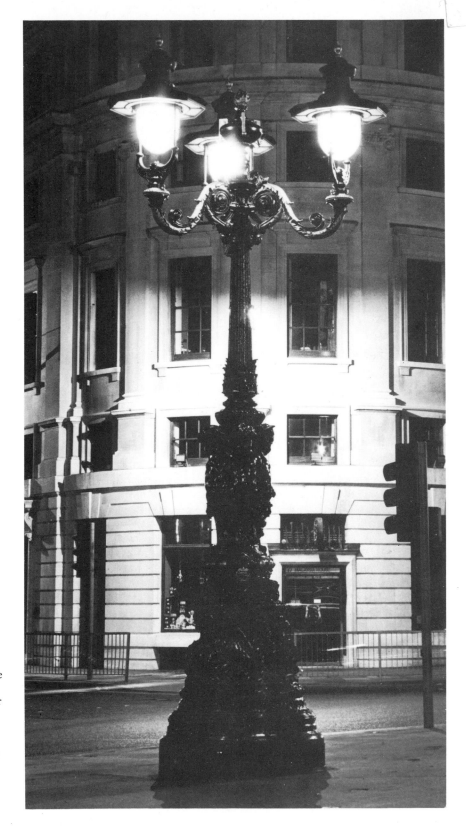

Unless the tops of buildings are well lit try to avoid including large areas of black sky in your night shots. Concentrate instead on interesting city detail, such as this ornamental street light at Trafalgar Square in London. *Olympus OM1n, 35–70mm zoom, 15 seconds at f16 – Ilford FP4 ISO 125/22.* Picture by David Chamberlain

Camera supports (a) Tripod (b) Monopod and (c) Bean-bag.

at an aperture which is small enough to provide the required amount of depth of field. There is really very little difference between waiting for a 30 second or a 1 second exposure to be carried out and, as even a fast film may require an exposure of several seconds, there is little point in using such a film merely to keep exposure times to a minimum. You might just as well use a more fine-grained 'medium-speed' film, and accept a somewhat longer exposure! Let the subject decide. Of course, if your intended photograph incorporates an element of subject movement which must be minimised, or if perhaps a stiff breeze is likely to cause camera movement, by all means use a faster film to provide shorter exposures. It is for you to examine and assess each picture-taking opportunity individually to arrive at the correct decision to provide the right balance of interests.

Camera Supports Long exposures make it absolutely essential to provide some form of totally static support for the camera if you are not to obtain results which are spoiled by camera shake. Do not think for one moment that it is possible to hand-hold your camera for long exposures. Any exposure time longer than 1/125 of a second will benefit from the use of some form of camera support, and in no way should you ever consider hand-holding for an exposure of 1/30 of a second or more. A

Some pictures are 'essentially' colour pictures. This shot would be much less effective in black-and-white. (See Chapter 4.) *Contax RTS, 50mm lens – Agfachrome 100.* Picture by David Chamberlain

camera support is useful even for daylight photography, but for night photography, it is indispensable.

For night photography and the long exposures that this entails, there is really only one totally satisfactory type of camera support – a good sturdy tripod. Without a doubt, the heavier and more rigid the tripod, the better. However, there has to be some sort of compromise in respect of weight and size. The tripod does of course have to be carried with you, and it would of course be foolish to attempt to carry a very large and heavy 'studio' type of tripod around the city streets! However, if you are to get the most out of night photography, you must be prepared to use the sturdiest and heaviest tripod which you can comfortably carry.

Choosing a tripod can be a little difficult in itself, as there are many different types available. Some are more suitable for outside use than others, and some models offer greater versatility than others. As a general guide, however, the models which have the least number of sections to their legs usually provide the highest degree of stability. A geared centre column which can be securely locked at any chosen height is a very useful feature. The tripod head should permit the camera to be securely locked in any position, and at any angle. Some tripods have a 'head' which operates through a system of locking handles, and this is normally very secure indeed. Quicker to use, perhaps, is the ball-and-socket type head. Such a head allows the camera to be quickly and easily positioned at the desired angle and locked into position *via* a single clamp. However, do avoid the cheaper versions of this type of head as they are rarely secure. Good ball-and-socket heads are quite expensive.

A very useful aid to stability found on many tripods is leg braces. These are only truly effective, however, if they are securely mounted to the centre column. Better-quality tripods often incorporate a leg-brace system which is adjustable, and such a system is much better, as it enables the tripod legs to be positioned more easily. This is particularly important when working on a steep slope or other unlevel ground.

The simple bean-bag is a very useful and convenient type of camera support. Taking up very little room in the gadget bag, it is very easily transported and requires no 'setting up.' The bean-bag is simply a cloth bag filled with small but fairly heavy particles such as dried beans, lentils etc. Positioned on a convenient wall etc, the camera is simply 'nestled' into it, to provide a stable 'base' for the camera. However, this does present the problem of having to find something on which to place the bean-bag, and such objects are not always quite so conveniently positioned!

Another type of camera support, which might at first appear almost ideal, is the monopod. This is rather like a single leg of a tripod, usually fitted with a simple ball-and-socket type head to which the camera is mounted.

Although a monopod will assist with vertical stability (up-and-down movement), its ability to control lateral (sideways) movement is much

Gossen Lunasix-3 exposure meter Highly sensitive hand-held exposure meters, such as this Gossen Lunasix-3, are capable of taking accurate readings even in dim moonlight. Picture by David Chamberlain

less effective and it cannot therefore be seriously considered for night-time use, when very long exposures may often be necessary.

EXPOSURE READINGS IN LOW LIGHT

Exposure-meter readings for night photography are taken in much the same way as when working during daylight hours. However, you will require an exposure meter which is sensitive enough to record readings in very low light.

CdS (cadmium sulphide) or SPD (silicon photo diode) cells are much more sensitive to low light levels than the old type of selenium cell, but some TTL metering systems which use these cells are still not sensitive enough for very low light readings. In many cases, it is better to use a good-quality separate hand-held meter of the CdS or SPD type, as these are often capable of taking accurate readings even in dim moonlight.

If you don't have one of these separate exposure meters, you can use your camera's TTL metering to take a substitute reading from a piece of white card placed in the same position as the subject. Take your reading from close up, so that the white card fills the frame of your camera's viewfinder. You may then use the reading thus obtained to estimate the 'correct' exposure. Simply give $2\frac{1}{2}$ f-stops more exposure than that indicated by the white card reading, i.e. if the indicated white card

NIGHT PHOTOGRAPHY EXPOSURE GUIDE

Subject/Lighting	Exposures with ISO 400/27 film		Subject/Lighting	Exposures with ISO 400/27 film	
Floodlit buildings (White light)	1/60	f2	Street scene (Dimly lit)	1/30	f2
	1/30	f2.8		1/15	f2.8
	1/15	f4		1/8	f4
	1/8	f5.6		1/4	f5.6
	1/4	f8		1/2	f8
	1/2	f11		1 sec	f11
	1 sec	f16		2 sec	f16
Floodlit buildings (Coloured lights)	1/30	f2	Shop windows (lit)	1/125	f2
	1/15	f2.8		1/60	f2.8
	1/8	f4		1/30	f4
	1/4	f5.6		1/15	f5.6
	1/2	f8		1/8	f8
	1 sec	f11		1/4	f11
	2 sec	f16		1/2	f16
Street scene (Brightly lit)	1/125	f2	Neon lights	1/250	f2
	1/60	f2.8		1/125	f2.8
	1/30	f4		1/60	f4
	1/15	f5.6		1/30	f5.6
	1/8	f8		1/15	f8
	1/4	f11		1/8	f11
	1/2	f16		1/4	f16

Exposure times of 1 second or longer may require extending to compensate for reciprocity-law failure – see film notes on data sheet which accompanies most films for details.

reading was 1/15 of a second at f5.6, you should expose for 1/15 of a second at between f2 and f2.8. Alternatively, you could increase exposure by using a combination of altering both the shutter speed and the aperture, i.e. open up the aperture by only a $\frac{1}{2}$ f-stop and select a speed which is two shutter speeds slower – $\frac{1}{4}$ of a second instead of 1/15.

The biggest problem with exposure-meter readings at night is that of excessively high subject contrast. You may sometimes be able to get over this by taking two separate readings – one for the highlights and one for the shadows – and selecting a setting midway between these two extremes. However, contrast is often so extreme that you will sometimes have to make a decision about which is most important, highlight or shadow detail, and decrease or increase exposure accordingly.

Satisfactory results can be obtained without an exposure meter, simply by following the guidelines for night-time exposures on the chart provided (p.97).

RECIPROCITY-LAW FAILURE

Another problem you will often encounter with night photography and the inherently low light levels that this will undoubtedly entail, is that of reciprocity-law failure. Some consideration of this is essential if you are to achieve satisfactory results with long exposure times.

First, let me clarify exactly what is meant by the term 'reciprocity law'. Photographic exposure is achieved by permitting a certain light intensity to act on a light-sensitive film emulsion for a specified exposure time. According to the reciprocity law, providing the exposure remains constant in relation to light intensity and time of exposure, the emulsion's response will be the same, i.e. double the light intensity will require the exposure time to be halved, or half the light intensity will require the exposure time to be doubled, to produce the same relative density on the negative.

Unfortunately, photographic film emulsions do not always adhere to this convenient rule, and most films are sensitive only to illumination of a specific intensity. When this light intensity deviates considerably from this 'ideal', the reciprocity law no longer holds true. Very low light levels which require long exposures or, indeed, very high light levels requiring extremely brief exposures produce much less effect on the film's emulsion. In such cases, it will often be necessary to increase exposure, sometimes far beyond that which may be indicated as 'correct' by your exposure meter. It is generally the low-light-intensity reciprocity-law failure which affects us most, and most certainly in the case of night photography.

Comparatively short exposure times may cause reciprocity-law failure with black-and-white film emulsions and, with some types of film, an indicated exposure of only 1 second may actually require a true exposure of 2 seconds. Longer indicated exposures may require a proportionally much larger increase in exposure compensation when,

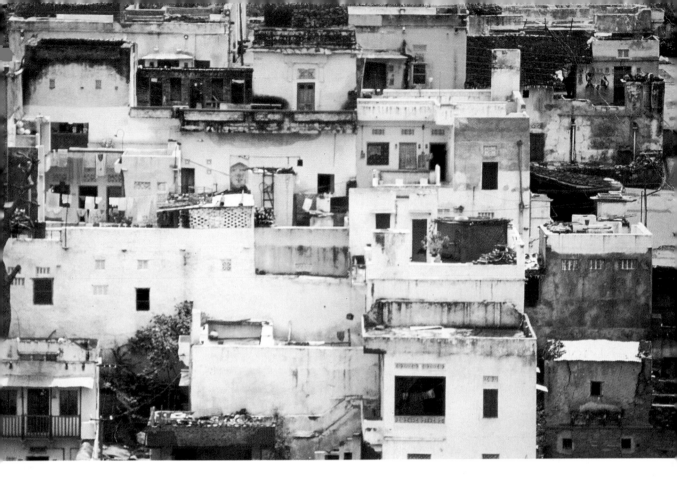

At first glance the picture looks almost abstract, but colour can be important in capturing the harsh reality of urban life, as in this shot of the slum terraces of Udaipur, Rajasthan. *Olympus, 70–200mm zoom – Agfa 100*. Picture by Abdus Sookia

for instance, an indicated reading of $1\frac{1}{2}$ minutes (90 seconds) might require an actual exposure of $16\frac{1}{2}$ minutes (990 seconds).

Colour film is affected in much the same way, but with these cmulsions thcrc is an additional problem – colour balance. Reciprocity-law failure may produce strange colour shifts during long exposure times. Although this may be corrected by using colour-correction filters over the camera's lens, the colour shifts are most unpredictable and the task is therefore made that much more difficult. Most film manufacturers provide information with their products regarding any necessary exposure compensation, or colour correction, which may be necessary through reciprocity-law failure.

FAST FILMS

Exposure times may be considerably shortened by using films which have a higher emulsion speed (greater sensitivity). Such films are available in black and white with film-speed settings from ISO 400/27 to ISO 1250/32, colour negative with speeds from ISO 400/27 to ISO 1600/33, and colour-reversal materials from ISO 400/27 to ISO 1000/31. Besides providing the potential for shorter exposures, fast films also provide an opportunity to use smaller lens apertures for increased depth of field. Such virtues, it might seem, would make fast films an ideal

choice for night photography. However, there is a price to pay. This comes in the form of increased graininess and results which are somewhat less than sharp when compared to those of slower films. However, a slightly grainy result, which is perhaps only a little less sharp than that from slower films, is often better than no result at all. If you have any element of subject movement within your picture, or if there is a chance of camera movement, you may have no alternative other than to use one of these faster emulsions.

Generally, the faster the speed of the film, the more grainy the result will be, with subsequent loss of sharpness. This applies equally to both colour and black-and-white films. The type of equipment you use may have some influence on your choice of fast film and, indeed, the type of result you achieve. 35mm workers will have to content themselves with the slower of these fast films unless they wish to make the 'graininess' of the film an important element of the picture. Films in the ISO 400/27 speed range are still capable of producing high-quality results with the 35mm format, but go much faster than this and it will almost certainly be necessary to accept very large and obvious grain. In such a case, it is best to take pictures where the grain can become an essential 'feature' of the picture, actually adding something by way of mood or atmosphere.

The medium-format user does not experience quite the same problems through graininess. In fact, it may be quite difficult for the medium-format photographer to use grain for pictorial effect, particularly with the larger medium formats, such as 6×7cm. With such large negative sizes, requiring much less enlargement, grain is rarely obtrusive. Grain, even on a quite large print, may be barely noticeable on a print produced from a good-sized medium-format negative. Indeed, if the medium-format worker wishes to utilise grain as a pictorial feature, it may often prove necessary to select a small section from his negative and to use this to make his print!

PUSH PROCESSING

Push processing a fast film to further increase film speed is a very useful technique which can enable photographs to be taken in very low light, when photography with normal fast films might not be possible. The technique can also be useful for creative or pictorial effect through the increased contrast and graininess which this technique produces.

Having said this, however, I must now make an apparently contradictory statement. In practical terms it is not possible to extract extra 'speed' from a film's emulsion by push processing or, indeed, by any other method. All that is possible, and it is this which is commonly referred to as 'push processing', is to knowingly and deliberately underexpose a film and then compensate for this by giving the film extended development. This does *not* impart any extra speed or sensitivity to the film's emulsion. Quite simply, what happens is that, during this extended development, the light-sensitive silver-halide

Shop-window displays can provide some very interesting subject matter and, with skilled printing, it is possible to modify or improve the original effect created by the display designer. Expensive sophisticated cameras are not necessary for such photographs. This picture was taken on a quite basic 35mm compact camera. *Olympus Trip, 35mm compact – Ilford HP5 at El 800*. Picture by John Disdale

grains are developed almost to exhaustion, including those which received only very little light. This improves the rendering of detail in the poorly-lit shadow areas and provides us with an 'apparent' increase in film speed.

Rarely is anything quite that simple, however, and, as with most things, for every 'gain' there is usually also a 'loss'. In this case, the losses are actually unwanted gains. Grain is increased, usually quite considerably, and so too is contrast.

So what is the value of such a technique? If push processing can only provide inferior results, is it really worth the effort? The answer to these questions must surely be *yes!* I am sure almost every photographer must have experienced the situation of being confronted by a potentially interesting picture when the lighting level is too low for a satisfactory exposure to be made – even with a normal 'fast' film. Other than using flash, which in many cases would destroy the atmosphere of a picture, there really is little choice other than uprating the speed of your film and 'push processing'.

The characteristics brought about by push processing can often be used to provide pictorial effect or impact. In this case, try to turn the inherent shortcomings into a bonus. Use the large grain and increased contrast as important elements within your composition to enhance the mood or atmosphere of the scene.

Nearly all fast films are suitable for push processing, black-and-white or colour. Black-and-white films, such as Kodak Tri-X or Ilford HP5, which have a normal speed rating of ISO 400/27, may be pushed to a 'speed' or exposure index (EI) of up to EI 3200 or even EI 6400, using a

suitable developer with extended development. Many general purpose 'fine-grain' developers are suitable for push processing, such as Kodak D76 or Ilford ID-11. There are, however, certain types of developer which are specially formulated for such techniques. Even some print developers may be suitable for push processing films.

Colour films are easily push processed simply by extending the first development time. With colour-transparency materials, be sure to extend the first development only. The colour-development time should remain the same as that for the standard film speed. Many chemical kits for colour processing also include instructions for push processing.

Colour Photography At Night

Colour photography at night, particularly with urban landscape work, relies for its success on the abundance of brightly coloured neon or other artificial lighting. However, always keep a look-out for more subtly lit scenes. Even scenes illuminated only by moonlight can provide very attractive results. It is not always necessary to incorporate bright or powerful colours into your night photographs, and quite often muted or more gentle colours can be equally as effective as bright ones.

COLOUR FILMS

Basically there are only two choices in film type available to the colour-worker – colour negative, for producing prints, or colour reversal, for transparencies. Your own choice will usually depend on which you prefer – prints or slides. However, you should also stop to consider that the colour-print worker has an additional stage in the process at which some extra 'control' is possible. To obtain the finished picture, a print has to be made from the negative. This provides the colour-negative worker with an opportunity to control or alter the final image by increasing or decreasing print density, or, more importantly, it provides a chance to manipulate the actual colour balance of the final result. If, for example, the original scene has recorded too yellow, it is quite a simple matter to filter this out, at least to some degree, when making the print, using the dial-in filtration of a colour enlarger. Of course, if you don't print your own work you will have to rely on your instructions being followed or interpreted correctly by a commercial processing company. Such extra control is not available to the person who prefers colour slides. However, you can, if you wish, still make prints from colour transparencies by printing on one of the positive printing papers, such as Cibachrome or Kodak Ektachrome 22, when you will have available the same degree of control as that available to the colour worker.

Daylight-Balanced Colour Film Colour films designed specifically for use in daylight or with electronic flash are known as 'daylight-balanced' films. Although such films are balanced to produce their most neutral colour balance during the middle hours of daytime sunlight, they

Some care is required with the use of filters for colour photography. Avoid 'obvious' effects or strong colours, unless it really suits the subject. Graduated filters – used subtly – can improve shots taken on dull 'grey' days. Two graduated filters were used for this picture of the Severn Bridge, which links South Wales to mainland England – a light yellow for the top and a pale mauve for the lower part. *Olympus OM1n, 75–150mm zoom with Cokin filters – Kodak Ektachrome 100.* Picture by David Chamberlain

can be used successfully for night-time photography. In the strange night-time world of artificial lighting, often found in large cities or towns, most colours will record very 'warm' on this type of film. Although certainly not recommended for those times when colour accuracy is required, this deliberate mis-matching of film type and light source can produce some extremely attractive pictorial results.

Although very strong colours, such as brightly coloured neon lights or other display lighting, will be little affected by using daylight-balanced film, the more subtle colours will be more noticeably affected. Most fluorescent lighting produces a very strong green cast on daylight film, whereas most tungsten or sodium-vapour lamps produce a yellow cast. It is often possible to find a situation where your picture may contain several different mixed light sources and this can produce some very striking results indeed.

Tungsten-Balanced Colour Film Colour films balanced for tungsten lighting are designed to produce their most neutral colour balance under tungsten artificial lighting. However, as the actual colour balance of such light sources may vary quite widely with different types of tungsten

lighting, the use of tungsten-balanced film alone will not automatically guarantee perfectly neutral results. In general, however, your night-time colour photographs will not exhibit such a strong overall yellow cast and may therefore appear somewhat more natural.

Certain light sources, such as mercury vapour, sodium vapour or fluorescent lights, will still produce quite pronounced colour casts, even with tungsten-balanced film. For night-time urban landscape photography, there may therefore be little real advantage in using either daylight- or tungsten-balanced materials and, consequently, the decision on which types of film to use may simply depend on your own personal preference.

COLOUR CORRECTION/CONVERSION FILTERS

If you want your night-time urban landscape pictures to be as near to neutral in colour balance as possible, you will have to use either colour-correction or colour-conversion filters. These are used just like any other filter, fitted in front of your camera's lens, and are used to compensate for the unusual colour temperature of artificial light sources.

Colour-correction filters are commonly used to 'correct' the 'cooler' or 'warmer' colours that exist with early morning and late afternoon daylight respectively, helping to obtain a neutral colour balance similar to that which a daylight-balanced colour film is designed for. However, these filters can also be used to either warm up or cool down an urban night-time scene illuminated by artificial light, or even moonlight.

These filters are available in two different colour tints – a yellowish tint and a bluish tint. Quite simply, if the colour balance of your proposed picture is too warm (yellowish), you can fit a blue-tinted filter to 'cool' the colour cast or, if the scene is too cool (bluish), you can fit a yellow-tinted filter to warm it up.

Artificial light sources which produce stronger colour casts may require the use of colour-compensating (CC) filters. These are available both in additive primary colours – red, blue and green – and complementary colours – cyan, yellow and magenta. These filters may be used to compensate for many different light sources, but to use them successfully you really need to use them with a colour-temperature meter. Unlike an ordinary exposure meter, a colour-temperature meter does not read the intensity of the light, but the actual colour of it (colour temperature).

One of the most commonly encountered artificial light sources is fluorescent lighting. Although you can purchase a special filter for use with fluorescent lighting, in practice such lights have large variations in their colour temperatures, depending on the type of tube and its age. For this reason, it is often better to work with the separate colour-compensating filters as a greater degree of correction may be possible in this way. If you don't have a colour-temperature meter, refer to the Colour-Correction Filter Chart on p.105. This will provide satisfactory

Slow shutter speeds at night can produce interesting effects with traffic movement, the lights of which will record as trails of light across the film. *Olympus OM1n, 28mm lens, 8 seconds at f11 – Ilford FP4 ISO 125/22. Picture by David Chamberlain*

results with most types of fluorescent lighting and with both daylight- or tungsten-balanced film.

COLOUR-CORRECTION FILTER CHARTS

BALANCING FILM TYPE TO LIGHT SOURCE

Film Type	Light Source					
	Daylight 5500 K	f-stop increase	Tungsten 3200 K	f-stop increase	Photolamp 3400 K	f-stop increase
Daylight	No filter	None	80A	+2	80B	$+1\frac{1}{2}$
Tungsten	85B	$+\frac{1}{2}$	No filter	None	81A	$+\frac{1}{2}$

FILTERS AND EXPOSURE COMPENSATION FOR FLUORESCENT LIGHT SOURCES

Lamp type	Filter(s) for daylight film	f-stop increase	Filter(s) for tungsten film	f-stop increase
Daylight	40M + 30Y	+1	85B + 30M + 10Y	$+1\frac{1}{2}$
Cool White	30M	$+\frac{1}{2}$	50M + 60Y	$+1\frac{1}{2}$
Cool White Deluxe	30C + 20M	+1	10M + 30Y	$+\frac{1}{2}$
White	20C + 30M	+1	40M + 40Y	+1
Warm White	40C + 30M	$+1\frac{1}{2}$	30M + 20Y	+1
Warm White Deluxe	60C + 30M	$+1\frac{1}{2}$	10Y	$+\frac{1}{2}$

With mixed lighting, which may perhaps incorporate several different types of light source, there is very little that one can do to 'correct' for all the different colour casts which are likely to be present. In this case it is usually best to forget all about trying to correct the colour balance, and content yourself with using the mixed lighting and different colour casts for pictorial effect.

You can even mix the lighting further yourself by illuminating a part of the scene, perhaps some foreground interest, by using electronic flash. This can be most effective, especially when using daylight-balanced colour film, providing a foreground element, which is correctly balanced for colour, set against the very artificial colours of city lights in the background. Illuminated shop-window displays, street lights and neon strip-lighting, can all be used to produce very interesting results, with lots of colour impact, for your night-time urban landscapes.

Exposures By Moonlight

Exposures are possible even in quite dim moonlight on both colour and monochrome films. However, exposure times will be very long indeed. A tripod will be absolutely essential, and you will have to give some consideration to reciprocity-law failure whether working with black-and-white or colour film.

To estimate exposures under such dull lighting you will need a highly sensitive CdS (cadmium sulphide) or SPD (silicon) exposure meter. This will almost certainly mean working with one of the separate 'hand-held' types of meter. However, if you do not have such a meter, I have provided a chart which can be used to assess almost any type of night-time exposure, and this will provide perfectly acceptable results under most circumstances. If working with a separate hand-held meter, you will almost certainly have to take your meter readings by the reflected-light reading method, as there will rarely be enough light to make incident-light readings possible.

Exposures by very dim moonlight can sometimes run into an hour or more and, with colour film, you are almost certain to experience colour-balance shifts through reciprocity-law failure. Although you can compensate for this to some extent by using colour-correction or conversion filters, it will be quite impossible to achieve a perfectly neutral colour balance. This, you will just have to accept.

Another problem which you may encounter is that of the moon itself, or stars, causing light trails across the sky due to the movement of the earth revolving on its axis. The only way that you can avoid this problem is to either try to keep exposures to a minimum by using a fast film and large lens apertures, or avoid including the night sky in your pictures.

Traffic Movement

Very effective results can be achieved at night by incorporating traffic

movement in your pictures. Using a long exposure, the headlights and tail-lights of passing traffic will record as streaks of light across your picture.

This is a very easy effect to achieve. Simply place your camera on a tripod and expose for the scene itself using the methods described earlier. Select an aperture which will require an exposure time of between 4 and 30 seconds, depending on how much traffic there is. If cars are only passing by very occasionally, you will obviously require a longer exposure time to ensure capturing some light trails on the film. If, on the other hand, traffic is very heavy, with cars rushing by continuously, you will require a shorter exposure to avoid the light trails becoming merely a burnt-out mess.

Special Problems With Night Photography

Working at night does present a few special problems. Mostly, however, these are very simple and inexpensive to solve.

Quite obvious, but easy to forget, is that it may be difficult to see exactly what you are doing. Camera controls which are quite easy to use during the daytime can become, quite literally, a nightmare to use in the dark. Furthermore, you can only appreciate how frustrating it is to be desperately searching for a small accessory in the bottom of your gadget bag in the dark when you have experienced it. Take a small torch with you. It will save you lots of trouble and make working in the dark less of a chore.

During some months, night-times can be very cold. Today's cameras depend heavily on their batteries for most of their functions, and without a healthy battery many cameras are as good as dead. Cold temperatures greatly reduce the power of your batteries, and an extended night of picture-taking in cold conditions may result in your battery losing so much power that the camera will no longer operate. Keep your batteries as warm as possible. Some cameras have a remote battery holder available which may be kept in your pocket, helping to keep the batteries warm and effective. The remote battery holder is connected to the camera's battery compartment by a short flexible lead. If no such remote battery holder is available for your camera, try keeping the camera warm in between taking pictures; alternatively, remove the batteries and keep them on your person between picture-taking activities.

Beyond this, keep yourself warm – *and safe!* The need for warm clothing should be quite obvious, for you will certainly not feel very much like taking pictures unless you are both warm and comfortable. You should also take steps to ensure your own safety. Wear something light, or bright, in colour if possible – even special reflective safety clothing. It is very easy to become so involved in what you are doing that you may not notice an approaching car or lorry. Wearing something light in colour will at least ensure that you can be seen.

6 · Choosing and Using Lenses

One of the biggest advantages of cameras which feature the facility for interchangeable lenses is the extra 'image' control which this makes possible. Single-lens-reflex cameras in particular often have a vast range of lenses of different focal lengths available, from ultra wide angle to super telephoto, making it possible to exercise considerable control over the final image which is recorded on the film.

The most obvious aspect of different types of lenses is that of focal length. However, it is not this aspect alone which provides the difference in results between the different lens types. Angle of acceptance (or angle of view) is the most important consideration, and this will vary with any given focal length of lens, depending on the format to which it is related. For example, a 50mm lens used on a 35mm camera will provide an angle of acceptance of about 46°. Such a lens is considered 'standard' on the 35mm format, providing an angle of view similar to that 'seen' by the human eye. However, if the same focal length is used with a larger format – say 6 × 7cm – the angle of acceptance would then be approximately 82° – wide angle. This is why a larger format requires a longer-focal-length 'standard' lens – 90mm to 110mm for the 6 × 7cm format – producing an angle of view of about 53° to 43°. With the 35mm format, such a lens would be considered a short-telephoto lens, producing an angle of view of only about 27°. It is this difference in the angle of view which provides us with the ability to obtain either a reduction in image scale (with wide-angle lenses) or a magnification (with longer-focal-length lenses). This in turn makes it possible for us to manipulate the image to some extent at the picture-taking stage, to alter the apparent scale of different parts of a scene and, ultimately, the perspective.

These apparent changes in scale are not caused by the actual lens itself, however, but more by the different viewpoint which a particular lens may permit us to use. For instance, the characteristic 'wide-angle' effect of enlarged foreground objects set against a diminished distant scene is only created through the exceptionally close viewpoint which such a lens enables us to take up. Try taking up a similar position using only your eyes. Position something in the foreground very close to yourself. You will see that the effect is really little different to that produced by a wide-angle lens. The object in the immediate foreground will appear disproportionally large in comparison to the more distant objects. The

Any camera is useless without a lens and it is the vast range of lenses which are available for SLR (single-lens-reflex) cameras which ultimately makes them supremely versatile. Illustrated are some of the lenses which make up the Pentax 6 × 7 system. Photo courtesy Pentax UK Limited

opposite occurs with long-focal-length lenses which by their nature demand a more distant viewpoint to be taken up. This creates something of an apparent compression of perspective and, with really long lenses and extremely distant viewpoints, objects in the distance may appear comparatively larger than those which are closer.

It is these very characteristics which make interchangeable lenses such valuable 'tools' for creative control. Use the various lenses which are available nowadays constructively, not merely to 'get more in' or to 'bring something closer'. With lenses, a little knowledge can go a very long way – towards making you a better and more capable photographer!

The Standard Lens

The standard lens – about 50mm on the 35mm format – provides a very similar field of view to that of the human eye. Such a lens also provides very natural perspective with little or no distortion, making it an ideal choice for all general photography. Of all the focal lengths which are available, the standard lens produces the least obtrusive results and, unless we take up an exceptionally close viewpoint, pictures taken with this lens will appear much as we 'see' them in reality.

Surprising Versatility Many amateur photographers, shortly after purchasing their first SLR camera, immediately want to rush out and buy other lenses for it. Yet it is surprising just how versatile the humble 'standard' lens can be. For a start, almost any standard lens – even a relatively inexpensive one – is an exceptionally good performer. It is relatively easy to design and manufacture a standard lens, and they are

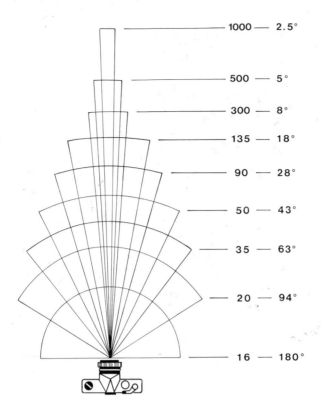

1000	2.5°
500	5°
300	8°
135	18°
90	28°
50	43°
35	63°
20	94°
16	180°

Lens focal length and respective angles of view. Focal length in millimetres, angle of view in degrees – relative to the 35mm format.

therefore usually all of very high optical quality. Most are quite fast too, with a maximum aperture of f1.7 or f1.8 being commonplace. Even lenses with a maximum aperture of f1.4 are nowadays very common, and still relatively inexpensive. Such wide apertures not only make it possible to take pictures in low-light-level situations, they also provide a much brighter image in the viewfinder of an SLR camera and, with the smaller depth of field provided by such wide apertures, this makes for much more accurate 'snappier' focusing.

It is surprising how many different types of photography can be handled successfully by the standard lens, from portraiture to land-scapes. The standard lens is ideal for urban landscape work, with its natural perspective and freedom from distortion. If at present you only have a standard lens with your camera, don't let this put you off tackling the urban scene. When I look through my own pictures, I am still often surprised just how many were taken with my camera's standard lens!

Making The Most Of Your Standard Lens To make the most of your standard lens you need do no more than use the facilities and characteristics which it quite naturally provides. Use it to record the urban scene just as it really is. Special effects or strange perspective do not 'make' a good picture on their own. Use the distortion-free characteristics of your standard lens to produce beautiful 'natural' results of extremely high quality.

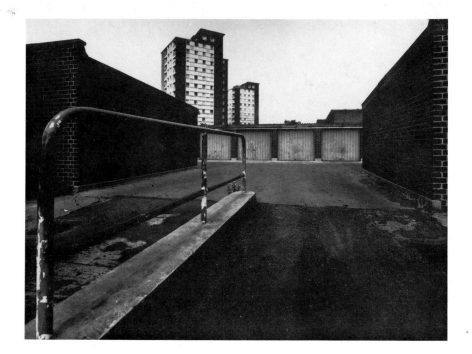

Wide-angle lenses can provide an enhanced impression of perspective and great depth of field for an 'over all' sharpness effect. *Contax RTS, 18mm lens – Ilford FP4 ISO 125/22.* Picture by David Chamberlain

Most standard lenses will provide very high-quality results at almost any aperture, so use your lens stopped right down to its minimum aperture – f16 or f22 – to provide great depth of field for results which are sharp from the immediate foreground right through to the more distant part of the scene. Alternatively, use the large maximum lens aperture to produce results with very limited depth of field, focusing selectively on one particular part of the scene so that only this is recorded sharply against an out-of-focus background. This technique is called 'differential focus', and is an extremely effective way of providing emphasis to a particular part, or small area of the scene. The wide aperture of your standard lens will also allow you to use quite fast shutter speeds. Use this facility to arrest the movement of traffic or people.

It is well worth learning to make the most of your standard lens *before* investing in further lenses of different focal lengths. I am sure you will find your standard lens to be the most useful lens you will ever own – no matter how many others you may buy in the future!

Wide-Angle Lenses

Wide-angle lenses are all those which have a shorter focal length, and consequently a wider angle of view, than your standard lens. Such lenses are not only useful for providing a means of 'getting all the subject in'. Used constructively, such lenses are extremely useful tools which may enable you to interpret a scene somewhat differently to how it may appear 'naturally' to the eye.

Wide-angle lenses are a little more difficult to design and manufacture

The great depth of field of wide-angle lenses can also be used to produce striking close-ups with interesting perspective effects. *Olympus OM1, 28mm lens – Ilford HP5 ISO 400/27*. Picture by David Chamberlain

than standard lenses and maximum apertures of such lenses are therefore frequently somewhat smaller than those of lenses of 'standard' focal length. Wide-aperture lenses are available in some manufacturer's range of wide angles, but these are often very expensive. Even a quite modest wide-angle lens, with a maximum aperture of f2 or f1.4, may cost a considerable amount of money. Extreme wide angles are almost impossible to design with very wide apertures, and such lenses are usually restricted to maximum apertures of around f2.8 to f4. Because of the extra difficulty in producing high-quality wide-angle lenses, it is usually better to buy the best that you can afford – usually one from the same company which produces your camera. In this way you can at least be certain of obtaining a good-quality lens which will produce results of an adequate standard.

Wide-angle lenses are no more and no less useful than any other type of lens. However, they can usefully extend your picture-taking activities, and your creative potential. By using a wide-angle lens, it is possible to move in close to a part of your subject, positioning this in the immediate foreground. The close viewpoint will provide an apparent distortion of scale and perspective, making the foreground object appear comparatively large against a diminished background. This is very useful for giving emphasis to a particular part of the scene, or for providing impact to your picture. However, beware of image distortion which can occur with more extreme wide-angle lenses. With some extreme wide-angle designs, parts of the image at, or near, the edge of the field of view may be quite considerably distorted. This most frequently

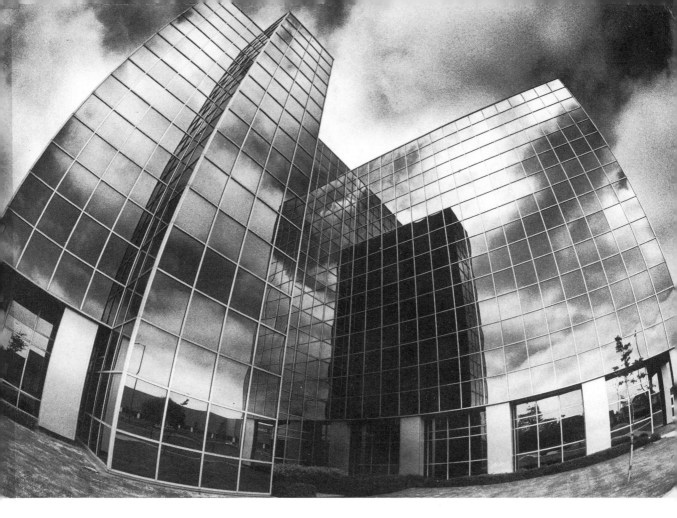

Full-frame fisheye lenses covering an angle of view of some 180° can be used to produce 'interesting' distortion effects. The extreme barrel distortion of these lenses 'bends' straight lines into curves towards the edge of the picture. *Olympus OM1, 16mm full-frame fisheye with orange filter (built-in) – Ilford HP5 ISO 400/27.* Picture by David Chamberlain

occurs with lenses having an angle of acceptance of 90° or more, and is caused by the strongly curved lens elements which have to 'bend' the light rays in order to cover such a large angle. This is often most noticeable with square or rectangular objects, such as buildings, or circular objects near the edge of the frame, which may be 'pulled' out of shape. There really is very little you can do about this problem other than attempt to compose each picture carefully, trying to avoid any such objects being positioned near the edge of the frame.

Wide-angle lenses can provide great depth of field, due to their short focal length, and this can be used very effectively in urban landscape photography. When combined with the characteristic steep perspective effects which can be produced by using wide-angle lenses, quite striking 'three-dimensional' results can be achieved, providing a great sense of 'depth' to a picture. Wide angles can also prove valuable to assist in getting an entire building in the picture, when perhaps a standard lens cannot be used due to there not being enough room available to stand far enough away. Be careful not to tilt the camera backwards, however, in an effort to get everything in, unless that is, you want steeply converging vertical lines. Keep the camera as parallel as possible to the subject, even

113

if this means taking in far too much foreground. This can always be cropped out of the picture later, either at the printing stage or, if working with transparencies, by masking.

FISHEYE LENSES

These special types of wide-angle lenses are able to take in a quite amazing angle of view – up to 220° with one such lens! True fisheye lenses such as this produce a circular image on the film. To take in such a vast angle of view, the image is grossly distorted, and this fact alone made these lenses very popular a few years ago. However, once we all became accustomed to this highly unusual type of image the novelty value quickly started to decline, and such lenses are now much less popular. The problem is that there really are very few occasions, or subject types, where such a lens can be successfully employed, unless the resulting photograph is intended to be taken merely for the sake of the effect. The serious use of such lenses is therefore extremely limited and, if you really want to use one, I would recommend that you hire one rather than buy one which will probably only be used once or twice.

Another type of fisheye lens – the full-frame fisheye – is a much more useful type. With this type of lens the entire negative format is covered, producing the normal rectangular or square negative, and although such lenses still produce quite extreme barrel distortion, this can be used to good effect if a little care is exercised. Full-frame fisheye lenses still take in a vast field of view – usually between 170° and 180°, but with careful composition quite 'straight'-looking results are possible.

All fisheye lenses provide enormous depth of field, even at quite wide apertures, due to the extremely short focal length of this type of lens. This vast depth of field, when combined with the exaggerated perspective effects which are possible with such lenses, can produce pictures which exhibit a great sense of three-dimensional 'depth'.

It is impossible to fit filters to many of these lenses in the normal way, due to the deeply curved and protruding front elements which are often necessary with this type of design. However, most such lenses incorporate their own built-in filters which are operated by a revolving turret. Simply turn a ring to change the filter, rather like turning the aperture ring.

Fisheye lenses, particularly the full-frame fisheye types, can be used to provide some very interesting results in urban landscape photography. By tilting the camera backwards, to include tall buildings etc, extremely steep perspective effects will be obtained, often with curved converging vertical lines. However, as with all such 'special effects', they can only be used for a limited number of pictures before the effect itself becomes something of a cliché.

ULTRA-WIDE-ANGLE LENSES

These lenses, with angles of view of between 84° and 110°, are normally

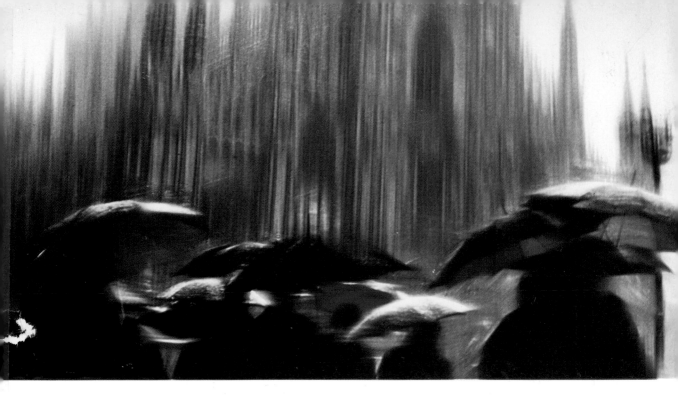

Special effects in colour may include the blending of two or more separate images either by multiple exposures in the camera or by sandwiching two finished slides together. Alternatively, you could experiment with copy manipulations using either a slide duplicator or separate close up accessories. To produce this picture, a thin sheet of glass was lightly smeared with cooking fat and positioned between the original slide and the copying lens. The grease can be manipulated by brushing or smearing with your fingers or small implements to achieve the desired effect. Picture by Norman Osborne

fully corrected for curvilinear distortion so that straight lines will be recorded as such. However, some distortion does still occur with these 'corrected' lenses and, although straight lines do in fact appear 'straight', there may be considerable 'stretching' of the image towards the edge of the frame. This is often most noticeable with circular objects, particularly if these are positioned near the corners of the viewfinder.

Many of these wider 'ultra-wides' have protruding curved-front lens elements similar to those of fisheye lenses, and these may often incorporate built-in filters also. Extremely-wide-angled 'corrected' lenses tend to be quite expensive and, although such lenses can be very useful in photographing the urban landscape, such expense could only really be justified if you also have other uses for such a lens.

These ultra-wide-angle 'corrected' lenses are much more useful than the fisheye varieties, and can be used to provide great three-dimensional 'depth' to a picture without any of the barrel distortion associated with the fisheye types. Most of these lenses are capable of focusing on objects very close to the camera and, indeed, some of the more expensive models may even feature special 'floating' lens elements which 'shift' their position in relation to the other lens elements to provide superior performance at close-up distances. As with all such extremely short focal length lenses, depth of field is quite amazing. With some lenses, using an aperture of f22 or smaller, it is possible to obtain sharpness extending from about 10in to infinity!

MODERATE-WIDE-ANGLE LENSES

These more moderate-wide-angle lenses, with angles of view of between

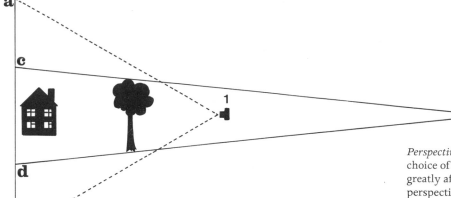

82° and 63°, are without doubt the most useful of all wide-angle lenses. They are easier both to design and manufacture, and are therefore usually considerably less expensive than their more ambitious counterparts. Being easier to design, quality is usually very high indeed, even with quite modestly priced lenses, although very wide-aperture versions of such lenses can become rather more expensive.

These lenses produce all the same characteristic 'wide angle' effects as their ultra-wide stablemates, but the effects are much more subtle – one could say more natural. This makes them an ideal choice for serious urban landscape work, when results will not be too obviously 'wide angle'. The use of such lenses enables the photographer to provide subtle emphasis to particular parts of the scene, so that although something may not actually 'jump' out the picture at the viewer, it is nevertheless 'more' noticeable. Very pleasing perspective may be produced by using one of these lenses, and they are still capable of providing great depth of field too.

As with all wide-angle lenses, a certain amount of care is required in their use. It is still very easy to obtain steeply converging vertical lines if you don't take care to keep the camera upright and parallel to the subject. But because of the pleasing and 'almost' natural perspective provided by these lenses, a kind of 'involvement' with the subject is possible.

Perspective-Control Lenses

Some special PC (perspective control) lenses are designed to enable the optical axis to be shifted, providing a range of 'movements' similar to the 'rise-and-fall' front of some large-format technical cameras. There are a few of these lenses available – all wide angle – for both 35mm and medium-format SLR cameras. Due to their fairly complex design they are mostly quite expensive and, for the same reason, most have manually operated aperture diaphragms.

Perspective and scale Your choice of lens focal length may greatly affect the apparent perspective of your photographs and the scale of objects within them. This occurs through the difference in angles of view of various lenses and the viewpoints from which they permit you to work.

A wide-angle lens (short focal length) will take in a large background area (*a–b*), yet at the same time permit a full-frame view of the nearby tree from a close viewpoint. The house in the background covers a relatively small area of the total background (*a–b*) and is therefore recorded proportionally small in scale compared to the tree.

A telephoto lens (long focal length) has the opposite effect. From a more distant viewpoint it will take in a much smaller area of background (*c-d*) (narrower angle of view) whilst still being able to fill the frame with the closer tree. The house now takes up a proportionally larger area of the total background and therefore appears bigger in scale.

Full-frame fisheye lenses are a specialised type of wide-angle lens that produce extremely pronounced barrel distortion. With a little care, this distortion can be used to good effect, making straight lines appear strongly curved. *Olympus OM1n, 16mm fisheye with orange filter – Kodak Technical Pan ISO 25/15.* Picture by David Chamberlain

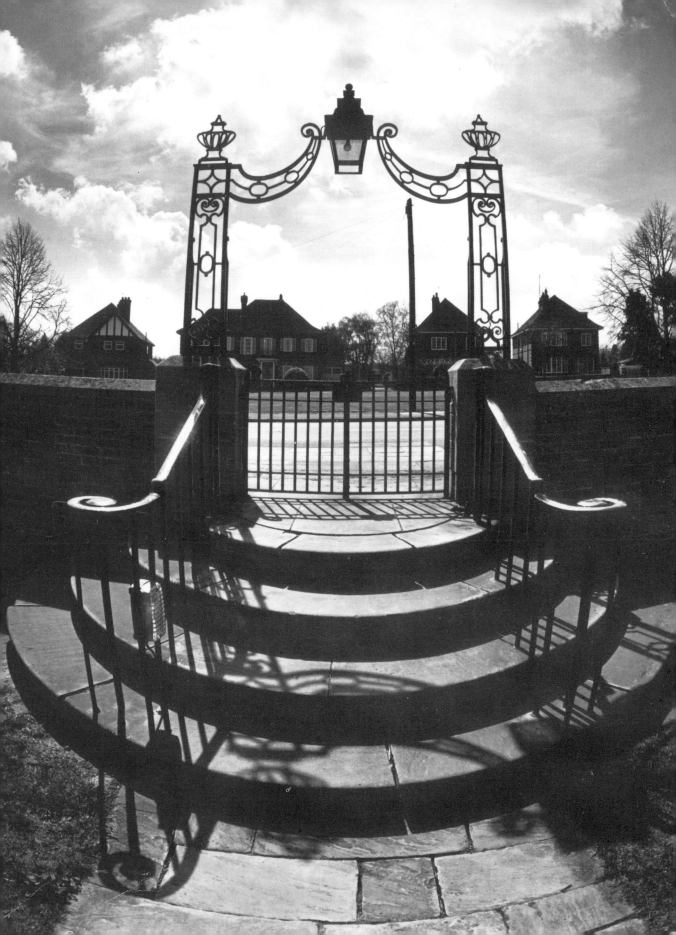

Ultra-wide-angle lenses can be used to create highly dramatic pictures with exaggerated perspective and immense depth of field. The strange structure is actually a display case for a public exhibit – my young son Jay was recruited to add a further sense of mystery to the picture. *Olympus OM1n, 21mm lens with red filter – Kodak Technical Pan ISO 25/15.* Picture by David Chamberlain

The shift movement operates by the lens rotating around its mount by a full 360°, permitting the shift movement to be used either vertically or horizontally, or even diagonally. The value of extra control in correcting converging vertical lines in the photography of tall buildings etc is quite unapproached by any other method in cameras having a rigid body construction, and the potential to the urban-landscape photographer should be immediately obvious.

Telephoto Lenses

Telephoto lenses are the opposite end of the scale to wide angles. As focal length increases beyond the focal length of our standard lens, the angle of view decreases or narrows. This provides us with an enlarged or magnified image and an apparent 'compression' of perspective – just the opposite to the wide-angle lens. Telephoto lenses are extremely useful tools, being suitable for anything from portraiture to wildlife photography, depending on focal length.

For urban landscape photography, telephoto lenses can be most useful for 'pulling in' a small selected part of the scene, isolating it from its immediate surroundings. This may be particularly useful with architectural details, perhaps high up on a building where they cannot be approached. However, another feature very useful to the urban-landscape photographer is the apparent compression of perspective brought about by the narrow angle of view and the more distant viewpoint which this makes possible. With very long focal lengths, rows of houses or other buildings may appear to be almost stacked up, one on top of the other, and a very strong foreshortening effect may thus be obtained. In much the same way, telephoto lenses can be used to emphasise or enhance the comparative scale of buildings or other

Extremely unusual and somewhat 'surreal' results can be obtained by using Kodak Ektachrome Infrared film. This records part of the invisible infra-red end of the spectrum in addition to normal visible wavelengths, resulting in strange colour rendition. The effect can be varied by using different coloured filters. This picture was taken with a yellow (Y2) filter. *Olympus OM1n, 21mm lens with yellow filter – Kodak Ektachrome Infrared film.* Picture by David Chamberlain

118

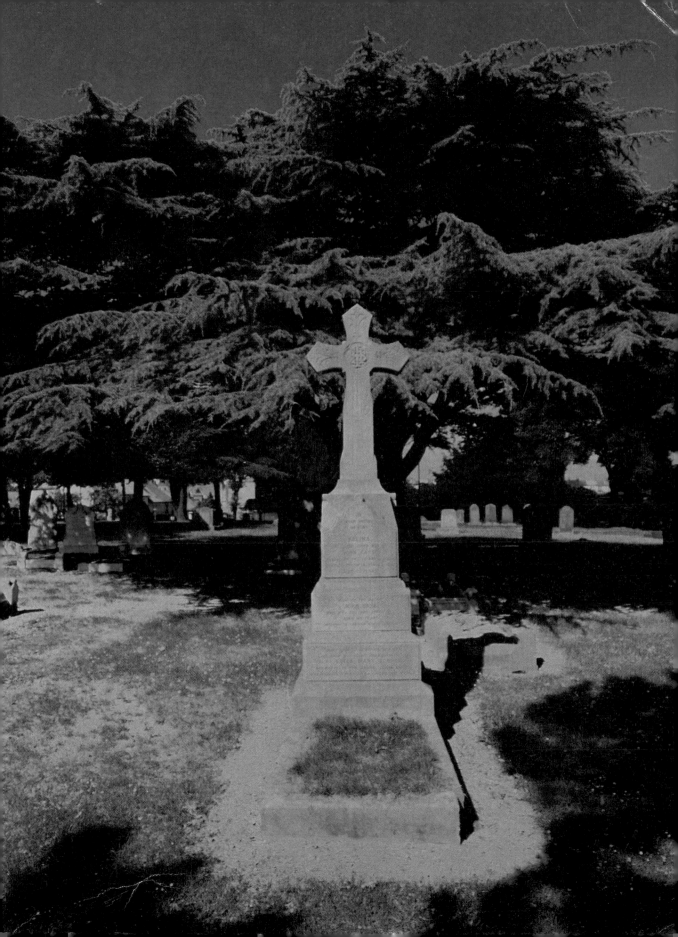

structures. With extremely long-focal-length lenses, more distant objects may appear comparatively larger than those positioned somewhat nearer.

As focal length increases, so depth of field diminishes. Very long-telephoto lenses, or shorter ones with wide maximum apertures, may have extremely limited depth of field, and we can use this highly restricted plane of sharp focus to isolate and emphasise a particular part of a scene.

Any telephoto lens requires a certain amount of care in its use if you are to obtain sharp results. With lenses of even quite modest focal length, any camera movement or vibration will be greatly magnified, causing unsharp results. Always therefore use a good sturdy tripod and a cable release when using telephoto lenses. Sharp results can be obtained with short- or medium-focal-length telephoto lenses when used 'hand-held', providing you use the fastest possible shutter speed – preferably 1/1000 or 1/2000 of a second – but don't be tempted to risk speeds much slower than this.

A further difficulty when using the longer telephoto lenses is that of atmospheric haze. This can greatly reduce the contrast and sharpness of pictures taken over a great distance. A yellow, orange or red filter will help increase the contrast with black-and-white film, effectively 'cutting' through the haze. With colour film, a UV (ultra violet) or Skylight filter may help a little. However, if there is a heat haze, there is little one can do about this, and it may be impossible to obtain sharp results in such circumstances.

Telephoto lenses can be used very effectively within the urban environment, but remember that they do have almost exactly the opposite effect to wide-angle lenses. Whereas wide angles tend to provide pictures which draw in the viewer, providing a kind of involvement, telephoto lenses tend to isolate the subject, producing a more distant 'detached' view. Used thoughtfully and constructively, however, this can provide very interesting results, giving a somewhat 'different' view of our surroundings.

Olympus Zuiko 24mm f3.5 shift lens The only truly satisfactory method of perspective control – correction of converging verticals on tall buildings etc – with a rigid-bodied camera is to use a PC (perspective control) or shift lens. These work in a similar way to the rise-and-fall movements of large-format cameras – the front section of the lens can be shifted up and down or sideways off the optical axis to utilise a different part of the much larger than normal image circle. Photo courtesy of Olympus Optical Co. (UK) Limited

SHORT- AND MEDIUM-TELEPHOTO LENSES

Telephotos in the short to medium focal lengths, with angles of view of between 36° and 18°, are almost certainly the most useful generally. Many of the lenses in this range are light in weight and compact enough to be used hand-held with good sharp results, providing reasonably fast shutter speeds are used.

This type of telephoto is relatively simple for the manufacturers to design and produce, so they tend not to be too expensive unless you require wide-aperture versions or other special features, such as internal focusing etc. Compact enough to be carried comfortably in the average gadget bag, this type of telephoto lens will make a useful addition to anyone's outfit.

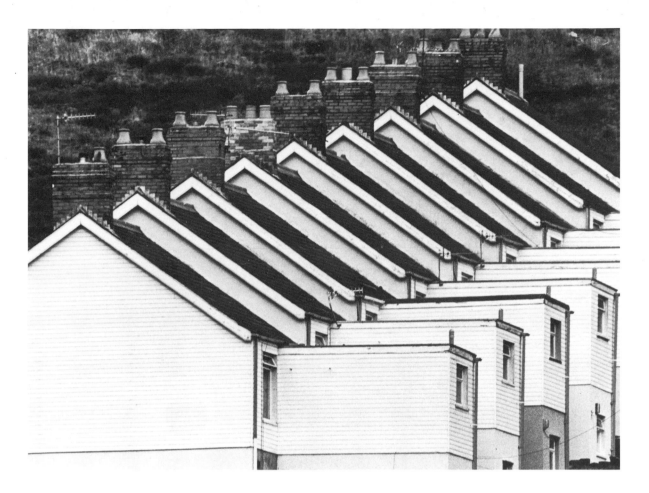

Super-telephoto lenses produce extreme compression of perspective, making distant objects apparently much closer together than they are in reality. This row of terraced houses seem to be almost stacked one on top of the other. *Olympus OM1, 600mm f6.5 lens – Ilford HP5 ISO 400/27.* Picture by David Chamberlain

Even telephotos of quite modest focal length can provide surprising 'pulling-in' power which is extremely useful for isolating urban detail, or obtaining frame-filling compositions of difficult-to-reach subjects. Very pleasing perspective may be obtained with such lenses and most stop down to much smaller apertures than the 'standard' lens, making it possible to obtain good depth of field even with the longer focal length. However, to make the most of this facility, long shutter speeds will be required, making the use of a tripod essential. With wide-aperture versions of these lenses, it is possible to achieve very effective differential focus effects by shooting at full aperture, thus restricting the plane of sharpness almost entirely to that part of the subject focused on.

With medium format, particularly 6 × 7cm format, even these quite modest telephoto lenses tend to be quite large and heavy. Use them with the respect they demand. If hand-holding, use only the fastest shutter speeds, but preferably use these heavier medium-format lenses with a tripod.

LONG-TELEPHOTO LENSES

This range of telephoto lenses, with their often very narrow angles of

view – from $12\frac{1}{2}°$ to only $2\frac{1}{2}°$ – can provide extremely striking results indeed. In most cases, the use of a good sturdy tripod is essential at all times when working with these lenses, and reasonable weather conditions are necessary if the best results are to be achieved with such long lenses, especially when pictures are being taken from a distant viewpoint. Wind is another problem with long-telephoto lenses. Even a slight breeze can cause some vibration, and this small movement will be greatly magnified through the longer-focal-length lenses, even when a tripod is used.

Most of the lenses in this longer-focal-length range tend to be quite expensive and, if you want one of the more specialised versions with a very wide maximum aperture, special lens elements and internal focusing, cost can be quite prohibitive! However, for photographing the urban scene, this sort of 'high tech' specification is hardly necessary and, unless you are also engaged professionally in sports or action photography, a lens of the more modest specification will produce results which will easily match those of its more ambitious counterparts.

These long-focal-length telephoto lenses have enormous 'pulling-in' power, enabling quite small areas of the urban scene to be selected and isolated. The necessary longer distance between camera and subject, along with the very narrow angle of view, produces quite pronounced apparent compression of perspective. This can make your pictures appear very 'detached' or 'remote', providing almost a sort of abstraction from reality. Scale may appear completely different when a subject is photographed from some distance away, producing quite a strong foreshortening effect with buildings apparently being almost 'stacked up' on top of each other. At closer focusing distances, depth of field will be extremely limited, and this can be both a problem and a bonus. Certainly it is a problem when you do require good depth of field, for it may not be possible to obtain adequate depth of field at close focusing distances, even when using the smallest aperture of the lens. It is better to use this shallow depth of field to your advantage whenever possible if working at close-focusing distances. Go for 'differential-focus' effects to isolate just a small part of the scene.

Mirror Lenses

These are really just a more compact version of a normal telephoto lens. However, because of their unusual design, they do incorporate some characteristics which are a little different from the more conventional telephoto designs.

Mirror lenses, or catadioptric lenses as they are more correctly referred to, use mirrors incorporated internally within their design to 'bend' the light path back and forth within the lens, so enabling a very long focal length to be contained within a lens of much shorter dimensions than would normally be possible. Consequently, mirror lenses tend to be much shorter and lighter in weight than conventional

Differential focus (shallow depth of field) can be used to subdue fussy background detail. Telephoto lenses, with their limited depth of field, are ideal for this. *Olympus OM1, 300mm f4.5 lens (at full aperture) – Ilford HP5 ISO 400/27.* Picture by David Chamberlain

Star-burst filters have been much over-used in the past but they can still be quite effective when used with the right choice of subject matter. This night shot of Birzebugia Church, Malta, is a natural choice for such an effect. *Canon AE1, 50mm lens and Cokin Starburst filter.* Picture by Andy Morant

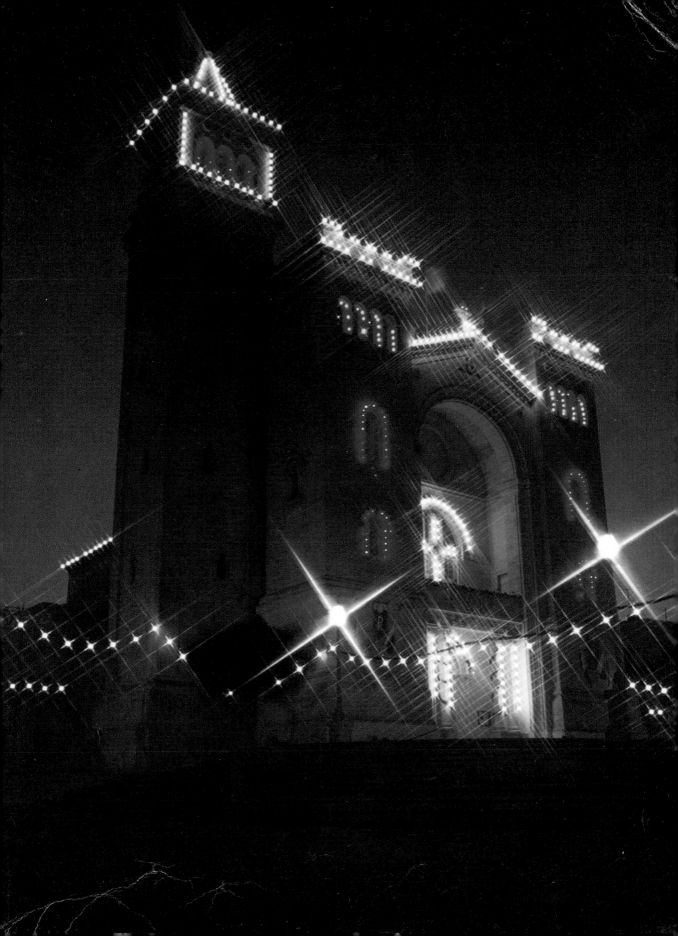

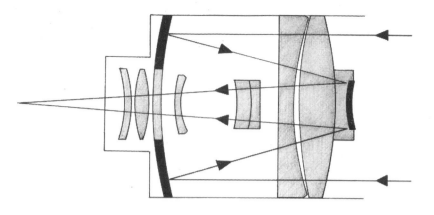

Mirror-lens design A mirror lens uses a system of internal mirrors to 'bounce' the image-forming light rays back and forth to contract a long focal length into a relatively short physical length, making for a more compact and lightweight design. Mirror lenses are usually restricted to one fixed aperture and exposure must be controlled by fitting neutral-density (ND) filters to cut down the light reaching the film.

telephoto designs. This, unfortunately, has led to many photographers believing that these lenses can safely be used hand-held. However, the main reason why long-focal-length lenses cannot be hand-held is not so much because of their size or weight, but because of the magnification. Any movement will be greatly magnified also, and this still holds true for the tantalisingly compact mirror lenses, as well as conventional telephoto lenses.

Mirror lenses usually have only a single fixed aperture, due to the difficulty of incorporating an iris diaphragm within the design. However, there are in fact now one or two mirror lens designs coming onto the market which do incorporate a diaphragm. Most mirror lenses with a fixed aperture rely on the use of neutral-density filters to control the amount of light passing through them. Although this serves to control exposure it does not in any way affect depth of field. This will remain constant for the fixed aperture of the lens.

Perhaps the most unusual characteristic of mirror lenses is the peculiar 'doughnut'-shaped out-of-focus highlights which often occur, with small 'out-of-focus' bright areas, such as patchy light passing through foliage or highlights on water etc. Such highlights are transformed into doughnut-shaped rings of light. This is caused by the front-mounted mirror incorporated in this type of lens. With out-of-focus detail, the central part of the image is, in effect, 'missing'.

The Zoom Lens

Particularly useful to the colour-slide worker is the zoom lens. The variable focal length and angle of view of this type of lens permits extremely accurate framing of the subject and, for the slide worker who does not perhaps have the same sort of opportunity for creative cropping of the image during a printing stage, such lenses can prove invaluable.

A zoom lens is rather like having a whole range of focal lengths available, all incorporated into a single lens, making it possible to frame and compose a picture very precisely from any chosen viewpoint.

Making a zoom lens is, however, a fairly complex job, and most zoom lenses incorporate a great many separate lens elements in their design. In

Mirror lenses are a super-compact type of telephoto lens. Internal mirrors reflect the image-forming light rays back and forth to obtain a long focal length in a relatively short physical length. Photo courtesy *Amateur Photographer* magazine

Above right: Quite a wide range of equivalent fixed focal length lenses can be incorporated in just two zoom lenses. These two zooms cover a range extending from 35mm wide-angle to 150mm telephoto. Other zoom lenses can provide an even wider range and recently there has been a trend towards single zooms which feature an extremely wide focal length range. Picture by David Chamberlain

the past, this has led to some zoom lenses often producing results somewhat inferior to their fixed-focal-length counterparts. Nowadays, however, great strides forward have been made in optical technology; and the best zoom lenses now compare much more favourably with the quality of fixed-focal-length lenses. Although most zooms are of more modest maximum aperture than equivalent fixed-focal-length lenses, faster zooms are now being made – at a cost.

Zoom lenses are now available in ranges which cover most of the fixed focal lengths, and there are 'wide-angle' zooms, 'wide-angle to short-tele' zooms, 'standard' zooms, 'telephoto' zooms and 'long-telephoto' zooms. One of the biggest advantages to using zoom lenses instead of fixed-focal-length lenses is that a whole range of focal lengths may be incorporated within just two or three zoom lenses, taking up much less room in the gadget bag. Another big advantage is that there is rather less chance of missing a picture-taking opportunity, due to less frequently required lens changes.

Zoom lenses do have some disadvantages also. Firstly, they are usually somewhat larger and heavier than fixed-focal-length lenses and may, in reality, more often need to be used on a tripod if camera shake is to be avoided. The fact that maximum apertures are usually considerably smaller than fixed-focal-length lenses only serves to increase this problem. Finally, even though zoom lenses are now capable of producing very high-quality results, generally they still cannot match fixed-focal-length lenses when used at maximum or minimum aperture.

7 · Exposure

With the high degree of sophistication now available in the built-in TTL exposure-metering systems incorporated in most SLR cameras of today, it isn't surprising that many photographers think that, in order to obtain correct exposure, all that is necessary is simply to point the camera at the subject and allow the camera's meter to provide a satisfactory exposure. Although many cameras are certainly capable of achieving perfectly satisfactory results in this way for most pictures, occasions still frequently occur when the camera's built-in meter may provide somewhat less than perfect results. Moreover, such 'blind' acceptance of your camera's chosen exposure reading does not provide much opportunity for any sort of creative control.

A better understanding of exposure-meter readings and the various methods of taking readings will inevitably help you to produce better results under all sorts of lighting situations. The exposure-meter reading provided by your camera's TTL meter, or indeed, any other sort of exposure meter, will not necessarily be the absolute 'best' for any given circumstances, and there may even be certain occasions when your camera's built-in meter is not the best instrument for the job. There are in fact several alternative metering systems available, all of which have their own particular advantages and disadvantages.

Types Of Exposure Meter

There are currently four main different types of light-sensitive cell used in modern exposure meters. These are as follows:

Selenium Cell This is the oldest type of light-sensitive cell still currently in use. The continuing popularity of this type of cell is almost certainly determined by the fact that it does not depend on batteries for its operation. A small electrical current is generated by the light falling on the cell itself, and it is this current which is measured by a highly sensitive galvanometer and finally displayed as a reading of light intensity by a moving needle on a calibrated scale.

Although some very early cameras did have this sort of cell incorporated in a 'built-in' exposure meter, it is far too large to be used for TTL metering systems and, anyway, it would be nowhere near sensitive enough for such use with its quite poor response to very low

Weston Euro-Master II Even in this age of high technology and the ultra-sophisticated exposure-metering systems built in to many SLR cameras, there is still a place for the separate hand-held exposure meter. Under certain conditions these meters offer advantages over TTL (through-the-lens) systems. Photo courtesy Actina Ltd

126

Pentax Spotmeter V With an angle of acceptance of only 1°, a spotmeter permits extremely accurate light readings to be taken from highly selective parts of a scene, providing the ultimate in creative control over exposure. Picture by David Chamberlain

light levels. This type of cell still remains popular, however, in separate hand-held exposure meters, such as the excellent Weston.

CdS (Cadmium Sulphide) Cell This type of light-sensitive cell is much more sensitive than the selenium type and, being somewhat smaller in size, has proved popular for meters built in to cameras. The earliest types of TTL metering systems used this type of cell, and it is still popular today. Although dependent on battery power for its operation, it makes up for this with its quite high sensitivity. Readings are possible even in dim reflected moonlight with some types of meter which use this type of cell, the famous Gossen Lunasix meters being perhaps the most notable of these.

There are some disadvantages to this type of cell, however. Notably, it can be a little slow to respond to sudden changes of light intensity, and it may tend to 'remember' a very high light intensity, providing a false reading when a low light reading is taken immediately afterwards. CdS cells are also a little over-sensitive to red, and this may sometimes cause false readings with subjects which are predominantly this colour.

Silicon (SPD) Cell This is a much more modern type of light-sensitive cell and is currently used in nearly all types of built-in TTL systems. It is extremely sensitive and very quick in its response, adjusting very quickly to changes of brightness without any lag. The SPD cell does not suffer from any colour bias and is therefore suitable for use under almost any sort of lighting conditions and with any subject. Like the older CdS cell however, the SPD cell is totally dependent on battery power for its operation.

Gallium (GPD) Cell This relatively new type of cell is quicker to respond than even the SPD cell. Most other characteristics are much the same however. It is currently used in only a few cameras' TTL metering systems.

Location of cells in TTL (through-the-lens) metering cameras Some SLR (single-lens reflex) cameras have their exposure meter's light-sensitive cell(s) situated in the pentaprism housing (*A*). These measure the light falling on the focusing screen and can take readings right up to the moment of exposure when metering is interrupted by the reflex mirror flipping-up beneath the focusing screen. Other systems may incorporate a light-sensitive cell in the base of the camera body, below the mirror-box (*B*). In this system,

the camera's reflex mirror may be only semi-silvered or have a series of minute holes in a certain area, allowing a percentage of the light from the lens to pass through it onto a secondary mirror (*C*) which in turn reflects this light onto the light-sensitive cell. During exposure, this secondary mirror flips out of the way and light metering may continue 'off the surface of the film' *during* the actual exposure – so exposure is constantly being assessed and monitored, up to and including the time of exposure!

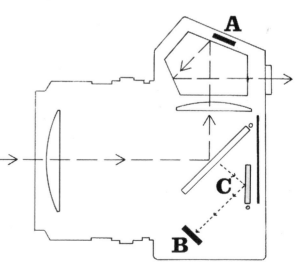

'Weighting' of TTL metering systems (*A*) Integrated or average metering systems take their measurements from the entire area of the focusing screen. (*B*) Centre-weighted systems also take their readings from the entire screen but take a proportionally larger percentage of the reading from a more central area – this being where the most important parts of the subject are likely to be. (*C*) Spot or selective-area systems take their readings only from a relatively small central area of the focusing screen – usually defined by an engraved circle. This can provide for much more accurate readings if used correctly.

TTL (THROUGH-THE-LENS) SYSTEMS

Most modern SLR cameras feature built-in TTL exposure-metering systems which utilise the actual image-forming light in taking their readings. CdS, SPD or GPD cells are located inside the camera body, either in the pentaprism housing to read directly off the focusing screen or in the body itself – usually behind the reflex mirror which may have a small area which is only partly silvered, so permitting a portion of the light to be transmitted through it from which the cell will take its readings.

Early TTL-metering systems were mostly designed to read all the light reaching the focusing screen. This provided a reading which would be an 'average' reading for all the tones and brightnesses present within the subject. Later versions, and many versions presently still in use, employ the same sort of system, but the meter's light-sensitive cells are arranged so that the reading is taken mostly from a fairly large central area of the focusing screen, the remainder of the screen area contributing somewhat less to the final reading. Such systems are referred to as 'centre-weighted' systems, and are capable of providing more accurate results under most circumstances.

Another type of system, called 'spotmetering', takes its readings only from a clearly defined centrally positioned circular area of the focusing screen. This will usually represent only a small portion of the entire field of view – usually about 12 per cent – and in experienced hands is capable of producing extremely accurate results indeed.

Light measurement with separate 'hand-held' exposure meters The intelligent use of a separate hand-held exposure meter can provide extremely accurate results. Basically there are two distinct methods of using such meters. (*A*) *Incident light measurement* This method utilises a white translucent plastic dome which fits into position 'over' the light-sensitive cell. The meter is positioned at the subject position, pointing back towards the camera to measure the light actually falling 'on the subject'. This system guarantees satisfactory highlight detail and can be extremely useful in difficult lighting conditions.
(*B*) *Reflected light measurements* This method works in exactly the same way as your camera's TTL metering. With the plastic dome removed from the light-sensitive cell, the meter is pointed at the subject to measure the light reflected back from it. This system is perfectly accurate for all 'normal' lighting situations.

SEPARATE HAND-HELD METERS

With today's almost universal use of TTL meters built in to cameras, it is sometimes difficult to understand how the separate hand-held exposure meter remains in production. However, many highly experienced photographers still prefer to work with this type of meter. Certainly, when used intelligently this type of exposure meter can provide ultimate control over exposure, and may often provide satisfactory readings in difficult lighting situations when this may not be quite so easy with a camera's TTL system.

There are currently still many different types of hand-held exposure meter available, and even the older and less sensitive selenium cell lives on in some examples of separate hand-held meter. More commonly, however, the far more sensitive and quicker-responding CdS and SPD cells are to be found in this type of instrument, and these are capable of providing extremely accurate readings and even under extremely low light conditions.

Nearly all separate meters offer the choice of taking readings, either by reflected-light or incident-light reading methods, *via* a small translucent 'invercone' which may be either an integral part of the meter, or a separate 'clip-on' attachment. Some separate meters, such as the Gossen Lunasix, have a range of special accessories available for them. Using

these, such a meter may be quickly converted to spotmeter or enlarging meter, making for an extremely versatile instrument.

THE HAND-HELD SPOTMETER

One other type of separate hand-held meter which deserves individual consideration is the spotmeter. This type of meter probably offers the ultimate in control over exposure measurement and, in experienced hands, can provide the ideal answer to almost any possible exposure problem.

This type of meter does not offer the facility for taking incident-light readings, relying on reflected light for its readings. However, extremely accurate exposure measurement is possible with such a meter, due to the extremely narrow angle of acceptance provided. This type of meter features a reflex viewing system, just like an SLR camera, and, indeed,

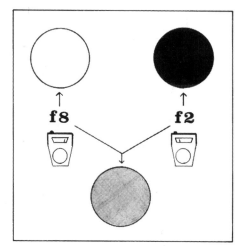

Exposure-meter calibration All exposure meters are calibrated to translate a light measurement from any tone, *light* or *dark*, into a reading which will record as an 18 per cent mid-grey. This will apply whether a measurement is taken from a white tone or a black tone – the meter will simply indicate more or less exposure to bring that tone to the 18 per cent mid-grey.

Viewfinder of hand-held spotmeter The true spotmeter – a hand-held device – has an angle of acceptance of only *one degree*, defined by a small engraved circle. This type of meter is highly accurate and can provide the ultimate in creative control over exposure. Featuring a full-reflex viewfinder system, looking through one of these exposure meters is very similar to looking through the viewfinder of your own 35mm SLR camera.

A subject of predominantly light tones will fool most TTL (through-the-lens) exposure meters into giving a reading which would result in under-exposure. Use the principles of the zone system to place tones on their correct or most suitable values. For this shot, the indicated exposure needed to be increased by 2 f-stops to record the desired tone range. *Pentax 6 × 7, 55mm lens – Ilford FP4 ISO 125/22*. Picture by David Chamberlain

the viewfinder is almost identical to that of many 35mm SLR cameras. In the centre of this viewfinder is a very small engraved circle. This defines the meter's angle of acceptance and is the only part of the screen from which the readings are taken. This may represent an angle of acceptance of only 1°, so very precise readings may be taken from small selective areas of a subject or scene, even when the subject may be quite some distance away. Using such a highly selective metering system, it is possible to take several readings from different parts of the subject, enabling the brightness range to be very accurately assessed.

Some spotmeters feature an exposure value (EV) scale across which a needle moves. The resulting exposure value is then transferred to a separate dial when a suitable range of exposures will be indicated in normal f-stops and shutter speeds. Others may have direct digital readout in f-stops. Simply set the film speed and desired shutter speed and the meter will indicate the required lens aperture.

Reflected-Light And Incident-Light Reading Methods

Most separate hand-held exposure meters, except the spotmeter, can be used for taking either reflected-light or incident-light readings. Which you use will depend on the particular lighting situation which prevails with any particular subject. Reflected-light readings will provide accurate results under most situations, but occasions do occur when accurate results might not be guaranteed with this method. In these cases, the incident-light reading method can provide more accurate results, especially for difficult or tricky lighting situations.

For taking reflected-light readings, it is simply a matter of setting the

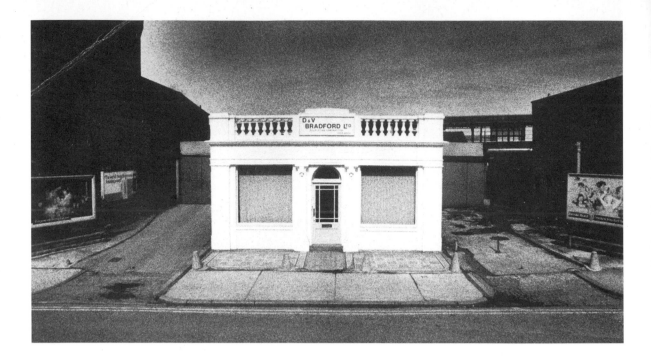

required film speed on the exposure meter and pointing the meter at the subject or scene. The meter will respond to the light reflected back from the subject and provide a reading which can then be transferred to your camera. However, you must remember that the angle of acceptance of an average exposure meter is about 30°, so, when taking your reading, try to avoid the sky being included within the angle of acceptance. This could cause false readings. Keep your meter pointed slightly downwards to avoid any problems. If there are still bright areas which could encroach within the meter's angle of view to give false readings, try moving in closer to the subject, taking a more selective reading.

Accurate readings may be impossible with certain lighting situations, such as strongly back-lit subjects. In this case incident-light reading methods can provide a more accurate type of measurement. The incident method utilises the light actually falling on the subject to take a reading. Slide the translucent invercone in position to cover the light-sensitive cell and, from the subject position, point the meter towards the camera. If the subject cannot be approached for some reason, it is often possible to take a substitute reading by positioning the meter a little way in front of the camera and pointing back towards it. This will only work, however, if the light falling on the camera position is similar to that falling on the subject itself. The reading thus obtained may be directly transferred to your camera's controls without further modification.

This type of reading may be particularly useful in conditions where there may be a great deal of scattered light, such as light reflected from water, or when snow is on the ground, and will provide extremely accurate results which will guarantee good highlight detail.

A spotmeter was used to measure and ascertain a suitable exposure to record the building as zone 8 – almost pure white but with some detail. A red filter has increased the contrast of the scene, producing a negative which prints 'straight', barring slight burning in to the sky. *Olympus OM1, 21mm lens with red filter – Ilford HP5 ISO 400/27*. Picture by David Chamberlain

Just an understanding of the zone system makes it possible for you to be able to previsualise the end result – the final print. *Pentax 6 × 7, 90mm lens – Ilford FP4 ISO 125/22*. Picture by David Chamberlain

Basic Principles Of Exposure Measurement

Basically, all exposure meters take their readings in the same way. All the tones and colours contained within a particular scene will be regarded as separate 'brightness ranges' by the exposure meter's light-sensitive cell. Every exposure meter is calibrated to an 18 per cent mid-grey reflectance and, if each of these different areas of brightness within a particular scene are metered, they will each produce a different indicated exposure setting which, if followed blindly, will produce a negative density which, in turn, will reproduce as a mid-grey tone in the final print. A reading taken from some distance away, to incorporate the entire scene within the exposure meter's angle of acceptance, relies on there being a full range of tones and brightness range within that scene to provide an 'average' reading. In theory, this sort of reading should provide a full range of tones, rendered more or less 'correctly' in relation to the tones present within the scene. However, not all subjects contain an 'average' range of tones, and subjects which are predominantly dark or light may cause false readings. A predominantly light subject, for instance, will cause our exposure meter to indicate an exposure setting which would produce an under-exposed result. In effect, the meter would provide a reading which would attempt to change the mainly light tones into a mid-grey tone. On the other hand, a subject which is predominantly dark would give a reading which would produce over-exposure, and any light tones present would be burnt out. In such cases, we must learn to make allowances for difficult metering situations, compensating by deliberately giving more or less exposure as necessary.

Exposure – Creative Control

Exposure, next to your own creative ability and imagination, is without a doubt the single most important aspect to photography. Any extra knowledge you may gain in the techniques and applications of exposure will greatly assist you in the ultimate aim – to produce better photographs.

The 'correct' exposure for a photographic image is an extremely subjective thing, and the ideal exposure for any particular subject may not necessarily be that which is initially indicated by your exposure meter. With many subjects it is quite possible to take pictures over a wide range of different exposures, only to find that most of the resulting photographs are acceptable and, indeed, each may hold its own particular attraction – under-exposed or over-exposed. Try a little experiment. Select a subject and take an accurate exposure-meter reading. Now take one exposure at this 'correct' reading. Now take four further exposures, the first two under-exposing by 1 f-stop, once again in $\frac{1}{2}$-stop increments, and the final two over-exposing by 1 f-stop, once again in $\frac{1}{2}$-stop increments. Use colour-transparency film, as this is most critical to exposure differences and the results do not require a print to be made, when some manipulation may be possible. You may be

At dusk, just before the sun dips below the horizon, beautiful rich shades of red and orange fill the sky. This is the time for traditional sunset pictures. It may be impossible to obtain visible detail in foreground objects without sacrificing the richness of the sky tones so it is best to look for subject shapes which form recognisable silhouettes. Picture by Ian Jenkins

surprised to find that the exposure which was indicated as 'correct' by your exposure meter is not actually the one you prefer. Furthermore, in many circumstances all five exposures may be 'acceptable', although they may considerably alter the mood, or atmosphere of the picture.

Under-exposure will darken the picture, providing a more sombre 'mood', or, in some cases, may create a sense of drama or impact. Over-exposure, on the other hand, will lighten the picture, sometimes producing a more 'wistful' or 'dream-like' atmosphere. The secret to creative exposure control is in knowing when to use it and how to apply it. In other words, you must know precisely the effect you want to achieve, and be able to previsualise the end result. This can only come about through experience, but experience can only be gained by practice, so don't be afraid to experiment. Try bracketing your exposures whenever you come across a scene which you feel may benefit from, or be enhanced by, either under- or over-exposure.

IN COLOUR

Creative exposure control may be a particularly useful technique to the colour-slide worker who does not have the extra potential for creative control available to him which is to be found in print making. Indeed, such techniques are the only method available by which the final result — a colour slide — may be darkened or lightened. This is not cheating in any way, but merely good technique. The black-and-white printer considers such control an integral part of his chosen medium and will simply make his print darker or lighter to suit the 'mood' of the picture as a completely normal part of his photographic technique.

Of course, there are limitations to the use of this technique, particularly with transparency material, which is notoriously unforgiving in its fairly limited exposure latitude. Not every subject or lighting situation is suitable for such treatment, particularly with respect to over-exposure. Highlights may quite easily become burnt out and devoid of any detail. With some subjects this may be quite acceptable, or even desirable, but it is up to you to be able to decide just when, or when not, to use the technique. Never under- or over-expose merely for the sake of it. There has been a tendency recently for some photographers to deliberately under-expose their pictures on colour-transparency film almost all the time. This can make such techniques something of a cliché. Only use them when you genuinely believe the technique will 'add' something to your picture by enhancing or creating mood and atmosphere.

TONE CONTROL IN BLACK AND WHITE

Although the black-and-white worker has the advantage of an additional stage in the process – printing – when a great deal of creative control may be exercised, thoughtful use of exposure techniques may still be extremely valuable and contribute quite considerably to achieving the desired end result.

Although it is possible to burn in or shade different parts of a picture during printing to alter the final characteristics of a subject, this will be far easier, or perhaps not even necessary, if the 'correct' exposure is chosen for a specific effect when the photograph is taken. Just as with colour, the monochrome worker can darken the final image by deliberately reducing exposure when taking his photograph, so producing a negative of thinner density (to produce a darker print). Although this may cause some loss of detail in the deeper shadow areas, highlights will be recorded with full detail and will stand out boldly from the darker elements of the picture. Conversely, a picture which is predominantly light may require some extra exposure to that indicated in order merely to reproduce the scene more or less 'as seen'. In black-and-white photography, we can carry out quite considerable tonal manipulation in this way, shifting tonal values up and down the scale almost at will. However, you must remember that any modification which you make to exposure in order to alter one particular tone will also affect all the other tones present within the picture. You must therefore stop to consider just what effect this might have on your final result.

With black-and-white photography, you also have the advantage of being able to use the different contrast grades of printing paper. These may enable you, with experience, to exercise considerable control over the final tonal rendition of your black-and-white photographs. Used in combination with careful control of exposure, extremely fine control over tonal range can be obtained, permitting a high degree of creative control to be exercised throughout.

136

Just one part of a subject may dictate the 'correct' exposure for a scene. In this amusing shot of a door which 'obviously' is no longer in use, the subtle tones of the door itself were the deciding factor. *Pentax 6 × 7, 165mm lens – Ilford FP4 ISO 125/22.* Picture by David Chamberlain

The Zone System

The zone system, devised by the great American photographer, Ansel Adams, is a system which can provide almost total control over the medium of black-and-white photography. It incorporates within one procedure all the different considerations which go into film exposure, negative development and the final making of the print. Basically, the zone system involves taking exposure-meter readings of the brightnesses which represent several important elements within a particular scene. You must then decide on the print values (tones of grey) at which these elements should reproduce in your final print. You then expose and develop your film to produce a negative which can reproduce the tonal range you had previsualised. This ability to previsualise is a key element to the zone system. It is imperative that you are able to imagine the desired end result – your final print.

Using a standardised development process, it is a simple matter to be able to relate a certain subject brightness to a relative print tone. The zone system enables you to previsualise precisely how the range of tones

in a scene will appear in your print and, furthermore, makes it possible for you to manipulate the final interpretation of how those tones will record whilst still being able to previsualise the intended effect. Just an understanding of the zone system is extremely valuable, for even if you don't fully follow it, you will at least have a better understanding of exposure control, enabling you to tackle all sorts of lighting situations and subjects with much greater confidence.

THE ZONE SYSTEM IN USE

Exposure meters measure light intensity to provide an indication of an exposure which is necessary to record a negative density representing an 18 per cent reflectance mid-grey tone. However, the photographer may choose to interpret this reading differently, depending on how he wishes the particular tone which was measured to reproduce in his final print. For instance, if one side of a light-toned building is lit by bright sunlight, he would have to decide if he wanted this to reproduce as blank white or a light tone of grey with some detail, in his final print. Alternatively, a scene with a very wide brightness range may be reproduced as such or, if the photographer chooses, the tonal range could be deliberately restricted. Although your exposure meter cannot make these decisions for you, it can be used as a valuable 'tool' to assist you in recording a scene in the way *you* wish to portray it.

The zone system is based on a grey scale which is divided into ten distinct shades of grey. These tones, or zones, represent the range of tones which can be encompassed within a black and white print, and range from Zone 0 (total black) to Zone 9 (pure white). Each succeeding zone represents 1 f-stop increase in exposure from the previous zone. In other words, Zone 2 represents precisely double the exposure of that required to produce zone '1', and so on. Zone 5 represents the same tone as that to which our exposure meters are calibrated — 18 per cent reflectance mid-grey — and any other tone metered will give an indicated reading which will record a negative density that will reproduce as Zone 5 in our final print. Likewise, any scene which contains a full range of different subject brightnesses will produce an average of tones which represent this same zone 5. In such a case, an average meter reading of the entire scene would provide a perfect result, with all the tones being faithfully recorded on the print. If, therefore, we should decide to make the overall result one zone lighter, so shifting the whole range of tones up the zone scale by one zone, it is simply necessary to increase exposure by 1 f-stop. To shift down the scale, for a darker result, simply reduce exposure by 1 f-stop.

We can even consider the reproduction of just a single tone within our picture. For example, let us consider again that light-toned building with one side illuminated by bright sunlight. If we were to take our reading from this brightly lit wall, the indicated exposure would produce a negative density which, in turn, would reproduce as Zone 5 (18 per cent

Zone System

9
8
7
6
5
4
3
2
1
0

Zone system scale Each separate section, or 'zone', represents one full f-stop difference in exposure. Zone 5 represents the 18 per cent mid-grey that exposure meters are calibrated to produce and, bearing this in mind, it is a simple matter to place a selected tone within your scene on a specific zone by giving more or less exposure to that indicated, so moving the tone 'up' or 'down' the zone scale.
0. Solid black *1.* Almost black, just noticeably lighter than zone *0 2.* Slight texture but not recognisable. *3.* Dark shadows — first signs of recognisable shadow detail *4.* Average shadow tones *5.* Mid-grey, 18% reflectance *6.* Light grey with full detail — normal value for Caucasian skin tones *7.* Bright areas with full detail *8.* Lightest tone with any detail *9.* Brightest highlights, detail-less white.

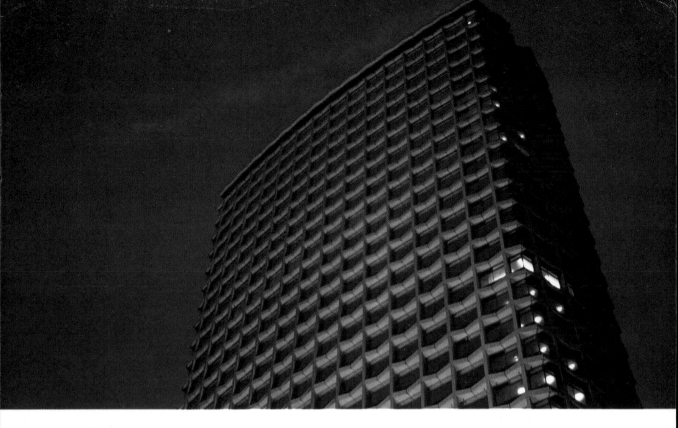

Late dusk can bring interesting effects of light – even after the sun has set below the horizon. While the sky may be rapidly changing to a rich dark blue, the sun's final golden rays may still strike the upper parts of tall buildings. (See p.00) Picture by Ian Jenkins

mid-grey) in our final print – far too dark. Now suppose we want this to reproduce as Zone 7 (light grey, with detail); we must increase the actual exposure, beyond that indicated, by a full 2 f-stops. This will have the effect of shifting the print tone from Zone 5 to Zone 7. Alternatively, if we wanted the wall to reproduce as pure white with no detail, we could increase exposure beyond the indicated reading by 4 f-stops to reproduce the wall as Zone 9.

Although it is possible to manipulate and control the tonal rendering of the final print in this way, you should always consider what will happen to the entire tonal range when making these adjustments. For instance, if you wish to place a tone which would normally record as Zone 5 on Zone 4 instead, this may mean that important shadow detail may be lost as the entire tone range is shifted down the zone scale, when for instance shadow detail which might previously have recorded as Zone 2 (the darkest zone still containing some detail) will be shifted down to Zone 1 which is virtually featureless extremely dark grey – almost black.

With experience and practice, the zone system can provide the ultimate method of control over the reproduction of tones in your black-and-white photographs. For truly accurate and consistent results it is really necessary to use the zone system with standardised and consistent processing techniques, but even by only loosely following the basics of the system you will be able to exercise much better control over your final results.

8 · Developing a Style

What Is Style?

Style is extremely difficult to define in photography or, indeed, in any sort of art form. It is a strange elusive quality, very real and easy to recognise when seen and yet at the same time extremely difficult to analyse.

Look at the work of some of the world's greatest photographers and their style will be immediately obvious, yet try to describe that style – even with the evidence before you – and you will undoubtedly experience great difficulty in tying it down to any particular aspects of their work. This is mainly because a 'style' incorporates many different aspects, built up around the photographer's interests, artistic abilities, lifestyle and, not least, his own personality and intellect.

It is very easy to mistake a technique for 'style'. But true style does not rely on technique alone and, certainly, the common utilisation by a photographer of any one particular technique – no matter how new or clever that technique might be – should not be construed as a style. True style will be evident throughout almost the entire work of a photographer, through all types of photographs, whatever the subject matter and whatever techniques are used.

I prefer to think of style almost as a mirror. A mirror which both reflects reality – through the images we produce – while at the same time reflecting a little of ourselves, incorporating and blending this into each picture we take. For this very reason, I believe that a photographer's pictures can tell you a great deal about him or her as a person. It is almost as if locked away in each photograph is a little of the photographer's personality. Personally, I sometimes find this aspect of photography more rewarding and interesting than the photographs themselves. The same can be found in the work of many of the great artists. Look, and you will see!

The Advantage Of Possessing Your Own Style

Perhaps the most obvious advantage to be found in possessing your own individual style will be experienced only if you are working professionally. Then, your personal style of photography may actually assist you in finding a market for your work, providing of course that your style is one which is popular with those who might want to use your work. If it is

'Band Stand in White Stone' *Olympus OM1n, 21mm lens with red filter – Kodak Technical Pan ISO 25/15.* Picture by David Chamberlain

General comment on pictures Style is difficult to define or describe but when present is easily recognisable. In this and the following photographs, the author combines a pleasing simplicity of design with strong graphics and geometry. Look for any characteristics which frequently seem to re-occur in your own photographs – then expand on this. Don't confuse gimmicks or special techniques with style; they are quite different.

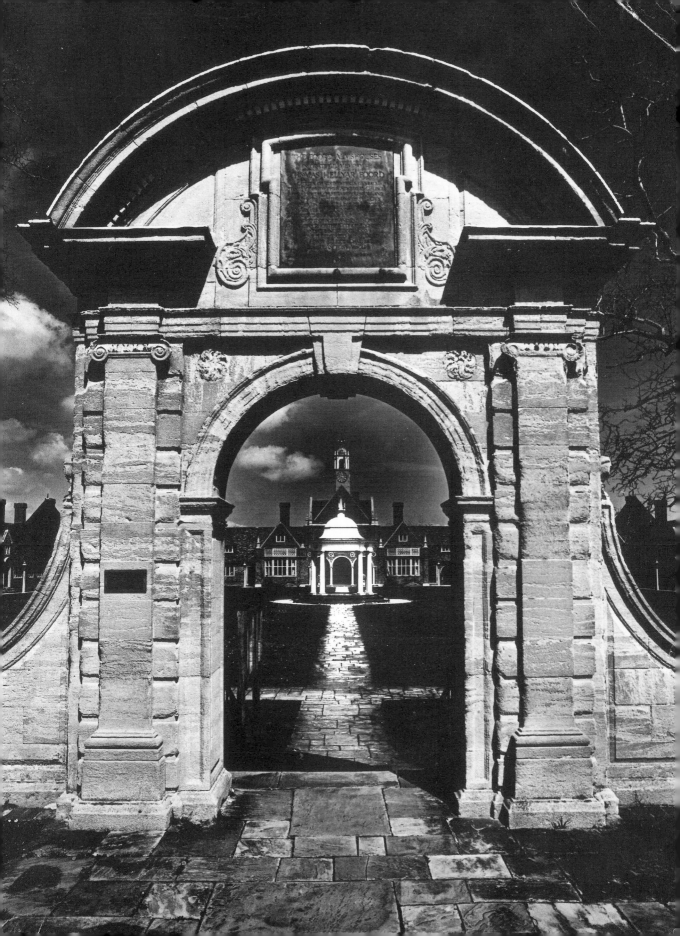

'Sky-Hook' *Olympus OM1, 35–70mm zoom with red filter – Ilford HP5 ISO 400/27*. Picture by David Chamberlain

not, your style may be a distinct disadvantage. More often than not, however, style is recognised by editors, art directors and buyers, and certainly some at least will be interested in using your work, providing it is applicable to their specific market.

Even if you don't work in photography professionally, and quite obviously there are far more amateurs taking photographs than there are professionals, there are still some advantages to be found in having your own recognisable style.

Firstly, you will benefit most if you can recognise a style yourself within your own work. This will provide you with both a greater sense of personal satisfaction and increased motivation in your attitude towards your hobby, helping to determine the direction in which your interest progresses. If you are able to see certain elements and characteristics of your style regularly being incorporated into your pictures, you will almost certainly improve your standard more rapidly. Never attempt to 'deliberately' force these characteristics into your pictures, however. They should come about almost subconsciously, without any obvious application by yourself.

Another very worthwhile advantage is that, wherever and whenever your work is shown in public, at exhibitions or in competitions etc, people will immediately recognise your work through your particular style. As you progress through your hobby, this fact alone will help gain you much wider acceptance, both with other photographers and those who, although not photographers themselves, still appreciate a good photograph. This can be extremely pleasing and rewarding in itself and can only serve to further encourage you, ultimately uplifting both your ego and your ability.

'Nat-West Tower from Throgmorton Street, London' *Pentax 6 × 7, 45mm lens with red filter – Kodak Tri-X Pan ISO 400/27*. Picture by David Chamberlain

142

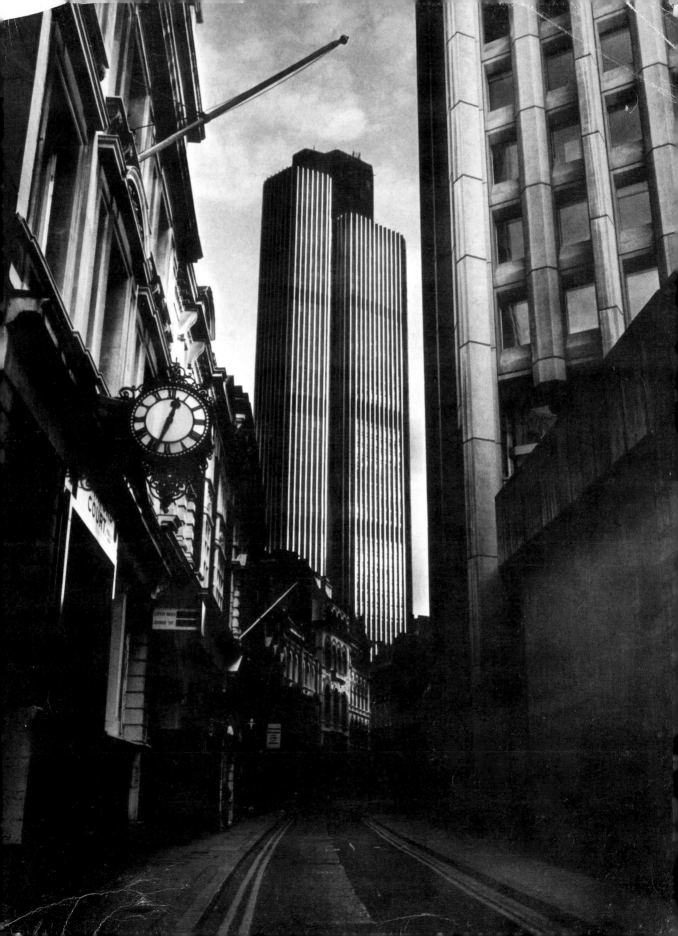

How You Can Develop A Style

This is a question which is frequently asked by photographers who wish to establish their own identity within their photographs. Unfortunately, it is a question which is usually impossible to answer to their satisfaction. The problem is that not everyone realises that style in photography is not created or manufactured. You cannot deliberately set out to make your work conform to any style, unless you are prepared to copy another photographer's style. This, however, is a dangerous and ultimately a pointless route, for a copied style will never be your own, and the time spent in trying to emulate the style of another photographer will ultimately be totally wasted. What most often escapes the notice of the less experienced photographer is that the well-known recognisable styles of the famous photographers have come about by a gradual and progressive development, often over many years. There simply is no such thing as 'instant' style – not in photography, art or any other medium for that matter. There are certainly 'gimmicks,' but these are never a substitute for genuine style brought about by talent.

One only has to look to the pop-music industry for evidence of this. There a vast number of pop groups or artistes who seem to turn up from nowhere. Many of them achieve overnight 'fame' merely by appearing 'different' through the application of a gimmick – usually their outrageous appearance or performance – but only those with real talent survive long enough to develop a genuine style which will last the long course of time.

If one is to have any chance of developing genuine style, one must be prepared to ignore such gimmicks. Don't try to force a style upon yourself. Take your time – a long time – and be prepared to let your style develop naturally. Follow your own natural interests, particularly in the way you like to see a picture composed. Try to incorporate these interests and personal 'tastes' into your own photographs.

Never try to restrict your picture-taking activities to one particular type of photograph. Try to bring as much variety into your photography as possible. The urban landscape can provide a vast variety of different pictures. Tackle them all. Eventually you may start to recognise certain characteristics within your photographs which consistently re-occur – this may be the beginnings of a style – but don't push yourself. Let it happen gradually.

Keep in touch with the work of other photographers. Take note of any characteristics of their work which you find particularly attractive, but don't copy them. Try to look for similar qualities within your own work and then exploit these. Don't be afraid to experiment with new techniques or processes. These may help you develop your creative ability in all fields of photography. But once again, don't make the mistake of thinking that a technique is a 'style'. A willingness to experiment is a key feature to progress, but is not an end unto itself. Generally, the more innovative you become, the more likely you are to

'British Caledonian Airways Building – Crawley' *Olympus OM1, 21mm lens with yellow filter – Ilford HP5 ISO 400/27.* Picture by David Chamberlain

find, or recognise, a style within your work. But remember, if you concentrate only on derivative work you may begin to lose track of 'real' photography, leaving little chance of ever developing a style.

ASSESSING YOUR OWN WORK

One of the most valuable contributions which you yourself can make towards developing a style of your own is to learn to assess your own work constructively over the course of time.

There are very definite dangers attached to consciously and rapidly developing a style of your own. Firstly, there will be a strong possibility that you will make your attempts too obvious and any characteristics which you consider to be elements of style will almost certainly appear somewhat contrived and therefore devoid of any real value. Secondly, you may well set yourself on a route which will ultimately turn out to be a dead-end, tying yourself to a 'style' which becomes progressively more and more restricted, so limiting your own creative potential.

However, there is a very definite need for 'direction' in your progress

and, without attempting to force your work into what might become a totally artificial 'style', you do need to guide and assess your own progress. It is therefore essential to chart your own creative progression, keeping notes of any particular characteristics which frequently seem to re-occur within your photographs, such as peculiar compositional elements which you may find repeated through several different types of picture, the use of perspective, scale, contrast or whatever. If similar characteristics frequently re-occur through many of your photographs, this may be the beginnings of a style. At the same time, keep in touch with those characteristics which you don't like about your work. Analyse each picture you take very carefully. Try to ascertain precisely which characteristics you like about each picture and those which you don't. Gradually, this analysis of your work will begin to show up a certain form of particular characteristics which regularly feature within your photographs. Once discovered, you may be able to use these characteristics more constructively, forming a sound basis from which a 'natural' style may develop.

'Stone Steps and Paving'
Olympus OM1, 21mm lens – Ilford HP5 ISO 400/27. Picture by David Chamberlain

After dark, floodlit buildings are good subjects. You can add interest to unlit foreground objects by using open flash (hand-held off the camera) to light small areas of the scene during a long exposure. By fitting coloured filters over the front of the flash, it is possible to 'paint' parts of the subject in different colours. *Olympus OM1n, 21mm lens, open flash with red and blue filters during a 2-minute exposure at f11 – Kodak Ektachrome 100.* Picture by David Chamberlain

146

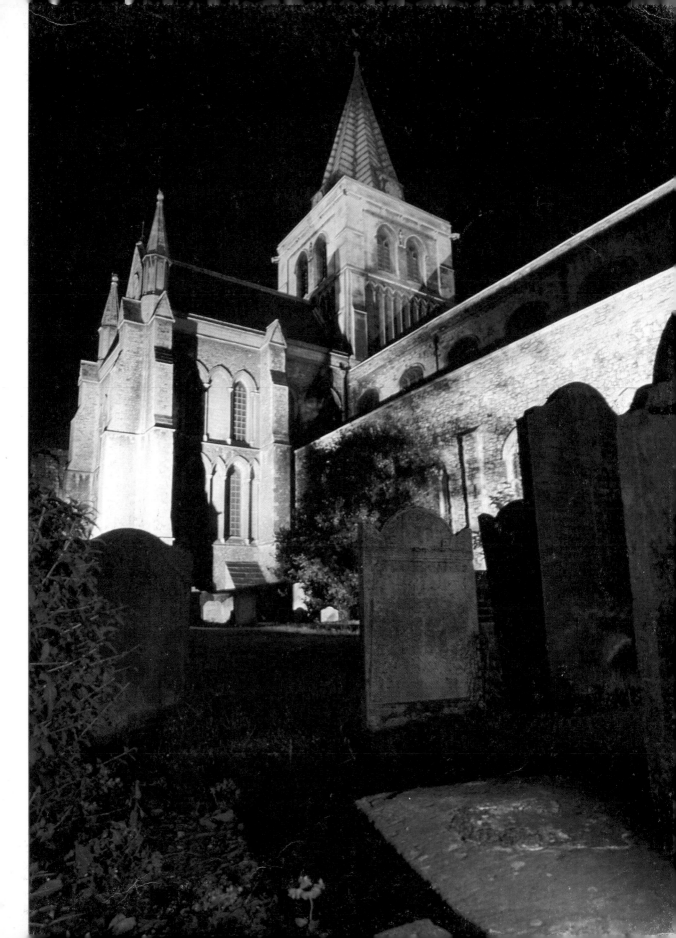

'Red Chair — in White' *Pentax 6 × 7, 55mm lens with red filter — Ilford FP4 ISO 125/22.* Picture by David Chamberlain

'Detail of New Lloyds Building — London' *Olympus OM1, 75—150mm zoom — Ilford HP5 ISO 400/27*. Picture by David Chamberlain

EARLY CHARACTERISTICS OF YOUR WORK

It is very easy to lose track of oneself when trying to assess one's progress. It is often all too easy to become so involved in the present and the future that your earlier work may easily be overlooked.

Always keep your early work. This can be extremely useful to refer back to whenever you may lose your sense of direction. It can sometimes happen that, after following a certain route in your photography, you suddenly find yourself dissatisfied with the direction in which you seem to be travelling. This is when your earlier work can prove most valuable. Look back to it. Try to ascertain at which stage your work started to move in the wrong direction and try to seek out any elements of potential style in this early work which you might alternatively follow. You must never be afraid to go back, or change direction. If you are travelling up a dead-end road, there is really little point in continuing.

AVOIDING TRENDY TECHNIQUES

Photography is a medium peculiar to itself. It has never successfully produced any of the 'formal' movements such as have been evident in painting and other arts. In painting, such movements as Cubism, Pointillism and, more generally, the Impressionism, are all accepted movements or styles. However, when similar techniques are applied to the medium of photography they are immediately reduced to mere gimmicks. Cheap and nasty. I feel, therefore, that the great painters had

148

'Detail – Naval War Memorial – Kent' *Olympus OM1n, 35–70mm zoom with red filter – Ilford FP4 ISO 125/22.* Picture by David Chamberlain

it relatively easy in developing a new 'style', although it must be said that most received very harsh criticism at the time.

It is, I feel, far more difficult to acquire true style in the medium of photography. Gimmicks or trendy techniques often arouse interest for a short time, but this is usually very short lived. A true style, if it is to transcend the years, must be something other than a gimmick or technique, and must be evident throughout all types of work – even when special techniques are utilised. Photographic 'style', therefore, is often much more subtle than many of the more obvious 'styles' used by painters, yet at the same time it must be powerful enough to show through in any type of work, no matter what the subject or technique.

I have sometimes been approached by photographers who will openly talk about their 'style'. In nearly all cases, when I have finally had the opportunity to view their work, it turns out to be no more than the

persistent use of one specific technique or special effect – often imitating the impressionist styles of painting!

'Roof-Tops – Modern Architecture' *Olympus OM1, 75–150mm zoom with yellow filter – Ilford HP5 ISO 400/27.* Picture by David Chamberlain

If you are to develop a real style of your own in your photographs, avoid the trendy techniques. Although many painters found success by such means, a photographer requires something else. A photographer may produce many thousands of images during his lifetime – a painter could only produce a comparative few – several thousand pictures all utilising the same technique will not do a great deal to impress anybody, nor provide any satisfaction for yourself.

APPRECIATING CRITICISM

Many people find it hard enough to accept criticism from others, let alone indulge in any form of self-criticism. Yet criticism of both sorts is one of the most valuable means of self-improvement.

The problems arise in translating criticism into constructive facts. There may often also be a problem in obtaining true and unbiased criticism. All too often, people allow their own petty likes and dislikes to colour or cloud their comments, not to mention a certain element of jealousy which may also sometimes creep in. However, any sort of criticism is better than none and, if you can separate the useful from the

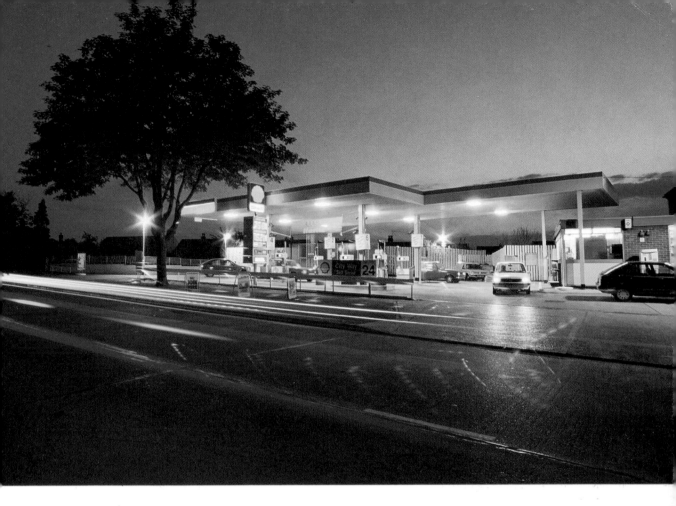

Head and tail-lights record as trails of coloured light during a long exposure at night. Try to blend this movement with other 'static' objects for greater impact. This picture was taken a little before total darkness, while some colour remained in the sky. A blue (80B) filter was used to partially 'correct' the strong yellow cast of the garage lights and add further colour to the sky. It would be impossible to obtain 'correct' colour balance with the various types of light source present and with such pictures it is best to accept the mixed lighting as a point of interest. (See Chapters 4 and 5.) *Olympus OM1n, 21mm lens with blue 80B filter, 4 seconds exposure at f11 – Kodak Ektachrome 100.* Picture by David Chamberlain

not so useful, you can use this to assess your work and ultimately improve it.

Listen carefully to the criticism of others – you will know when their comments are right. When deep in your heart you agree with unfavourable comments, even though outwardly you may pretend not to agree, act on them accordingly.

In much the same way, self-criticism can be extremely valuable. If you can pluck up the courage to be really honest with yourself, to recognise and admit when something is less than satisfactory with your work, you will also have the courage to do something about it and take positive action to rectify any faults in future photographs.

The biggest problem with criticism is that deep down, everyone wants to be a winner – number one. Fortunately, photography is too big and varied for this to be possible. There is no such thing as the 'greatest' or 'best' photographer, only good ones, average ones and poor ones. You can never hope to become a world champion photographer, so don't try! The sooner you appreciate this the better, and the more easily will you be able to both accept criticism and inflict it upon yourself, so speeding your progress towards both developing a style of your own and becoming a 'better' photographer.

151

9 · Useful Hints and Tips

Although photography is a hobby and should therefore be enjoyable, you should be prepared to tackle each subject quite seriously. Urban landscape photography in particular requires a serious and dedicated approach if you are to get the most out of this challenging and rewarding subject. In fact, if you are to be really serious about it and wish to obtain truly worthwhile pictures, you need to put just as much effort into the subject as that required by top-class 'conventional' landscape photographers.

Such photographers may often go to great lengths to 'get' their pictures and, if you are also prepared to put this same sort of effort into your own urban landscape photography, you will ultimately be rewarded with superb and exciting photographs. Remember, the difference between success and failure often depends entirely on your own enthusiasm and dedication. Half-hearted efforts will produce only half-hearted results!

Making Photography Enjoyable

You should not have to 'make' your photography enjoyable, for it should naturally be so. Although a serious approach to your subject is necessary, this in no way implies that you should try to treat your hobby more like a 'job'. On the contrary, any hobby must surely be enjoyable if indeed it is to remain a hobby. Adopting a serious and perhaps more professional approach to your hobby can actually add to your sense of enjoyment. It enables you to tackle your subject much more constructively, provides more to think about, a greater sense of 'involvement' in your hobby and, ultimately, a great deal more personal satisfaction and enjoyment.

Useful Non-Photographic Extras

Preparation for any photographic trip is always important. Although you may hardly be likely to be miles away from civilisation when photographing the urban landscape, you do still need to plan your trip quite carefully. Start by making notes of everything you might need in your gadget bag. Although this might seem a little unnecessary, there really is nothing worse than arriving at your destination only to find that you have left something important at home.

Photography is fun and there is nothing wrong with 'fun' pictures. This old typewriter and bottle were lying on a small heap of rubbish. No re-organising was necessary other than to stand the bottle upright. Amusing titles for this picture might be 'Writer's Ruin' or 'Deadline'. *Olympus OM1, 21mm lens with red filter – Ilford HP5 ISO 400/27.* Picture by David Chamberlain

Obviously, it will not be too difficult in deciding just what items of photographic equipment you should take, but there are a few small but useful non-photographic extras which can often prove extremely useful.

Firstly, if you are not fully familiar with the area in which you will be working, take a map with you. This will prove invaluable in finding your way around and save a great deal of both time and trouble. To complement the map, also take a small compass with you. If you don't already have one, buy one; they are relatively inexpensive and small enough to be conveniently carried on your person. So that you may keep a record of where you have been, what you have photographed, where you are going, exposure and other technical details, or any other useful information, take with you a small notepad and pen. You will be surprised just how useful such simple items may be.

A few other simple items, which might at first seem a little strange, may prove extremely valuable when you come across a situation where

they are needed. Transparent sticky tape, masking tape or insulation tape can be particularly useful for anything from holding twigs or small tree branches out of the way to effecting a temporary repair to small items of equipment which may break. Similarly, a ball of string, or preferably a length of fishing line, can be used to hold things out of the way. This can be extremely useful when small tree or bush branches may be encroaching on your field of view, partly obscuring your subject matter. Fine fishing line is particularly useful in this respect, for it is extremely strong yet may often be fine enough to be invisible in your final photograph. A few small pegs or other clips may also be useful in much the same way.

Using A Map And Compass

A good map and a small compass are perhaps two of the most useful items of non-photographic equipment you can carry with you. Buy a good-quality map which features compass bearings and select one which is as large a scale as possible. These small and relatively inexpensive items will not only assist you in finding your way around in perhaps unfamiliar surroundings, but will also prove to be an invaluable aid to photography itself.

It is possible to forecast the position of the sun in the sky for any particular time of day and season of the year, and using this information, and your map and compass, you should be able to determine in what direction the light will be falling on any particular building which you may wish to photograph. If you have not previously explored the area in which you are working, make notes of any potentially interesting buildings or other features, using your compass to determine when the light might be at its best. You can then make a point of returning at a future date with the advanced knowledge of the expected lighting conditions. This is a very real advantage.

Maps (a), a compass (b), and note-pad and pencil (c) are some of the most useful of 'non-photographic' accessories for urban landscape photography.

154

If you want to be certain of arriving at a scene when the light is just right, make good use of weather forecasts, a map and a compass. Picture taken at Thamesmead, on the outskirts of London. *Olympus OM1, 50mm lens with red filter – Ilford HP5 ISO 400/27*. Picture by David Chamberlain

Weather conditions are often another important consideration when photographing the urban landscape. Always take advantage of weather forecasts relevant to the area in which you intend to work. Simply utilising three simple things – weather forecasts, map reading and compass bearings – it is possible to obtain quite a considerable amount of advance information which will enable you to plan your trip much more constructively, ultimately increasing greatly your chances of embarking on a successful photographic trip.

Avoiding Problems With The Law

If you want to enjoy your photography of the urban landscape, at all costs avoid any chance of falling foul of the law. Although this might seem quite obvious, it can be surprising just how easy it is accidently to break the law, or at least put yourself in a somewhat awkward situation.

Most obviously, many cities and towns have by-laws, particularly with regard to 'obstruction'. These may prohibit the use of a tripod, say on a footpath for instance or, in some cases, anywhere within a specific area. More of a problem are buildings or other areas which may be either politically or militarily sensitive. These are not always as obvious as one might expect. In addition to these potential restrictions are areas which may be controlled by 'private' or 'company' security personnel. Some officials may have the power to seize and confiscate your equipment, so caution is essential. If in doubt, ask!

By way of a warning, I will relate a short story of a true experience which occurred to me. Whilst preparing to take photographs of a local power station during normal daylight hours, and from a narrow perimeter road, I was extremely alarmed to be quite literally 'pounced upon' by two very large security guards. I was very surprised as I had not really noticed their rapid approach in a motor vehicle, until they skidded to a halt at my side. They immediately asked me what I was doing and whom I was working for, and then very firmly insisted that I hand over my camera to them. I refused quite politely and related the fact that there were no 'warning' signs or notices visible, either at the entrance to the road or indeed where we were standing. Although the security guards were still pretty insistent for a short time, the matter was finally resolved by the fact that, at the time, I had not actually taken any photographs and I was able to provide identification. Nevertheless, quite a harrowing experience!

The moral to this unfortunate story is, if you are taking photographs from a road which is any other than an obviously 'public' road, and particularly if you are photographing a location which could in any way be considered sensitive, *beware*! Try if possible to locate somebody in authority and *ask their permission*. Also, do always carry some form of identification with you, as this will always help to establish your authenticity.

Avoiding Problems With The Public

Much the same applies to avoiding trouble with the general public. Always try to avoid upsetting or offending people and, not least, avoid getting in their way or obstructing them. Most people do not mind having their picture taken, but if you are to include 'specific' people in your urban landscape photographs, particularly if they will be quite obvious in the final picture, at least ask them if they have any objections. Most will not mind.

If you are photographing someone's home or private property, always

try to obtain their permission beforehand. For although you may not strictly need their permission when taking photographs from a public road, it costs nothing to simply knock at the door and ask. This will at least let the people concerned know what you are doing and help save any embarrassment, particularly if they should telephone the police believing you are up to no good!

Prohibited Buildings And Other Areas

Sometimes you may wish to gain access to a building or perhaps a certain area which is normally prohibited in order to obtain a photograph you particularly want. This can sometimes occur when photographing a tall building, when it might be beneficial to gain access to an adjacent building in order to obtain a more satisfactory viewpoint. Once again, never be afraid to ask. It is quite surprising just how helpful people can be if you simply show them respect and a little courtesy.

Keeping Notes

Finally, always keep notes of every photograph you take. Use your notebook, which you should always carry with you when out and about taking your pictures, to make the initial entries, then, when you get home and finally process your photographs, transfer these notes into a reference notebook, so that you have a permanent record of all facts relating to each picture. Information such as location, date, time, the actual equipment used and full exposure details, including film type, are the sort of details which are always useful for future reference and may prove valuable over the course of time, not only as an important reference to each picture, but also in assessing and charting your own progress.

Index